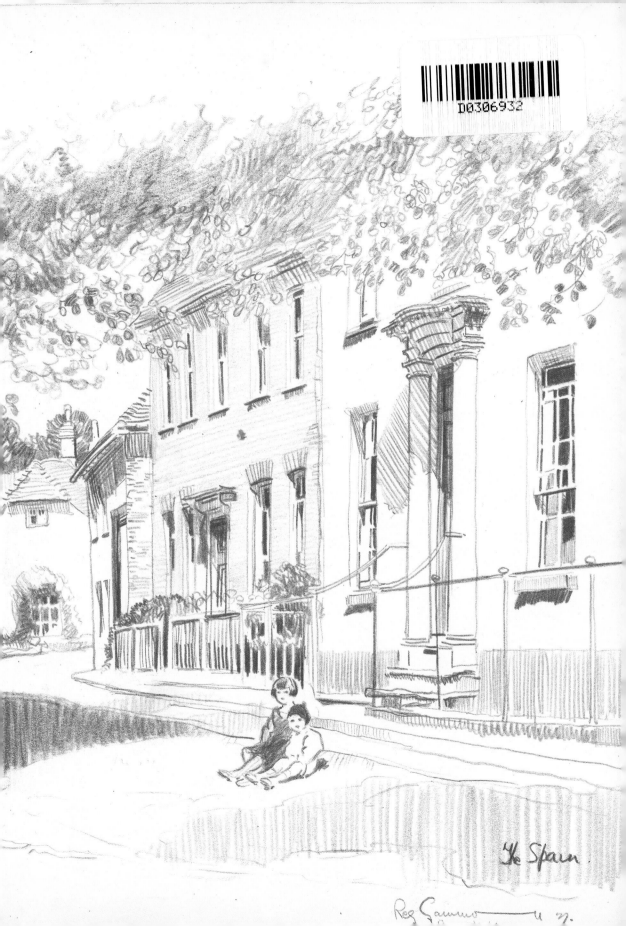

The Spain

Reg Gammon

ONE MAN'S FURROW

ONE MAN'S FURROW
Ninety Years of Country Living

REG GAMMON

Compiled by
ENID FAIRHEAD

Preface by Raymond Spurrier

Webb & Bower

First published in Great Britain in 1990
by Webb & Bower (Publishers) Limited,
5 Cathedral Close, Exeter, Devon EX1 1EZ
Distributed by The Penguin Group
Penguin Books Ltd, Registered Offices: Harmondsworth,
Middlesex, England
Penguin Books Australia Ltd, Ringwood, Victoria, Australia
Penguin Books Canada Ltd, 2801 John Street, Markham
Ontario, Canada L3R 1D4
Penguin Books (NZ) Ltd, 182–189 Wairau Road, Auckland 10,
New Zealand

Designed by Enid Fairhead FCSD

Map drawn by Malcolm Couch

Text and illustrations copyright © 1990 Reg Gammon

British Library Cataloguing in Publication Data
Gammon, Reg, 1894–
 One man's furrow: ninety years of country living
 1. Great Britain. Rural Regions. Social
 life, history
 I. Title
 941'.009'734
 ISBN 0–86350–329–2

Typeset in Great Britain by August Filmsetting, Haydock, St Helens
Colour and mono reproduction by Peninsular Repro Service Limited, Exeter, Devon
Printed and bound in Great Britain by BPCC Paulton Books Limited

CONTENTS

To Betty, my partner for sixty-four years,
mother of Peter and Gordon

Among many to whose kindness and wise council I owe a debt of extreme gratitude I will name six.

G H Stancer, editor of *Cycling*, who bought some of my first drawings in 1917, and when he became secretary of the Cyclists' Touring Club and editor of the club's *Gazette* invited me to contribute – this continued for sixty years.

Haydn Dimmock, editor of *The Scout* who wrote a story round one of the first drawings I sold and was a true friend for many years after that while I contributed to the magazine.

H John Way, my nephew, trained on the *The Scout* by Dimmock, and who eventually as editor of the *CTC Gazette* first edited and published much of the material in this book.

Stan Baron who introduced me to the *News Chronicle* – an epic period!

Hugh Redwood (of 'God in the slums'), who fixed me with a retaining fee on the *News Chronicle*, giving me a sure income for the only time in my life.

Finally my sincere thanks to Enid Fairhead whose idea it was to create, design and publish this book and bring order out of chaos.

I also wish to thank the owners of paintings reproduced herein and trust the account of what went into the production of their paintings will afford them a pleasure equal to that of owning the paintings.

RG

The publishers would like to thank George Sassoon for permission to quote from 'Lost in France' by Siegfried Sassoon (page 121).

PREFACE

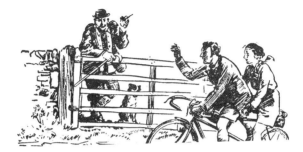

Back in the 1930s when I was still a schoolboy, Reg Gammon was my hero. His drawings were then appearing regularly in the pages of *The Scout* and the *News Chronicle* and each week I could scarcely wait to inspect them for content and technique. I was keen on drawing and soon decided I wanted to be like him: to explore the countryside on a bicycle, describe what I saw in words and pictures, to have them published, and be rewarded with money, preferably measured in guineas!

That was not to be. But nearly half a century later it was an enormous pleasure to be able to write a piece about him in an art magazine and, a year or two after that, to report a retrospective exhibition of his work put on by the Royal West of England Academy.

When I eventually got to meeting him he was well into his eighties, bubbling with irrepressible energy, and I took immediately to the merry twinkle that never seems to be missing from his eyes. He was, at the time, conducting a painting holiday for amateurs, hopping around a farmyard in gumboots with a stick and far more verve than the students half his age. 'Some of these people', he wryly remarked in an aside, 'are too old for this sort of thing!' and then darted off to dish out another helping of kindly advice and encouragement.

But this is not a book about art and Reg would not thank me for going on about his sure brushwork, pictorial influences, or his expressionist technique. For anyone who knows about these things the pictures speak for themselves – the crispness of black and white that had to survive cheap paper and the rotary press, or the paintings that glow with vibrant and unexpected colours. Though he is apt to paint blue cows and green donkeys with a Chagall-like naïvety and a Fauve-like intensity, to put advancing colours where the more timid would tone them down, Reg Gammon's subject matter stems from a deep knowledge and love of country life as it used to be.

7

This is no art for art's sake. Nor are the contents of this book a sentimental evocation of times past. Any nostalgia they might engender will be entirely in the reader's mind. For those familiar only with the monoculture landscape of agri-business, these lively vignettes of an all-but vanished country life may come as something of a revelation. For today's town-based painter in search of rural pictur-esque they will provide a breath of genuine country air.

Reg Gammon has never ceased to plough a steady furrow, painting only what he understands – his natural habitat – for he is one of a fast disappearing breed, a genuine countryman who could survive in primitive conditions. He once startled a party of dejected cyclists by brewing up coffee in the rain on a fire lit in a puddle.

So this book tells of simple pleasures and old-fashioned values while bringing the talents and personality of its author to a wider public and a new generation of admirers. And, incidentally, it is also a valuable record of times and habits long gone.

To be writing this preface is more than a great pleasure: it is a homage. At ninety-six the hand may be a bit shaky but Reg's brush stroke is as firm as ever, the furrow still straight, and the paintings much sought after. Reg Gammon is still my hero. I am lucky to be counted among his friends. I only wish I had met him in my teens.

RAYMOND SPURRIER RI ARWA

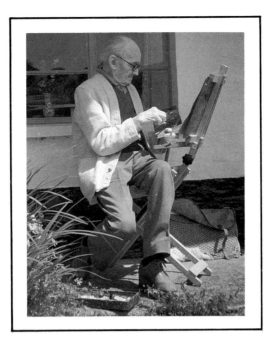

INTRODUCTION

To be dumped screaming into a sawn-off cider cask at the age of five years and sent spinning into the middle of a sheep-wash pool among struggling sheep was a unique christening. To be thrown out of a high gig by a bolting horse shortly after, while waiting to go to Petersfield market with my grandfather, was a baptism: a sure sign that I was destined for a country life.

In fact that has been my good fortune for over ninety years. To be told frequently by my uncles on the farm 'Nothing no good never comes to any harm' seems to clinch the matter. (I must have been unpopular with my uncles; grandfather made too much of his only grandson.) However, the experiences are an abiding memory; I am happier on my feet than on anything that floats or flies.

The company of cows and sheep, hens and ducks and geese, watching young unbroken horses being trained for the mail vans and dodging about in the way when old Bentley Bridle came to kill the pig was all part of life. Crawling through a hedge to steal the nurseryman's strawberries and hiding beneath the dining-room table carefully crushing in my fingers the contents of the egg collection of one of my uncles were more painful occasions. Small wonder my uncles regarded me with awe!

When my grandfather Andrew Gammon had laid his second wife to rest, in true Victorian tradition he cast around for a third to assist with a family of three sons and two daughters.

His eye lighted on Miss Alice Holder, a prominent young member of the congregational chapel. But his eldest son William was also after Alice. Experience triumphed over youth and she became William's stepmother, known thereafter as Aunt Alice, to mitigate her lack of years.

So William changed direction and I have been told that there was consternation in the Richardson camp when he 'set his cap' at Edith Mary. John Richardson regarded 'Young Gammon' as a bad lot. Opposition was strong and numerous as the accompanying photograph will show: none of the sons had married at the time, and anyway Edith Mary was the family slave, Victorian style.

John Richardson founded the first collective milk factory opposite Petersfield railway station and lived in the large house adjoining. A big cellar in the basement was used for butter making and in winter this was often flooded so the worker had to stand on boxes. In summer butter making began at four-thirty am to avoid the later heat. Edith Mary was the butter maker, delivering hundreds of pounds every week.

On his way to the coal office in the station yard Father passed the entrance to the cellar just after five am to get to work by eight! Butter making and courting paid off. When this was discovered Edith Mary was packed off to a farm at Ogbourne St George to get her away from him but Father was a good cyclist and they met on Mary's 'off days'. Then the family moved to a milk factory in Eastleigh and William Alfred Gammon and Edith Mary Richardson were married on 28 February 1893; I was born on 8 January 1894. Father was a doughty fighter.

In fact Edith Mary had 'kicked over the traces' before the move to Eastleigh and had cycled with the Petersfield Club, being the first woman in the town to have a bicycle. I believe my father gave her a new Globe bicycle as a wedding gift and her father's comment was 'Better to give her a few brooms and brushes'.

My mother Edith Mary (front row, centre) with her sister, her six brothers, her parents (seated), and Nimble the family dog

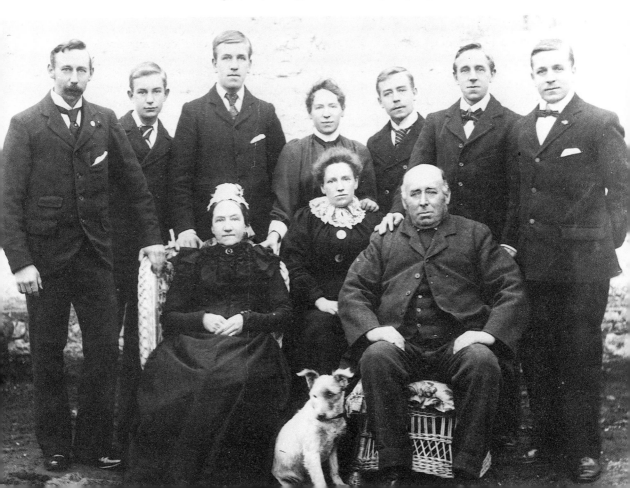

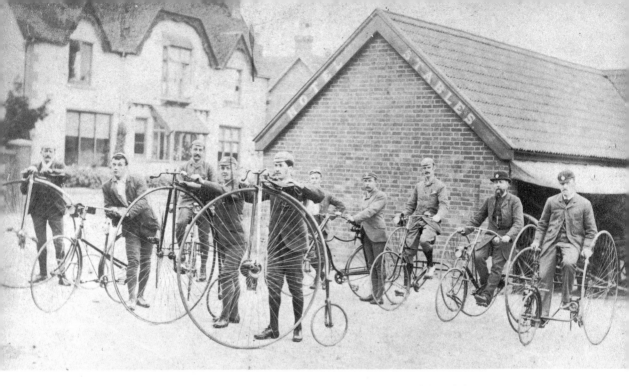

The Petersfield Cycling Club c1886 which my father (second from left) was involved in starting. It shows three fifty-six-inch Ordinarys, four tricycles and two Safetys – my father's being the most modern, a new machine and replacing his Ordinary. All of course solid-tyred.

A few years later, with another youth, I was on holiday on my uncle's farm at Fernhurst being looked after by a stern spinster, Aunt Bess. One evening Aunt went to 'the meeting' leaving us with instructions to 'go to bed like good boys at eight'. Having exhausted the idea of hurling turf at each other across a stream (defending Crusoe's island from savages) we decided to camp out for the night. Two wooden sheep hurdles and few old sacks made a tent well hidden behind a tall hedge. Straw from the barn and more corn sacks from the granary and a raid on the larder, in case of famine, completed the blissful evening. We ate the supper left by Aunt, with what we had purloined from the larder, and turned in to await results. Later that night a trail of straw gave us away. We were hauled out, reminded that 'gracious God' was watching and recording all our sins, and put to bed with some anti-everything medicine and stone hotwater bottles. But the 'sin' had taken root. The last I heard of Roland he was cook for a logging camp in Canada where bears came to raid the garbage bins at night. And for myself, the following pages will tell.

Aunt Bess entered the Post Office a young girl when the 'telephone' was a key-operated morse transmitter (telegrams delivered by a boy on a bike), was post-mistress at Rogate and later housekeeper to her unmarried brothers and aged mother on the farm. My sister and I spent all our holidays with her – 'Edith's children are dragged-up little brats'. She felt it her Christian duty to rectify that. We were made to eat what was put before us without comment, nothing was to be wasted (she finished up every dry crust herself as a self-denying duty) and once made some green tomato jam (to save the fruit) and made us eat it. Neither of us have ever forgotten her austerity which had full play in our young lives. Nonetheless we loved her and mature years have framed her in gold. She appears in later

Me aged twelve

pages. Living was primitive at Lower Hawksfold, approached over field tracks, with well water, candlelight and a 'two holer' up the garden gained at night with a stuttering candle that usually blew out halfway to success.

In those early days Petersfield fire engine was still a six-a-side manual pump; men sat back to back on the long box-seat that held hosepipes, bracing themselves with their firemen's boots on the wooden pumping handles folded along the side of the machine. Various stables around the town agreed to keep horses ready to be used at any time, night or day. When the steam hooter on Miss Amey's brewery wailed over the town men came cycling or running from every direction fastening jackets and belts and axes, with huge shining helmets awry, all converging on the square where the engine was kept. Horses were 'shut in' the shafts and away in quick time.

Father gave me my first bicycle when I was eight and thereafter, when free of school, I seldom missed a fire. He was a fireman for years and my great grandson has his medal presented on retirement.

There was great excitement when a shining new fire engine with a steam-driven pump arrived from Merryweather. The firebox was always kept laid for my father to light it with a large 'fusee' match so that the pump engine was ready to operate when the fire was reached; but this machine was pulled by horses and it was years before a fully motorized fire engine came from Dennis of Guildford. Father was engineer and much polishing and cleaning there was at the weekly practice. At the yearly flower show the fire brigade, with Father well to the fore, demonstrated the power of a volume of water, spraying occasionally where it was not welcome.

I recall the names of some of the firemen: W Jacobs (auctioneer) was chief, my father (engineer), Tew (cycle shop) Joe Guard (builder), Bob Luker (brewer), Norton Palmer (art and carpentry at Churchers College, the school I attended), the Binstead brothers (grocer and bankers), Freeman (barber) – and whose huge, spinning brush nearly decapitated me at the end of every threepenny haircut.

The brigade had an annual outing to London which included me on one occasion. We went to 'the waxworks' and to a theatre to see *Little Titch*.

'Time out o' mind' said Jim, 'Wednesday has been market day in Petersfield'. It was in the 1900s when returning home from the board school on Tuesday afternoons that the square would be a riot of wooden hurdles – to be climbed over rather than

walked round – and only fear of the cane got us to school on time the following day. Dinner break was an opportunity to race home, eat and return to contribute our bit to the fun and games. The market served a very wide area and there were hundreds of animals penned and tied to the railings or just standing around free, guarded by the owner.

Of the various salesmen and cheapjacks around the statue of William of Orange, I was most interested by the self-styled dentist. He stood in a high wagonette furnished with a strong armchair, an armoury of pincers dangling from the wheelboard and an accomplice with a cornet. Addressing the crowd and enlarging on his fame he offered a first, *free*, painless extraction. When a victim was forthcoming he was seated in the armchair, the molar was selected and as the crucial moment arrived the trumpeter would give a shattering blast on the cornet to effectually drown his cries.

The climax of the day came when the mob of pigs and sheep and cattle, which dealers from Portsmouth had purchased, were driven through Chapel Street and Lavant Street to the railway station to be trucked. There were no huge cattle lorries; animal walked or went by rail. This generally coincided with our release from school and we made the most of it.

Pigs were the most troublesome to control – they were all together, each dealer having marked his purchase with a coloured chalk – and the Gadarene swine were not the only pigs possessed by devils, believe me. Woe betide anyone who left a door open or a gate unlatched. A couple of pigs can work wonders in a china shop.

'Jigger' Waters shut his corn store and the Misses Tribe closed their sweet shop, and Mr Fuller his high-class grocer's establishment. Mr Roach 'Family Purveyor and Licensed Game Dealer' (who in later years I taught to drive a Frazer Nash cycle-car) stood on the pavement appraising the value of the livestock as meat. The Misses C & C Pickering, Photographers, viewed the cavalcade from within, wringing their hands when the cows decorated the wide elegant windows with their

The Square, Petersfield, c1905 on market day, with oxen in the foreground

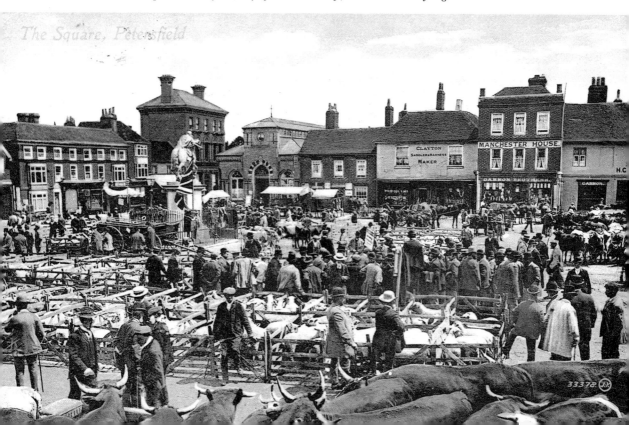

tails! Mr Emm (or 'Archie' as he was known) carried inside his collection of every household item anyone could ever require (including natty little canes, which I sampled more than once) and 'Skinner' Tew wheeled his 'Bicycles for hire' to safety.

We boys were allowed to guard the sidelines while the professional drovers and dogs created bedlam. The last hundred yards up to the station were very tricky with a crossroads and on the left an open field, with a very inadequate fence, owned by my grandfather. Any pig that slipped through the fence gained acres of freedom and many expressive words from the drovers. Only experts could 'truck' all the animals – cows called for calves and calves bawled for lost mothers, sheep baaed, lambs cried and pigs fought. We kept out of the main battle.

A circus was held each year in Grandfather's field, the parade round the town was a great event and I lived near enough to hear the lions roaring at night. German hands were frequent and around the time of the war always reckoned to be spies. The Italian barrel-organ grinders on the other hand were popular and would occasionally allow a boy to have a go and then turn the little handle at the side to change the tune. The organ on a single pole, usually with a monkey in a red jacket and cap, was also around quite often. The hose and watercart paraded the streets to lay the dust on summer days and you were liable to have your cap snatched off and thrown into the water spray and horse droppings.

The volunteers came home from the South African war marching down Lavant Street in their white helmets under an arch of 'welcome' Father had helped to erect.

Solicitor Robbins was a marvellous reciter, and Norton Palmer who dressed in a smock sang country songs at the Saturday night 'penny pop' in the Corn Exchange. The Coffee Tavern in the square was administered by the Congregational church for temperance reasons. (I was made a trustee when about nineteen to keep young blood in it.) Mr Joy ran the Band of Hope at the chapel and high up on the wall of the Sunday school was painted 'Wine is a mocker, strong drink is raging'.

Taro Fair on the heath on 6 October brought folk in from far and wide as it had done for generations and still does today. The various chapels combined in an annual outing to Hayling Island and the girls were kissed in the tunnel darkness on the rail journey home.

At the railway station was a level crossing with four ponderous gates which were operated by a signalman in the box. Father's coal office was on the far side of the crossing and he used the crossing several times a day, occasionally slipping through on his bicycle when the gates were half closed. The gates were operated by a large iron wheel with a handle, which old one-legged Viney worked. When he saw Father at his trick he would turn the handle like mad to shut Father in on the rails from where he had to walk to the station platform exit: the alternative to a long wait for the train to pass was to carry his bicycle over this high footbridge.

Three great wagons with horses awaited the special train that brought the 'hoppers' from Portsmouth. Piled with boxes and prams and bedding and pots and kettles, and the people on top, the wagons went through the town to the Weston 'hoppers' huts' for the hop picking.

When I left school I was apprenticed to Frank Patterson, a well-known cycling artist and brother-in-law to Father, who paid him a premium for me in the time-honoured way. I learnt a few tricks and a whole lot about poaching in the woods around his small farm near Billingshurst and generally had a good time from 1911

Rey Gammon 1914

until the weekend when war was declared. That Saturday, with several other ex-Churcher pals, I went to the Drill Hall in Petersfield and joined up.

August 1918 – I am discharged and unemployed with thousands of other young men. I am also married to Betty, who I first met in Sunday school in 1901. We began courting in 1912, were married in 1917 and were parted by her death in 1982.

My father (bless his memory) ran his coal and building business with horses. I could by then drive and maintain a lorry. He gave me an open cheque and with another mechanically-minded youth I attended one of the many ex-army lorry sales being held around the country. We bought a Napier lorry, and Gammon & Son were mechanized. Only years after did I fully appreciate the enormity of the step and his confidence in me. I was with him for about two years, driving by day and drawing and illustrating at night.

Sir Muirhead Bone was one of our customers and my father had a word with him. I crept up to Steep, Petersfield, with some drawings to show. He was very kind and obviously thought no ill of my efforts. He offered to get me into the Slade art school.

Work 24·6·15

Joe 11·6·15.

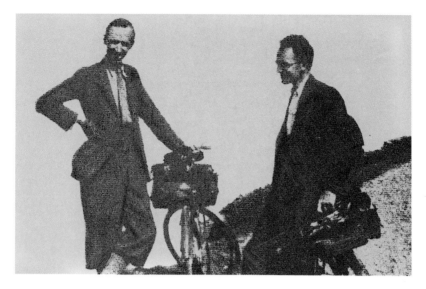

With Stan Baron (left) on one of our cycling tours for the News Chronicle *in the '30s*

'But, Sir,' I said, 'I have a wife and child!' There were no student grants then which was lucky as neither the Slade nor I would have profited by my presence.

I had been selling a few things to *Cycling* magazine and humorous papers, of which there were several after the war, so I offered my job with Father to a trustworthy friend and rented a small cottage from my uncles at Fernhurst for £20 a year. Father sent us a lorry load of coal, and we were off. However, it was not long before we touched rock bottom financially, so Father lent us £100 and we bought Sunnyside, an old Sussex cottage, the beginning of our real country life.

At first the financial barometer rose and fell but gradually I gained a sure footing. When I joined Stan Baron on the *News Chronicle* in 1930 I had as much work as I could do, with my own weekly feature on that paper and my watercolours continuously accepted in several London galleries.

A friend writing in *The Artist* labelled me 'artist, writer, countryman'; I sometimes wonder if 'countryman' should come first. This record of country living is a collection of illustrated writings published between 1922 and 1982 in the *Cyclists' Touring Club Gazette*, the *News Chronicle*, *The Scout*, and *Fibres Post*, a magazine published by British Nylon Spinners (later ICI). Also included are some of the watercolours and oil paintings I have done over the years.

The cuttings had been saved in glorious disorder in odd envelopes and packets, and pasted into press cuttings books during the past five years with no thought of subsequent publishing. Some take only a few minutes' reading; others are longer. They describe living, talking and working with countryfolk, hill farming in the Llanthony Valley, walking and cycling, sketching and painting in the British Isles and Eire. I believe all are worth preserving and trust none is boring.

I have not considered it necessary to change the names of places or to invent any names for characters since all were my friends and I have not overstepped the bounds of that friendship.

RG

REG GAMMON RWA ROI BIOGRAPHICAL NOTES

1894 Born in Petersfield, Hampshire
Educated at Churchers College, Petersfield

1908 Apprenticed to village builder at Fernhurst, Sussex; apprenticeship terminated by illness

1911 Apprenticed to Frank Patterson, black and white artist of Billingshurst, Sussex

1914 Enlisted Hampshire Volunteers
Discharged owing to recurrence of illness

1915 Taxi driver in Portsmouth

1916 Re-enlisted in the Army Service Corps

1918 Discharged. Married Betty and moved into cottage at Fernhurst, Sussex. Began career as freelance artist, writer and painter in watercolour, contributing to humorous journals, cycling and motoring journals and *The Scout*.

1920 Began regular freelance work for the Temple Press on *The Motor*, *The Light Car* and *Motor Cycling* magazines until 1932

1924 Wrote and illustrated a country feature for the *Cyclists' Touring Club Gazette* until September 1984, a total of sixty years

1928 Did illustrations for *The Morris Owner* magazine until 1944

1930 On 8 January joined team participating in the Monte Carlo Rally, commissioned by *The Motor* to submit drawings of the event. (Team did not reach Athens the starting point because of appalling weather conditions but Reg Gammon went on to Monte Carlo by the Orient Express to complete the commission.)
Early in 1930 the *News Chronicle* invited him to team up with Stanley Baron, their cycling journalist, to illustrate his weekly cycling feature on the 'Saturday Page'. During the following eight years they cycled together over much of England, Wales and Scotland writing and illustrating daily articles. 'The Week in the Country' was Reg's own weekly feature for the *News Chronicle* which he wrote and illustrated until 1939.
Illustrated six books based on the very popular BBC children's series 'Romany'. These were published in the 1930s.

1932 Formed a scout group in Haslemere, Surrey
Began weekly illustrated article 'In the Open Air' for *The Scout*. Continued this until 1960.
Arranged and conducted cycling and scout tours and hikes in Scotland, the Lake District and Ireland over the following years

1934 Jarrolds published *Westward Ho! From Cumbria to Cornwall* by Stanley R Baron with Reg Gammon's illustrations as they had appeared in the *News Chronicle*

1939 The outbreak of the Second World War stopped his work with the *News Chronicle*

1940 Moved to Capel-y-ffin, Wales, and rebuilt a derelict cottage. Joined Home Guard, continued with *CTC Gazette* and *The Scout* and began contributing a weekly feature, 'Country Corner', to the British Nylon Spinner's industrial newspaper and monthly magazine.

1942 Purchased a forty-acre hill sheep farm in the Llanthony Valley, Abergavenny, Wales, working with his younger son, Gordon. They pioneered milk production and crop growing for the war effort and were instrumental in bringing electricity and the telephone to the valley.

1962 Retired from farming and moved to Somerset.

PAINTING

From Exhibiting at the
1938 RBA Royal Society of British Artists
 NEAC New English Art Club
 RI Royal Institute of Watercolour Painters
 RA Royal Academy
 ROI Royal Institute of Oil Painters
 RWA Royal West of England Academy
 This latter has continued to 1989, being an unbroken record of over fifty
 years. Honoured with a retrospective exhibition in 1985.
1966 Elected RWA and ROI
1985 Retrospective exhibition at the RWA
1986 First London one-man exhibition at the New Grafton Gallery
1988 Second London one-man exhibition at the New Grafton Gallery
 Both exhibitions were the subject of very favourable reviews in *The Times*
1990 Still painting vigorously and exhibiting
 Has works in the RWA permanent collection and private collections in
 Great Britain, New Zealand, Canada and the United States

1990 *One Man's Furrow* published.

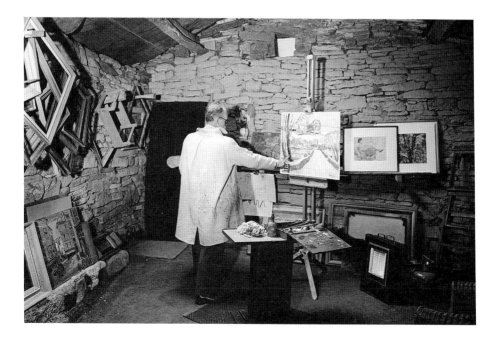

I born in town! Oh no, my dawn
O'life broke here beside thease lawn:
Not where pent air do roll along,
In darkness drough the wall-bound drong,
An never bring the coo-coo's zong
Nor sweets o'blossoms in the hedge,
Or bend 'en rush, or shee 'en zedge
Or sounds o'flow' en water.

The air that I've a-breath'd did sheake
The draps o'rain upon the breake,
An' bear aloft the swingen lark,
An' huffle roun' the elem's bark,
In boughty grove, an' woody park,
An' brought us down the dewy dells
The high-wound songs of nightingeales
An' sounds o'flowen water.

WILLIAM BARNES

My Early Years

1894 – 1939

One of my earliest recollections is of gathering mushrooms at six o'clock on chill September mornings under the eagle eye of my maiden aunt. With an indescribable hat perched above her stern features, armed with an old knife and a large basket, she scoured the home fields. I trailed reluctantly behind through the dew-sodden grass in plimsolls ('gum-boots' were unknown) and it was the only occasion I got my feet wet without being admonished. Playing Robinson Crusoe on an island in the river was an unnecessary frivolity not to be encouraged. We usually returned with a full basket. This was comparatively easy because in those days horses, not tractors, provided power on the farm and grazed the fields, and not a button escaped my aunt's keen eye.

My childhood years were spent on a pleasant farm in the cradle of the Hampshire hills. I have many pleasant memories of a lovely English garden, where fruit trees lined the walls and bees hummed above the flower beds; where raspberries and strawberries grew to perfection, and the scent of thyme and mint and roses filled the air; a garden at the foot of which flowed a chalk stream, where minnows and 'tiddlers' waited, almost asked, to be caught on the crudest of bent pins, and where birds nested in profusion.

I count myself fortunate to have been born in the country and to have come of country stock. My forbears were craftsmen: a farmer who started one of the earliest milk collecting depots, and a builder-cum-carpenter-cum-undertaker-cum-coalmerchant whose stamp is on some of the tools still in my workshop.

The former was bluff and hearty and came near to idolizing and spoiling his grandson. One Christmas I rejoiced in my first farm tool – a perfect little wheelbarrow he had ordered from the local wheelwright. Possibly that began my love of craftsmanship. The latter was a stern but lovable noncomformist to whom work – good work – was the chief end in life. For many years my father's only holidays were Christmas Day and bank holidays. However he was lenient with me and spared the rod that had weighed so heavily on himself. In later years, when 'gramp' was mellowed and a little less vigorous, I worked with him building some houses. He taught me how to mix paint from white lead, oil, driers and turpentine, long before I thought of art as a career.

During those impressionable years I was constantly in the company of one or other of the farm workers or poking about the wheelwright's or blacksmith's shop. So the love of a good job grew on me.

A character who loomed large upon my youthful horizon was old Bentley Bridle. He arrived when there was a fat pig in the sty – that was pretty well throughout the year. He came equipped with a leather apron in which he had

rolled the tools of his trade. On the morning of his coming the great copper had been heated up until clouds of steam poured from the boilerhouse door, and the pig bench and a huge wooden tub were set ready.

Bentley removed his jacket, rolled up his sleeves revealing the largest, hairiest arms I had ever beheld, and girded on his apron. Two very sharp knives, a huge butcher's steel, a scraper, and a short length of very strong cord were the only tools he needed to subdue a very large pig to succulent pork.

Having assisted on many similar occasions since then, I realize how quick and efficient he must have been: an artist at his job. I usually danced about in the way while the pig was being scalded and cleaned, and was rewarded with the pig's bladder being draped around my unwilling neck. But I had a rare 'fool's bladder' to whack about with when it was dried and inflated.

One of the real occasions of my youth was a visit to the family cobbler, carrying a pair of boots or shoes for repair.

Kings and queens, noble lords and ladies, famous soldiers, and Admiral Lord Nelson himself had thundered by the tiny shop in Dragon Street in coaches and carriages on the London to Portsmouth road. The Regulator and the Royal Mail, the Rocket and the Hero, changed horses at the Dolphin a hundred yards away, and many a performance on the posthorn must have split the ears of former cobblers.

The small square windowpanes of the shop were almost entirely obscured on the inside by a marvellous assortment of oddments appertaining to the cobbler's trade: some cards of porpoise hide and ordinary black bootlaces; prepared waxed

threads; a lump of heel-ball; small black and brown buttons used on ladies' boots in those days; a rack of awls, needles, and reels of thread; and a few tins of the old-fashioned 'blacking' – which seemed to give the best shine when mixed with spittle.

The obscured window mattered little to old John, for the top half of the double door was usually open and he could see his customers coming some time before they arrived. He was like a shaggy old lion, aged and weatherbeaten, and possessed of a voice in keeping with his fierce appearance. He used to put the fear of death into me on occasions, and it took a deal of courage to look over the half-door of his den.

'Well boy', he would roar, 'what d'ye want?'

'Mother sent these boots, Mister Bramley – '

'Oh, did she?' – pause while he peered at the boots through a pair of very old spectacles with small grimy lenses – 'Hm . . . you can tell your mother she ought to have sent these before, boy. Tell her I said so! . . . How's your father, boy?'

'Very well, Mister Bramley.'

'Ah, good. Now clear off and leave me to my work . . . and give your father my respects.'

Actually of course everyone liked him, and he often made my father a pair of boots – a job that took a long time and much consultation ere they were completed. But what boots they were.

John has gone now, and his place will know him no more – nor any to match him for skill and honest work.

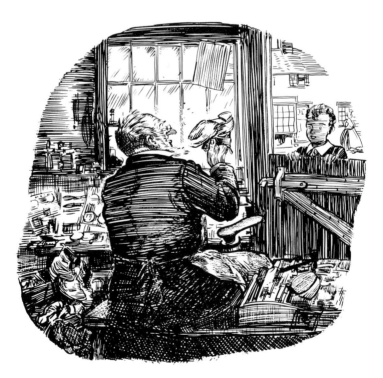

24

Bill Tidy turned up on the common one day, and came to our cottage seeking knives to grind or kettles to mend – a real old-time tinker. We found him some work, and soon discovered that he really did grind knives and scissors so that they cut. He was in fact a genuine craftsman and not an artful dodger who had bought a fourpenny file with which to utterly ruin the tools of simple folk who trusted him.

He came at intervals after that first visit and I got on well with him. Formerly he had pushed his 'contrapshun' by hand, but he was getting old and had conceived the idea of mounting it on an ancient wagonette so that he could use a pony and drive round the countryside.

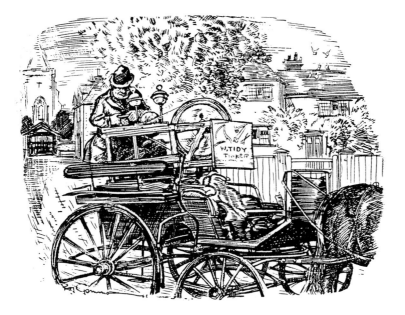

It was odd to see him perched high on the vehicle, and his signboard on the front depicting the emblems of his trade was a work of art. At the time I made a sketch of him at work and later I produced the accompanying drawing from it.

One spring he failed to turn up. The cold winds of winter had taken their toll.

Many others I could write of: John Burt the wheelwright working in a shop whose door was thick with many coats of brilliant colour where he had cleaned out his brushes after painting a wagon.

Across the road Harry Larby the blacksmith was a diminutive weed of a man who looked less like a smith than any I have ever seen. How he ever raised the leg of a carthorse, much less held it between his knees to fix a shoe, is a mystery. I can remember him blowing away the fumes, so that he could see his work, and scenting the morning air with the pungent smell of burning hoof. The creak of his huge bellows as he re-heated a shoe in the furnace sounded over half the village.

Both passed on while I was in the village and there was no one to fill their place. It will be a sad day if the like of such splendid countrymen should vanish forever.

25

On my eighth birthday, my father gave me a Rudge-Whitworth, my first bicycle. A clubman of experience, he was keen that I should start right and had previously given me careful lessons on an old machine.

He was an early Cyclists' Touring Club member – I wish I knew when he joined, but do remember that he had one of the old shield-type badges. He made and set up the first 'Cyclists – this hill is dangerous' sign on Butser Hill on the Portsmouth road south of Petersfield, followed later by a CTC sign, and with other club members made periodic visits to the narrow chalk cutting to clear boulders off the road. To collide with one of these when riding a solid-tyred Ordinary was no joke. My mother was the first lady in Petersfield to own and ride a bicycle: a young single woman, as she was then, riding with an all-male club much to her mother's dismay.

We rode fixed wheel: no mudguards, no cape, a tubular spare tied under the saddle, a couple of spanners and a stiff hairpin for tubular repairing and an outfit in one's pocket. The wheels had wooden (hickory) rims. My cycle carried me to the farm where all my holidays were spent, and facilitated my wandering far afield into Surrey and Sussex. Later, as a youth, I cycled over and around those hills, searching every lane for blackberries or crab apples, and probing the downland for brightly coloured snail shells, odd bird skulls, and small flints with curious holes in them. Alone, or with a companion of my own age, on those wide, spreading down tops the sense of having part in a great adventure was tremendous – a

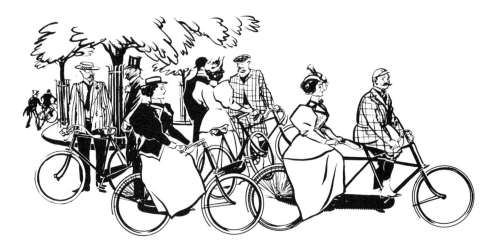

never-to-be-forgotten break into the unknown. Wandering about among the juniper bushes or in the thick woods that fill the downland combes, our experiences rivalled those of any explorer penetrating an untrodden jungle. The one thing that could effectively mar the adventure was the presence of an adult who had lost or outgrown any sense of wonder.

How often have I laid on the heather listening to the curlew at nesting time . . . calling . . . calling – with no other sound but the soft rustle of the heathland grasses or the occasional bark of a raven flying overhead. The flute-like call of the ring-ouzle ('ouzlem bird' the old village folk called it), the clack clack of the wheatears on Sussex downland was my country music, with the full orchestra playing in the dawn chorus and only the voice of the farmer calling in the cows for the morning milking.

Thus, in those early days was born my love of cycling and of country life and ways.

A hazel rod and a hank of line, a bent pin and a glass jar – those were the ingredients of many a happy day in my youth. And if the bent pin could be replaced by a small hook, then indeed all heaven smiled. Even when it finally became firmly fixed in my finger I returned home triumphant if my jam jar held some poor sticklebacks, vainly circling round and round.

I was fortunate in my youth to live near a large pond set amid open heathland – a natural playground for youngsters. Here we could fish for ancient carp, our hooks baited with dough or soaked bread.

We wondering boys viewed with awe the veterans who came up from Portsmouth, bedecked with rods and creels and jars of Brickwood's Best, to sit all night by the water's edge. In our hearts we resented this intrusion on our preserves, especially when we saw the results of a night's fishing swimming about in the shallows, firmly held by a string through mouths and gills.

On occasion, when enthusiasm ran high, four am found us yawning by the waterside, swinging the loaded line round and round to cast far out along the edge of the weeds, in the hope of beating the experts from the great seaport. It was the only thing that ever got me out of bed early!

On summer evenings, if we kept beyond the bylaws noticeboard on the far side of the pond, we could swim and sport in the costume nature gave us, without fear of falling into deep holes or being 'shushed' at by outraged females.

The *Boys' Own Paper* published details for the construction of a canvas canoe, complete with small mast and sail, and thereafter for several seasons my pal and I were the envy of our contemporaries. To this day I marvel that my parents trusted that wretched sailboat: it had all the makings of a tragedy in it, as I could not then swim more than a few yards. Indeed, in my young mind the pond was early associated with a tragedy, for my desk-mate was drowned by slipping through a hole in the ice when sliding there in the dinner hour.

Beyond our bathing-place a part of the pond had been fenced off by the local squire. Here was deep mystery, when trees and undergrowth grew at will in wild disorder, a paradise for birds and waterfowl. We longed to enter this sanctuary, but never dared risk an encounter with the keeper who, for aught we knew, prowled there by night and day. What we could see from a distance only served to whet our interest.

My canoe gave me greater freedom on the pond. I could paddle along the fringe of the forbidden land, look into the moorhens' nest built in the fork of a fallen branch, and sometimes surprise the youngsters before they could slip over the side of the

nest and submerge. A wild duck and her brood sometimes graced the scene – and there are very few lovelier sights in nature than that.

As I grew out of boyhood, things changed. The heath pond became the Heath Lake. The surroundings were 'cleaned up'. The retired and affluent built houses to overlook the lake, and 'boats for hire' drove the birds from the sanctuary until only the inaccessible rooks looked down on the litter of the picnic parties and the lordly swans who held to their place by force of character.

One touch of old times remains. On the heath, where we small kids fed lustily in honour of Queen Victoria's jubilee and carried home a generous royal mug, an annual October fair is still held, with a whelk stall, shooting gallery and coconut shy.

In those days I also spent many delightful hours by the River Rother. In later years I knew it where it flowed through Sussex meadows, turning the great stones in many fine mills, grinding the wheat and barley from the fields which opened to let its waters pass through to the sea.

At all seasons of the year rivers team with interest. A flash of blue following every twist is all you may see of a kingfisher as you round a bend. But on another day, if your progress has been silent, you may see him dive from a branch into the stream, return to his perch the next instant with a minnow in his long bill, bang the life out of it on the branch, and then toss it into the air and swallow it head first. It may be your luck to see the parents feeding a row of youngsters sitting on a branch over the stream, but such a sight it not often witnessed without careful preparation where a nest of young is known to exist.

In days of spring and summer the watermeadows are made delightful with wildflowers. I have seen whole areas of flowering yellow iris, and the boggy ground in which the alders grow so well made beautiful with a golden carpet of kingcups. Primroses crowd the riverbank to the water's edge, and where the tempo of the river is slow and leisurely the dainty water crowfoot and water lilies spread beauty over the surface.

Your river may be broad, where the cattle stand in the shallows and with swinging tails whisk the water over themselves and the tormenting midges; where the long-shanked heron stands silent, waiting for a passing trout. Or it may be swift and narrow, coming down from the great hills in leaps and bounds; here a deep pool – home of some lively mountain trout – and then a tumbling, rock-strewn passage ending in a ford where people and animals have crossed time out of mind. A stream where the lovely grey-and-yellow wagtails mate and nest in summer, and the dippers smartly bob to you as you cross from rock to rock. Wherever your river, it is worth while, as you swish over the hump bridge, to delay a while, and enjoy its beauty.

In autumn the road beneath the chestnut trees was strewn with prickly green fruits. If the spines were soft and appeared to have fallen prematurely I would open several with my hands; usually the nuts had to be delivered by rolling under one's foot.

The diarist Evelyn commended sweet chestnuts as a lusty and masculine food for rustics at all times, and of better nourishment for husbandmen than kale and rusty bacon.

The horse chestnut (not to be confused with the sweet chestnut as commended by Evelyn) was our ploy in a country game. Threaded on a string we tried to smash our opponent's suspended nut with a blow. If the chestnut had been baked in the oven a short time, chances of success were much greater.

As a boy, I wandered at will in the chestnut woods of Sussex and collected the fruit on October days under the great trees in Cowdray Park, where the lovely deer shared nature's bounty. Many happy winter evenings were spent roasting sweet chestnuts by a log fire, watching to see which nut would jump farthest when it split in the heat.

No wireless, no television – only occasional songs and hymns round the piano, and on very special evenings the Edison Bell phonograph with its cylindrical records was produced with great ceremony, and a rather distant voice sang 'Home, Sweet Home'... wonderful Nellie Melba.

Oh happy days... so swift to pass, so lightly regarded until they are beyond recall.

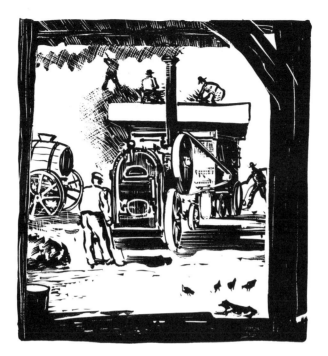

Among the red-letter days of youth I count threshing day supreme. The huge engine and tall drum, the box van and iron water-tank lurched drunkenly down the lane, missed the overhang of the barn roof by inches and came to rest in the field behind the barn. When winter mud surrounded the barn my cup of joy overflowed because they always got stuck fast. Iron skid-pans were bolted to the wheels and Bill said 'let 'er 'ave it'. A wire rope and the engine winch, aided by Bill's pungent vocabulary, yanked the drum through the clinging clay on to the barn floor. The way the yard was churned up during this 'setting up' process was nobody's business – nor were some of the words I learned until I repeated them to my aunt. Anticipating the event, five hundredweight of Welsh steam coal lay ready for the engine.

By seven am the following day the long belt was put on and the droning task-master began sucking down sheaves of corn. As 'cider-boy' I was popular up to a point, but sent off with a 'flea in my ear' when I got too cocky. At nightfall they packed up and drew out ready for a six am departure, and the driver, to my intense indignation, packed all the remaining steam coal into his bunker.

But when all was quiet and Bill had gone to the local to send something chasing my cider, my aunt and I crept out to the rear of the drum. Opening up the little slides we ran out every grain of wheat – our wheat, mind you – that Bill, as he cleaned the machine, had carefully kept back for his hens. A fitting end to an exciting day.

We each had a short stout stick to form a seat when placed across a ditch. I carried the sticks, and the old man carried the little twelve-bore shotgun that could be 'broken' into two parts and concealed in a good pocket – the sort of pocket that would hold a hare or a pheasant without showing a bulge.

Our 'seats' in position, the old man sat in front with his feet in the ditch and his gun across his knees. I sat behind, with my feet also in the ditch but my heart in my mouth, and every time I tried to swallow it the sound seemed to equal an express train leaving a tunnel. At intervals an uncontrollable desire to sneeze or cough came over me, both of which actions were expressly forbidden. I was too young to smoke, and my companion never took his pipe on these little 'excursions', for the scent of tobacco travels far on a dark night.

Over the low concealing bank on our right was an oak wood wherein we could hear the rustlings that may always be heard on a dry October evening in a Sussex wood. Overhead the branches of a large oak tree spread a knotted, twisted tracery against the lighter background of the sky.

Suddenly the bent back stiffened. The shuffling sound that a bird makes in turning over the dead leaves has drawn nearer. Expectation is high.

Then, without any warning, the cock pheasant is up to its roost with a flutter of wings and a shrill call. The 'old un' turns half right, raises his gun, and – bang! My heart nearly leapt from its place – surely all the keepers from Chanctonbury to Chichester must hear the crash of that twelve, and the bird's wings beating on the dead leaves.

'Get the bird, boy', he whispers, and I scramble silently over the bank to retrieve the dead pheasant.

In ten minutes we are back in the house again. The bird is in the larder, the gun is cleaned through, and we ourselves are seated in the chimney corner before a huge log fire.

'Worst o' guns they makes sich a lot of noise,' said the old man as he pulled at a stout clay pipe, stained to a deep brown colour by very many fillings of the strongest shag.

'I do say', he continued, 'as I'd rether ketch a bird more quiet like. The wind was a'blowin' rough tonight, but the wind wot snatches away the sound of a gun makes it as you can't hear a keeper comin' either, and thet's dangerous.

'Now if 't'ad been a quiet night we would have let 'im bide to settle down, and then we could have burned a bit of sulphur under 'im, and down he would have flopped, all quiet and unconscious from the fumes.

'There's plenty o' quiet ways with pheasants, and partridges too for that matter.

But if you're after partridges, boy, you want to be out before 'tis light of a mornin' and shoot them as they come along a furrow in file or as they're a'roostin' in a circle.

'Partridges allus roost in a circle, you understand, with their 'eads pointin' outwards so as they can all fly off without running into each other if so be a fox comes along after 'em in the dark.

'But nettin' is best, only it takes two of you to drag a net as is a good thirty or forty yards long, and I'd rather work alone.'

The old man had a mug of cider at his elbow in a recess in the wall which I afterwards discovered was the entrance to the baking oven. The cider was made by the travelling press that went the rounds of the villages, and the addition of a beef steak suspended in it while it was 'working' made it of leg-shaking quality for the uninitiated. He drained the blue-banded mug and resumed.

'A good many partridges I've a'caught in a cage made of wire netting with a entrance at one end with the ends of the wire all turned inwards. I lays a little trail of maize up to the entrance and scatters a bit around and inside the cage.

'I once took a 'ole covey of partridges from one cage, but they're rather awkward things to cover up, and I don't hold with 'em.

'Pheasants and partridges and hares is the best payers. Rabbits I never bothered with: they 'ont fetch much after you've ketched 'em.'

The old man thought for a while and slowly refilled his pipe.

'I 'aven't told you about hares. I was on a farm one time in Hampshire where we 'ad plenty of hares. You see a 'are always leaves a field the same way as she goes into it, and that is usually by a gate-run. So what's easier than to drap a net down along the bottom of the gate, send the dog round – I had a right good dog them days – and startle the hares feedin' in the field to run to the gate and into your net.

'Many's the hare I've lifted from my net and set off home quiet-like before the keeper were out of 'is bed. And he didn't linger there very much in the season I kin tell you.'

Taking his pipe in his hand, the old man directed the stem towards me to ensure my attention to his final words.

'I've a'bin lucky,' he said. 'A good poacher is born, not made atterwards. I've a give it up now – except for that little bit of a hexpedition tonight to show you, and as there ain't no keeper here now I knowed we didn't risk nothing, but, licky or not, you must remember several things. And the fust is this: the keeper knows all you do – and sometimes a bit more. You must allus enter a wood with the wind in your face, so as you can hear any sounds and smell anyone smoking – you don't never smoke yourself, mind.

'And – most important – you 'as to be a regular churchgoer and live quiet and mostly sober. Then when there's bin a bit of a shindy in the woods the passon gives 'ee a good name, and squire don't look your way, and keeper's prapper foxed.'

He leaned across to whisper a final instruction.

''Tis best if 'ee don't get wed to no woman. They 'on't keep quiet. But doan't you tell she!'

Now that I am older, I recognize that out of my country boyhood is growing a deeper awareness and love of the natural world. Sometimes this can leave me bereft and saddened.

The axe is laid at the root of the tree, the oaks are crashing to earth and soon Reeks Wood will be only a memory.

Of all our country sights and sounds the least enjoyable to my eye and ear is the death quiver of a fine tree, and the rending of its limbs as the woodman deals the final blow which sends it toppling to earth – two hundred years of glorious growth, of winter storm and summer sun felled in twice a hundred seconds.

No longer shall we be able to steal beneath the mighty trees hoping to glimpse the straying deer that have frequented the wood for some time past; nor shall we hear the nightingales in spring, three or four singing at one time in different parts of the wood.

At winter's end the trees will be lying naked and mud spattered amid piles of cord wood and splintered saplings, with the copse rides waterlogged and ploughed up by the hauling of treetrunks and the timber wagons. I have spoken of these things to the woodmen, but they have hard hearts and answer me only that 'Good oak is hard to come by'.

At least they don't build battleships of oak these days.

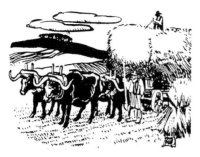

In recent years a new and terrible farm implement has reared its ugly head above our pleasant Sussex hedges. Though we have now become used to the staccato popping of the farm tractor as it lurches its fussy way across the ploughland this modern 170 horsepower monstrosity is almost more than country flesh and blood can bear.

'By gor' said the old countryman, 'what be us a comin' to!' What indeed! A mechanical rotary plough, thirty-six feet long and fifteen feet high, creeping over the fallow with a roaring of engines that could be heard for miles.

I watched the demonstration on my brother's farm with my ears plugged with cottonwool. Farmers from all the district around came to view the giant. Some were grey bearded and weatherbeaten with years of walking on our Sussex fields; others with the down of fresh youth upon chin and cheek, had been sent by the 'old man' to report. Some accompanied the 'old man' to urge upon him the need for change and new methods on the farm.

Shrewd and capable, men of whom England may be justly proud, they followed behind the 'gyrotiller' with its revolving ploughshares, kicked the great clods and picked up the broken earth and sifted it through their fingers. They bawled their remarks into each other's ears – the machine drowned every sound – and prophesied with devastating certainty, some for good, others for ill, on the results of such a stirring up of the surface of Sussex.

Success? Oh yes, it was successful. Such a crop of sugar beet was gathered off that field as never grew there before. But at what a price!

Another innovation which caused some astonishment not to say hilarity among the old hands involved the use of two huge traction engines and an equally gigantic double six-furrow V-shaped plough.

The traction engines were set on opposite sides of the field facing the same way. Between them and attached to the pulleys by a long wire cable was the double plough with one section waving in the air while the other was in the ground.

Three men were needed, one on each engine and a third riding and guiding the huge plough. At the end of the furrows this man reversed the plough and blew a whistle (the only thing to be heard above the row), and the plough returned to the opposite side – twelve furrows at a go! How they 'marked out' the field for this method of to-ing and fro-ing can't be imagined.

It is not many years since we had fine teams of oxen working on our Sussex farms. Lovers of W H Hudson will recall his description, in *Nature in Downland*, of the Sussex oxen:

There one may see the corn reaped with sickles in the ancient way; and better still, the wheat carried from the field in wains drawn by two or three couples of

great, long-horned black oxen ... One gazes lovingly at them, and on leaving casts many a longing, lingering look behind, fearing that after a little while their place will know them no more for ever. Within the last five or six years I have seen the use of oxen given up in farms where they have always been employed, and I greatly fear that those who will walk on the downs a quarter of a century hence will see no patient team of 'slow black oxen'.

Hudson was quite correct and, as he says in this poem, no more can we walk and see:

> *Where the pale stubble shines with golden gleam,*
> *The silver plough-share cleaves its hard-won way*
> *Behind the patient team,*
> *The slow black oxen toiling through the day:*
> *Tireless, impassive still*
> *From dawning dusk and chill*
> *To twilight grey.*

Mr Barclay Wills, who has collected many interesting downland records of sheep and shepherds and farms, states that the last farm team of oxen was sold just before 1927, but that another team of six was started by Major Harding, of Burling Farm, East Dean. It may well be that these, if they are still working, will be the last of our Sussex oxen.

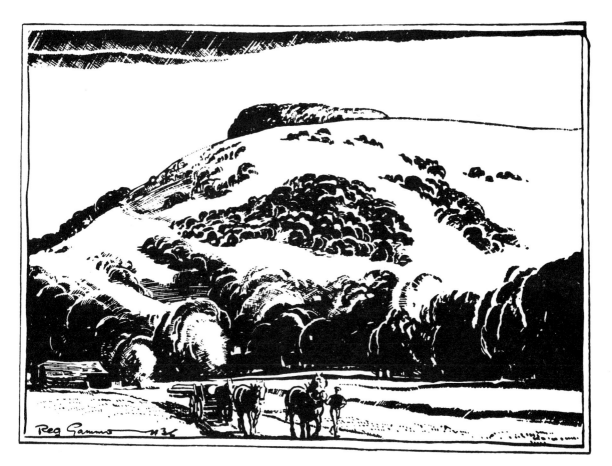

A pale winter sun was doing its best to thaw the curiously starred ice forms that roofed the deep cart-ruts along the copse ride. Recent heavy rains have turned these roads into bogs, and the cart-horses have so churned up the centres of the tracks that the only walking ways are the narrow strips on each side, between the wheel tracks. If any attempt is made to walk along the side, the overhanging chestnut, mud covered and frozen, whips wickedly at one's face. On such a lovely morning when the keen air cuts through one like a knife, it is pleasant to leave the cycle and 'foot it' up the hill to restore the circulation to feet and hands.

Sounds and scents travel far, and from above there came pouring down into the valley the sound of a piano played by a master hand; Tobias Mathay, the great music teacher, lives on the hill looking south over the Weald of Sussex. I could hear the sound of the woodman's bill-hook and axe felling the straight, eight-year-old chestnut underwood growing higher up the hillside. Standing in the valley I had seen the blue smoke from his wood fire curling up into the crystal clear air, and long before I reached him the scent of wood smoke came to my nostrils.

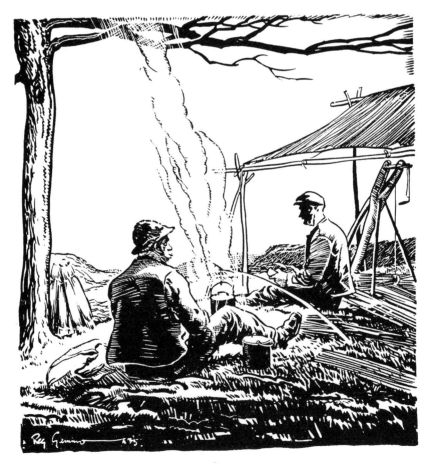

The countryman will usually talk willingly of his work. For cutting forty-eight walking sticks he is paid sixpence, for twenty-five broomsticks threepence, for twenty-five bean sticks threepence, for twenty-four scout poles fourpence, and so on. His mate was shaving hoops on a 'brake' fixed up underneath a canvas shelter. Every winter for years he has been doing this work – a skilled country trade that is in danger of falling into decay because of the decreasing demand for barrel hoops. At one time hoops were required in various lengths from two feet to fourteen feet, but now only three or four sizes are wanted, making it difficult to earn a living wage. A bundle of chips is usually allowed to the cutter each day, with a shoulder stick to carry it home. He stacks these in his garden for next winter's fuel, and the odd ends of log-wood are sold to a neighbour, who usually borrows a horse and cart on Saturday afternoon and brings them home.

This is one of the old country occupations that are nearest to my heart, and I cannot well describe the sense of quiet refreshment that came to mind and body as, in quiet conversation, I shared his morning can of tea, looking the while out over the undulating Weald of West Sussex to far-off Chanctonbury Ring. 'The young men don't take kindly to the trade,' he said, 'and when the old 'uns are gone 'tis like to die out.'

Well, the youngsters may make more money in the towns and cities, but they will lose a serenity of mind and spirit that money can neither buy nor compensate for its loss. I turned down the hillside fervently hoping he might be wrong. Surely the line of generations of woodmen cannot die out like that.

Will Dudman took a delight in every job he did as woodreeve on a large estate. He could lay a hedge, erect a fence of cleft oak that would stand for years, make a gate and hang it as a good gate should be hung. He taught me to choose a good oak gate made of cleft timber and I helped him whiten some of his roadside hollies just before Christmas to prevent the gypsies cutting them to sell.

No one followed him in his ancient trade, and soon the word woodreeve will be forgotten.

Most of the lambs have arrived on the downland farms in Sussex, but at Broadreed I found Old Shep still waiting on some expectant mother.

'They dratted rams let I down and the ewes did turn and now they be a month late,' he explained.

The lambing yard, with its sheltering wall of hurdles backed and overtopped with tightly packed straw, its many separate little pens and the large central yard deep in dry, warm straw, was typical of the care and thoroughness with which the old-time shepherd does his job.

During the lambing season Old Shep is about night after night working untiringly, ready always to ease a ewe in difficulties and care for a weakly lamb. At seventy years he looks no more than fifty and is as quiet and gentle as his own lambs.

I once inquired after his young wife, aged nineteen, and his baby daughter of seven months – his eyes lit up with pleasure as he spoke of them. He has no son to carry on his ancient occupation – not yet – but who knows!

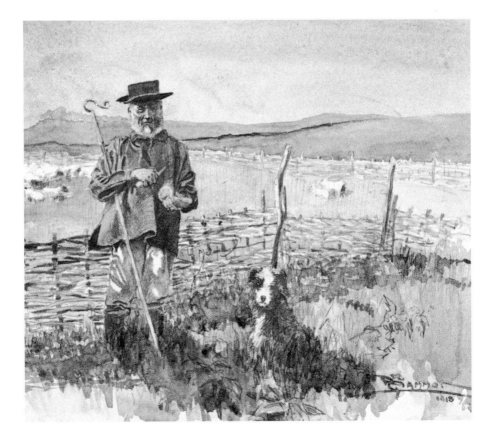

The rains had flooded the countryside. For long stretches the course followed by the river through the meadows was only discernible because it was marked by the double line of alders and willows that grew along the riverbanks. Now they stood out above the water with some of their slender branches trailing in, and bending beneath, the swirling flood. Every now and then a branch would swing back as if it were trying to free itself from the clutching hands of the river. For a brief moment it remained, quivering in suspense, only to be pressed back relentlessly by the power of the water and the weight of the leaves and twigs which it gathered from the flood. When the load became too great a branch snapped off, and went racing away downstream with the rest.

A little down the valley from the flooded meadows a fine old mill straddled the river, and the water was once more contained within a deep culvert, cut many years previously to conduct it to the sluice gates. The regulation of the hatches enabled the miller to divert a sufficient volume of water beneath a road bridge and into the mill where the great wheel revolved. The wheel was mounted inside the building, and not outside as is so often the case.

The surplus water ran beneath the flood gates and splashed into the large mill-pool, whence it flowed under the bridge to join the other below the mill. Now the level above and below was the same, and the yellow flood scarcely passed through the arches. The miller had raised his hatches to their limit, and they stood, gaunt and ghostly in the evening light, above the stonework into which they fitted.

People crossing the bridge paused and looked anxiously over at the swirling water that raced through so close under their feet. The miller smiled confidently.

'I've a seen many worse,' he bawled, above the rumbling of the great wheel. 'It 'ould take more'n that to move this old 'ouse and bridge, I can tell 'ee; 'sides, 'er'll sink in the night if us don't get more rain.'

Below the mill masses of debris floated along in the flood, and catching crossways in the alder trees growing by the waterside became firmly wedged. More and more sticks and driftwood came racing along to be trapped, and so the pile grew. A yellow scum gathered against the obstruction and spread upstream; the water seemed to dive beneath it in its haste to the sea.

That night the level of the river gradually fell, leaving the sticks and rubbish stranded high and bedraggled around the tree trunks. All along the riverbank a creamy foam was left by the receding water. At a bend in the river's course there appeared a long bank of sand. Smooth and beautiful it looked in the pale winter moonlight, its surface broken only by a clump or two of broad-leaved irises that

had saved themselves from destruction by bending to the fury of the flood.

Suddenly, but without a sound or a splash, a dark, flat head rose above the surface of the water. A few swift strokes and a lithe form, like a large weasel, with a broad, flat tail, drew itself on to the sandbank. The water on its skin glistened in the moonlight as the graceful animal paused to listen and test the night air for the scent of any enemy. It walked the length of the sandbank, mounted the river side, and moved here and there over the waterlogged meadow before returning to the sandbank where it had landed. Then, with its pole gripping the sand and acting as a brake the animal slid silently back into the water and rapidly disappeared downstream, leaving long ripples that looked like slender silver arrows on the dark surface of the river. And that was why, when I was walking by the river next morning, I found the perfect tracks of an otter.

I wondered where it was going, because otters are great travellers and have been known to cover as much as fifteen miles in a single night. They are as well acquainted with the great waterways where the ships come and go, and where the vital raw materials and food are unloaded by a thousand rattling cranes, as with the little stream meandering through quiet meadows.

George's father

Among the greatest pleasures of country life are the human contacts. In a town one may live for years and scarcely know the people next door. In a village it is quite different.

For eighteen years I have lived in my present cottage. It was on a stormy November day that we moved in. I well remember watching the furniture van bump its way along the track that crosses the common. Hefty fellows deposited its contents in and around the house. I became scarred and tired as I 'did my bit'. Then the van departed, and I was left where I had always wanted to be – in a real country cottage, with apple trees, a well to supply the water, and a garden for vegetables and flowers.

At the moment the garden was breast high with weeds and nettles. A path had to be made, too, to connect the house with the distant road. My promise to construct a path, suitable for cycle and perambulator, had been a trump card in persuading my wife (with a young baby) to leave 'civilization' and live in a country cottage. The promise seemed rash, now that October rains had liquefied the wealden clay.

Later that day, when the wind turned east, we kindled a wood fire on the wide hearth. It taught us why cottage ceilings are usually a delightful smoke-brown colour. Farm life and work, and country ways and manners were not new to us, however, and every difficulty yielded in the end to our energy.

It was George who informed us that 'they old chimneys allus smokes in a east wind'. He was our nearest neighbour, and early appeared on the rural scene with offers of assistance in the garden (at the usual rates, of course). Offers of assistance to conquer *that* garden were not to be turned lightly down, and thereafter George frequently bent an unwilling back in rendering it. He would remove one piece of convolvulus root or running grass, but leave two pieces to sprout and grow, lest by too close attention to detail he should kill the goose that was laying the golden egg.

During the first few years George's father sometimes came to my studio as a model – and fell asleep in the chair while I sketched. He was a gentle, lovable countryman; and the village was the poorer when the pathetic little procession, slipping and stumbling down the common, carried him slowly up to the little chapel and then to rest in the burial ground below the crossroads.

George did not share the old man's 'chapel-going ideas'. Still less did he hold with them after the funeral, for the sermon had been aimed at George's lost estate and the sorrow he had caused his parent. It was one of the rare occasions on which he entered the chapel, and it offered the old minister an opportunity too good to be lost, so George had perforce to remain in the hard old pew and take his medicine. I

must say that to me it seemed like hitting a man who was down, for despite his apparent roughness George had had a great regard for the old man. Even today he refers to things his father said or did forty or fifty years ago.

George's greatest trouble was a constant dryness of the throat and the consequent necessity of lubricating that passage. The methods he adopted to that end – apart from working in the garden – were sometimes amusing. Every season the manure heap outside his cow stall – he always kept several cows – produced gigantic harvest-festival-like marrows. On his evening walk to the Lion or the King's Arms, George would tap gently on my studio door and, when I appeared, open a small sack, disclosing a huge fruit. 'Ah, I thought Mrs Gammon med like a "marrer".' Although I knew we already had 'marrers' galore, I had not the heart to turn him away empty. For the same reason a loan in advance on a day's work, or on a load of garden manure, was never turned down.

But this method of veiled blackmail becomes an annoyance after several years, and relations frequently became strained between us. Peace was restored when cottages at the higher end of our common came into the hands of 'they furriners from London', for then other gardens needed expert treatment, and the 'marrers' were worth their salt again.

For years George ran a contra-account with the jovial landlord of the Eagle – beer against work in the garden – always carefully keeping the beer side of the account in his own favour. Once when George was well 'lit up' at the Eagle, he proclaimed to the assembled company, 'I'm Ally Sloper'. Ally Sloper was a comic character in a Victorian comic weekly, and the nickname of 'Sloper' stuck. But of late years the beer account seemed likely to handed down for posterity to work out, so the slate was cleaned off and the 'account' closed. George now walks an extra mile each evening.

George's local knowledge has been invaluable on many occasions. There is not a track or path that he does not know, and the history of our common in all its lurid details is an open book to him. His knowledge of the rearing of cows and pigs is second to none, and but for the constant throat trouble George would have been a successful farmer.

One autumn day George and I went to the annual fair in a neighbouring town. 'Ye Olde Englishe Fair' had been sadly modernized, but George lost his money in the same old-fashioned way. Much of it passed into the paw of an artful dodger who demonstrated how easy it was to bowl down a little pin with a suspended wooden ball, thus winning one of the very chromium-plated watches or gold Albert chains hanging up for all to see (but well out of reach). George failed, of course. 'Never could 'it un; tried for years I 'ave.' Who was I to dash his faith in human nature by pointing out that the showman neatly adjusted the centre of gravity every time he tried?

Betsy Lee, 'only genuine granddaughter of the famous Gipsy Lee', was there to advise George over the cards on health, business, love and marriage, and to pay two hundred pounds if she were proved incorrect. That two hundred pounds drew him like a magnet, but seeing trouble ahead I pressed the claims of that marvel of the universe, 'Mermadia – part fish, part woman', and the 'Casino girls in the French revue'. The appeal was not in vain.

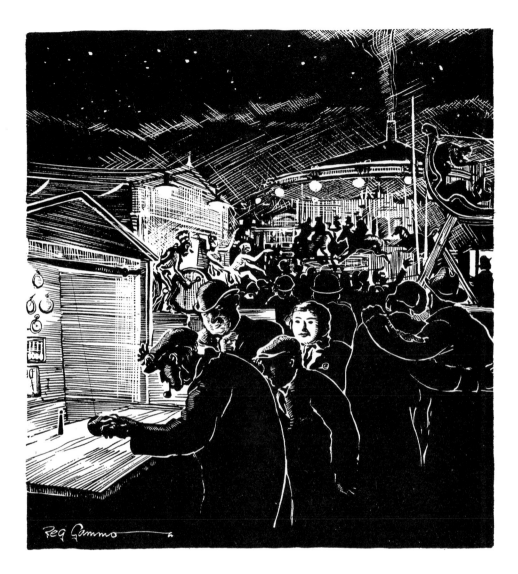

Cyclone Jim and Madcap Olivet did their thrilling acts on a motorcycle within a few inches of our noses for a nimble sixpence; George won a pair of vases whose shape and colour were like nothing I had ever seen before. Finally we inspected 'Blossom, the double-bodied cow with six legs and six feet'. But George would not have that one. 'Cows', said he 'is summat as I do know summat about. Now if 'er 'ad 'ad two udders an' six teats, it med a' bin different.' He had no use for Blossom.

Eighteen years have taken their toll of George: he works in three coats now instead of one. But the change is most evident in the rhythm of his homeward steps each night. No longer does he hesitate and miss a beat or dot an 'i'; slowly but surely he gains his cottage door. We shall miss him one day and in mercy remember him most for the fun he created in our village.

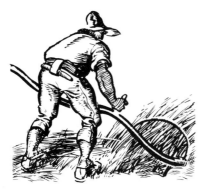

The keen blade flashed in the early morning sunlight. A thousand diamonds of dew scattered and fell to the ground. Pollen from the over-ripe grasses came like snuff to my nose, but I did not cease swinging my scythe until I had cut a lane across the orchard and the first swathe of the mowing lay behind.

Back through that lane I walked with a sense of expectation and adventure impossible to describe, experienced annually at the commencement of this festival of haying. A second, and a third swathe were cut less vigorously than the first, and then I settled down to a rhythmic swing and pull that sent the scythe cracking through the grass, each time gathering up the cut and throwing it clear – an action I hoped to continue until my hefty friends, John, Harry and Bill, came to take over.

At intervals, dictated by the 'feel' of the scythe as it swished through the tough stalks, I rested the point on the ground, took the whetstone from the leather case at my hip, and vigorously stropped the ringing blade. To finish sharpening the extreme point I had to stand the scythe up on its contorted handle (ever a mystery to the townsman at the first handling), curve my left arm over the deliciously cool steel, and apply the stone to the point, working each side alternately. Keeping a good edge on the long blade is a matter of experience and practice.

By seven am, after an hour of cutting, I was working stripped to the waist. Two of the village fathers who came along the path regarded me with what I hope was admiration. Fortunately they had departed on their way to work, subdued and wondering at such energy, before the point of the scythe became embedded in a wretched ant hill hidden by the long grass. The village ancient is very critical when he sees 'one o' they furriners a-usin' a tool', and when they had departed without making any helpful suggestions on wielding a scythe I felt that I had passed the most severe test to which I was likely to be subjected. (You must understand, by the way, that a mere two score years of residence in a Sussex village does not necessarily qualify one for full acceptance by the old 'uns; only the third or fourth generation is finally blessed with this distinction.)

The lady of the house came out at nine o'clock with a cooling drink; the birds, which had been singing vigorously since early dawn, had fallen silent; the cattle were already seeking the shade of the trees, and the day had settled down to be really hot. The action of using the scythe had by now become automatic. I believed I could keep on mowing all day, with honest sweat running down between my eyes and dripping from the tip of my nose. But the tantalizing rattle of farmer Pritchard's cutter, two fields away, made me conscious of the comparative slowness of my solo efforts and glad that I had arranged overnight for his stalwart sons to bring their scythes to my assistance. At ten o'clock, having completed the

milking and feeding on their own farm, they descended upon me, and I was happy to retire from the contest into the shade of an apple tree. There I am now writing my notes.

After much sharpening and feeling of edges with wetted thumbs (the scythes had been unused since autumn) they set to with great swinging strokes. The towns and cities claim numbers of our young men from the country in these days, and of those who remain many, because of mechanical aids, decline to learn to use the old countryside tools on which their fathers relied. (Who can use a flail or a barley chumper now?) It is, therefore, the greater pleasure to find three sons of one farmer able and willing to swing a scythe.

The ox-eye daisies (marguerites), vetches, ragged robins and other tiny flowers hidden in the tall grass fell in hundreds at every blow. The orchard was a lake of these waving white yellow-eyed daisies. Each year at this season they were cut down at the height of their beauty, and with the sparkling dew still upon them. This was the only sad moment that occured in the whole of our haying.

Dress and customs changed. What a sight it must have been to see three or four gangs of mowers, with six or eight in each gang, working in a field of tall grass. They 'found' their own scythes and the rubber for sharpening was carried in a leather case at the back, strapped on round the waist. The leader set the pace, the time for sharpening the scythes, and also the time to stop for a drink of beer. The swish of so many scythes and the ring of stone upon steel must have made music far better than the chatter of the mowing-maching.

I never hear a scythe being sharpened without remembering also another wonderful day in Wales. We were approaching the top of Bwlch-y-Groes from Bala. Far across the valley a girl was singing, and the sound came clearly to the height. Immediately below, in a steeply banked field, two men, one behind the other, were mowing with tremendous energy and precision; stopping at the same moment to sharpen the enormous blades and then starting again, as if joined by an invisible thread. They seemed to take a delight in their labour, to glory in the human strength that could wrest a living from those steep mountain slopes. The sense of completeness and peace in that valley will always remain with me a precious memory.

One day I parked my car near Binderton House. An old hay-tyer volunteered to keep on eye on it.

'Yon's what I want,' said his mate, who was working the pressing machine. 'I cycled from Littlehampton this mornin', and goin' back to-night.' 'And I', said the old man, with emphasis on the personal pronoun, 'slep' in ther. 'Tis too much fer I, bikin' to and fro atop of a day's work.' I glanced 'in ther', which was a tarpaulin sheet rigged against the side of another hayrick and banked all round with straw. It constituted a cosy den floored with clean wheat straw – drier and warmer than many a so-called cosy cottage with earthen floor and reeking walls.

The old man was cutting out the trusses of hay in steps up the side of the rick, and every few minutes the hay knife struck against a flint stone buried in the hay. 'Dang those hay sweeps,' he ejaculated. 'Everything gets swep' up, stones an' all. I've knowed the time when I could cut a ton o' hay – thet's forty truss, sir – and only sharpen 'er once; now a'times I 'as t'stone 'er dwo or dree times fer one truss.'

''Ad to bring his best knife from 'ome on my bike this mornin',' chimed in the younger man. 'Wants a bit o' handlin' on a bike, a 'ay-knife do!' I agreed. Personally I would as soon carry a live pig under my arm!

''Adn't no right to be usin' of 'un on this old stuff at all,' continued the cutter. 'Cost I thirty shillun.'

I wondered how many pounds weight of flints would be found in a ton of hay. It is certainly a new and unpopular problem for the hay-buyer.

'I 'opes you've got a coat,' said the cutter, ''cause you'll need 'un.' I had, and put it on, for the rain was already sweeping over the fields. They both regarded me sadly, incredulous that I should be out for pleasure on such a day, and as I went slipping and splashing down the chalky lane I heard the young man chuckle.

Summer's concealing leafage lay in the mud, and the naked hedges bordering the lane revealed the ruins of many springtime nurseries. They were filled now with either sodden leaves or the remains of rosehips that had made a feast for the woodmouse. The lane was evidently a sanctuary for birds, and every few yards revealed a nest.

Crossing a road and a field I was soon among the yew and juniper and black-thorn trees that grew thickly upon the sides of Bow Hill. These trees were alive with birds. Yews, being so thick and dark, can conceal a whole flock of chaffinches, and not until they leave the tree with a whirring of tiny wings does one realize their presence. The trees were all dripping wet and yet the birds seemed to keep dry. A robin constantly whistled his joy – or defiance – of the rain.

The Great Western Railway tipped us out at Aberystwyth along with the Sunday papers at nine am, and by night we were camped and swimming in the Rheidol Valley.

The trip was made with six other scouts and my assistant scoutmaster, our equipment packed in rucksacks and on a single-wheeled trike cart, made with scout poles and canvas on a metal frame with the small wheel of a trade bicycle.

We continued up the almost perpendicular lane to Ystum-Tuen where the entire village school and teachers gathered round us in the tiny shop and the headmistress delayed afternoon school until our departure. Then we went over Bryn Bras, plunged down into Pont-Erwyd and after purchasing a day's stores, came in the evening to camp at Nant-y-Môch, fifteen miles from anywhere in the heart of the bare hills.

Our chief difficulty in this treeless region was to obtain wood for fires and a single discarded fence post, which sorely tried our small pocket axes was the only fuel we had for cooking that night.

Several blisters on soft feet, a desire to top Plinlimmon and a severe frost which froze the dew-soaked tents and had us out at five am running up the road and buffing our hands for warmth made us decide to stay a second night.

This necessitated a tramp back to Pont-Erwyd for stores and wood to cook with since we had only carried one day's supply of food to save weight.

Plinlimmon, climbed in the afternoon, minus rucksacks, gave us glorious views, and Llyn Llygad-Rheidol, a swim at 1,800 feet up.

We saw six cars in five days. One night we camped with the miller at Ffridd Mill and the River Dulas supplied a twenty-foot pool to dive into in the morning – by way of a daily good turn we cleared some of the weeds from the water duct.

The previous strenuous day called for rest and (tell it not in Gath) the bus took us a day's tramp in fifty minutes to Dinas Mawddwy. Here we felt like Pied Pipers (only our pipes were mouth organs) for the entire child population of Dinas followed us with shouts and laughter, on foot and cycle for several miles up the valley towards Llanymawddwy and only returned after they had been photographed with my scouts and a promise extracted to send a print to the schoolmaster.

From the foot of Bwlch-y-Groes (Blaenpennant) we followed the path to Talardd. At 1,200 feet we had to carry our trike cart up and over some considerable rock with a delightful river and foaming waterfalls below us.

A spot of bad map reading on my part and a badly defined track brought us after four and a half hours of hauling and struggling across trackless bog to Lake Craiglyn Dyfi, lying dark and sinister in the evening light under the crags of Aran Fawddwy, and with a final unloading of our cart, we topped Craig Cwm-du, 2,246 feet.

Sheltering from a cold wind we refuelled on biscuits, chocolate and cheese and by a steep and circuitous route to avoid perpendicular rock and scree we came finally at dusk to the valley, and Nant-y-Barcut farm welcomed us carrying wood and water, milk and eggs to the tent doors.

That trip cost us fifteen shillings each for the nine days apart from rail fares. To my lads it was an adventure in every sense of the word.

In our 'bare knee days' we made it a matter of keen competition on scouting exercises to move through a wood in absolute silence. Whoever trod heavily enough to snap a dry stick and awake the echoes like a gunshot, or could not curb his tongue, lost marks for his patrol.

But watchful and quiet observation recorded at the conclusion of the afternoon's adventure gained points. If one could walk through a copse and avoid notice by that watchdog of the woods, the jay, with his shattering alarm call, or pass unheralded by the shrill laughter of the green woodpecker, it was a worthy achievement.

At the time war clouds were gathering and some of my lads valued this early training later when clumsy movement was often rewarded with a sniper's bullet.

The Week in the Country

By Reg Gammon

WE came upon the notice at the top of Harting Hill when returning from a circuitous route through Midhurst, Singleton, West Dean and Chilgrove. We had shown a friend the best of the West Sussex and Hampshire border, the beauty of the massed trees standing rank on rank away to the south from the Trundle at Goodwood with the spire of Chichester Cathedral pointing its slender finger heavenwards, the downland about lovely Kingley Vale, where dark yew trees that have braved two thousand winters still grow, where, tradition says, a great battle was fought by the men of Chichester against the Danes eleven hundred years ago, and the slain sea-kings were buried under the mounds on the hill.

And now we were looking down with delight on one of the best of England's villages, Harting, with its cluster of cottages and green copper-roofed church (I recommend the district to you this Whit week-end) and the notice:

SAVE THE COUNTRYSIDE

A littered landscape is a shame to England.

Clear up before you leave. Others will thank you. The marvel is that anyone should need to be reminded to preserve what is really his own possession.

The clean beauty of the English countryside. I mean, we don't put the *dust-bin* in the *rose border*, do we?

An article from the News Chronicle *May 1937*

Many years ago a well-known cycling writer startled his readers by announcing his intention of throwing away all his wet-weather cycling gear and henceforth riding on in his ordinary kit, wet or fine. To avoid any ill consequences, it was only necessary to pour sixpenn'orth of whisky into one's shoes (sixpence would buy it in those days) and have a rub down at the end of the journey.

The idea of throwing something away and thus lightening the machine met with an enthusiastic response from me. Already I rode a cycle devoid of mudguards, with an inadequate strip of canvas tied to the down-tube and a cape strapped under the saddle, both of which caught some of the mud that sprayed from the wheels. From the front wheel it shot upward and forward, ending in a graceful backward curve that exactly coincided with my face. The fountain from the rear painted a charming stripe from my posterior (usually well elevated) to the top of my head – and what hit the frame of the bike splayed abroad to fill up any parts that might have been missed.

When things were very bad it was possible to cape-up, and then immerse the plastered cape in a horse-trough to wash it. Tarmac was, of course, the exception and not the rule on any but main roads.

At one time I was cycling every weekend between Billingshurst, in Sussex, and a Hampshire town, and this cult lasted until the threats of my mother at one end and my landlady at the other end of the ride forced me to abandon my weekly mud-bath and use mudguards and a cape for winter riding. With our modern light and airy weatherproofs, it is doubtful if many cyclists today prefer to go capeless and suffer a ducking.

The first time I purchased some whisky and poured it into my shoes the landlord punched a hole in the sixpence and hung it on his Albert watch chain. 'Pat' made a joke drawing out of it, which you may see in *Cycling* dated 29 January 1914, if you happen to have a copy on your shelves. One thing I must add: the 'awful waste' of good whisky seemed to do the trick, for I seldom caught cold from my soakings.

There was a time when miles covered seemed to be the important part of a tour: the greater the distance covered each day, by so much was my pleasure multiplied. If those miles included a quick scramble over a well-known castle or other landmark, I felt I'd done pretty well. But quite soon I discovered that so far as I was concerned there was more to the cycling game than that – more of lasting benefit and interest to be gained from riding in the lanes and byways of Britain and Ireland.

Lacking the opportunity for club riding, I did much lone riding, and I am still inclined that way. I like to cycle quietly along, or to loaf about and sit on a bridge to watch the trout in the water below. If not alone, I like a companion who knows the value of silence in the presence of such beauty. Most artists hate being overlooked when they are working, and as I share this feeling to a marked degree it accounts in large measure for my preference.

*

The boat train wheezed to a standstill in Galway Station. Eagerly we tumbled out, hoping to catch our precious cycles as they were thrown out of the brake van at the rear. Our anxiety was needless. The machines were treated with respect – 'sure, weren't they the finest ivver seen in Galway?'

We looked eagerly westward, across a boiling sea, in the direction of the Aran Islands. With the spindrift whipping our faces, we decided, in spite of long anticipation, that the passage was not for the likes of us with such a sea running. The famous Claddagh at Galway presented a strange unlovely conglomeration of ancient thatched, whitewashed cottages and ugly box-like modern dwellings. Heaps of blackened timbers, thatch and stones blocked the narrow roadways: the Claddagh was being modernized. Geese waddled from puddle to puddle; children, healthy looking under the grime, were everywhere, ready to be photographed.

A tall dark-eyed woman of undoubtedly Spanish descent invited us to enter her tiny cottage, adjacent to the now derelict dwelling of the last King of Claddagh. Passing through the half-door we descended into the middle of the room. The earthen floor seemed to have suffered most brushing at its centre, and consequently it sloped upwards from that point towards each wall, where the scanty furniture seemed elevated above its normal height. A turf fire was reflected in the spotless china and family treasures. Things were clean despite an earthen floor, unceiled rafters and thatch, and a conspicuous lack of sanitation.

A discreet peep into the only other room, the family bedroom, revealed a candle burning before the Sacred Heart and highly coloured pictures of biblical subjects hanging on the walls. From this Claddagh dweller we learned strange truths. The sanitary authority had condemned the ancient houses as unfit for habitation, although Claddagh folk were seldom ill. Now, in the new houses, they have colds and trouble; and the old people are afraid to mount the stairs. The rent of her cottage is eight shillings a year – almost a family possession, in fact – but it is condemned. One of the new houses will cost her five shillings a week. There is small wonder that the old folk refuse to leave until the walls are pulled down about their ears. This unique Gaelic village is fast disappearing and we were glad to have seen it before the end.

The Saturday market in Galway was Ireland at its best. There were indescribably ancient trousers and coats, patched and re-patched, and the patches themselves repaired with, and hidden beneath, later generations of Irish homespun cloth. Whole outfits were apparently handed down from father to son to the nth generation. Of asses and little carts there seemed no end.

Time spent in Galway made it impossible to cycle the whole distance to Kylemore Abbey, where we were booked that night; so we took the only alternative – the Galway–Clifden bus, which had replaced the railway. With quaking hearts we watched each precious Evans bicycle hauled on to the roof of the bus and dropped like a sack of coal. It was too much (Cyclists' Touring Club insurance notwithstanding), and I climbed to the roof, disentangled the pedals of the upper cycle from the spokes of the lower machine, and was assured by the driver (and bystanders) that he often carried seven or eight machines all piled one on the other. May heaven forgive him.

At the start of the journey two of our own countrymen – well fed and important looking – spread themselves and their superfluity of fishing gear on a seat apiece. That was before the bus stopped in the marketplace and pandemonium broke out. Afterwards we lurched along with every available inch of inside space filled and with more parcels on the roof. Two stout market women, with creel-like baskets, now shared seats with the anglers. It was a jolly and perspiring mass of humorous Irish humanity that swayed and bumped to the motion of the ancient vehicle.

At Oughterard we disembarked, marvelled at the soundness of our machines (not a spoke out of place) and rode on into the paradise of Connemara, though neither the road nor the headwind were such as one would expect to lead to paradise.

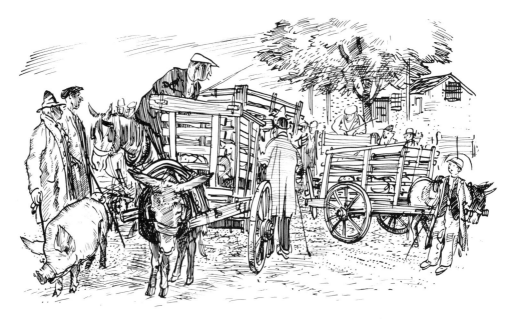

Northwards from Recess, as our wheels bit into six inches of shingle and dust, the wheatears bowed us a welcome from the rocks and the pipits trilled above the bog. We were on a bog road sure enough, and when a lorry passed us the ground quivered and rocked and a dust storm blotted out the landscape.

Just when the shingle road had almost broken our spirits, Lough Inagh held a mirror to the sky, and the Connemara Bens peeped all round the edge of that intense blue loveliness. The beautiful evening light on one of the wildest and grandest of roads, and a saint's welcome at Kylemore, constituted our introduction to Eire.

Overlooking Killary Harbour from its western shore is a tiny cottage. We called there to ask a direction and to enquire whether we could get our cycles over the pass to Salruck. I said – and I meant it – that I should like to live there.

'Then God forgive ye,' said 'herself'. ''Tis terrible hard, and Annie – that's me granddaughter – has to walk all thim miles over the pass to schule. Maybe ye'll see her.' We did see her, walking alone and barefooted over a rock-strewn pass that would have been sheer terror to a town child. (We had to carry our bicycles over it.) Aged nine, Annie Coyne's daily journey was three miles each way and climbed to an altitude of 1,000 feet, from sea-level at Killary to sea-level at Salruck.

Another day we shared in the excitement of a salmon haul with the fishers by Killary Harbour, and saw the net come in containing the great silver salmon.

The small green fields and the intense blue hills of Connemara are always linked in my mind with a potato patch that hung suspended high above Killary Harbour. An old man clad in homespun, a very miracle of patches and rents, and wearing a weather-greened, battered hat, was toiling up and down the steep field (a tiny green pocket-handkerchief of a field), carefully dusting fertilizer on each row. The scanty soil had been carried in baskets and emptied here in ridges about two feet across; on these three rows of potatoes grew green and obviously healthy.

They were carrying something heavy slung in a sack between them – a man and a young woman. He was bent and worn with the labour of years and the load weighed most heavily upon him; his hair was silver-white against the brown of his face and partly hidden by a battered rusty black hat; his clothing was homespun with trousers in natural wool colour, undyed.

But the woman was young and vigorous in the flush of life and bore her share of the burden with ease. A coloured 'kerchief set off her black hair and her blue dress was lovely against her sun-bronzed skin. She had cast off her shoes and went barefoot over the bog, her legs and feet dark with the dust of crumpled turf.

To and fro they went, tumbling the heaps of dry turf into the open sack (much as we used to collect 'burdens' of hay in the hills), and carrying it to the large stack.

Presently, she filled a smaller sack with turves, tossed it over her shoulder and went away across the moor to the cottage half a mile distant. A few minutes after she entered the house, smoke came from the chimney; she had stirred the turf fire and put on the kettle. She came out again and I saw three calves cross a small paddock to feed from the bucket she carried.

Meanwhile the man had finished piling the turf, put on his coat and threw himself down on the sheltered side of the stack to rest, before following her to the cottage.

Together they had laboured – himself weary with declining years, she rejoicing in her young strength, to ensure a kindling on the hearth when the cruel Atlantic gales sweep into the Kerry hills in winter.

Another evening I was painting when a young woman, neat and delightful with a 'kerchief over her hair and pink blouse, came with her water-can to fill at the well. Of course, she came to see what I was doing.

'Now isn't that lovely!' she said in her soft Irish speech. 'And you have done all that already.'

'Will I show it to you when I have finished?' I asked, for I wished to see inside the cottage and possibly make a drawing.

'Yes, indeed,' she replied. 'Let you come in.'

Having finished, I went to the low half-door and entered a typical Irish cottage. A turf fire glowed on the hearth, which was wide and high, with sides and shelf painted black with white decorative panels; at the side a box-bed built into the wall and curtained at night. Pictures in Catholic taste round the walls and a tiny light before a crucifix.

The following evening we went to visit them again, presented them with a small watercolour of their cottage, which at once got me permission to sketch inside as they talked to my wife. I later made the painting opposite.

They compared housekeeping and farming notes – the two women ran their own farm – common interests soon break down any reserve with countryfolk. A delightful memory of true Irish hospitality.

Annie Coyne sitting on the school step at Salruck, Connemara

Betty (right) in a cottage at Connemara

Connemara peat-cutters working on the bog

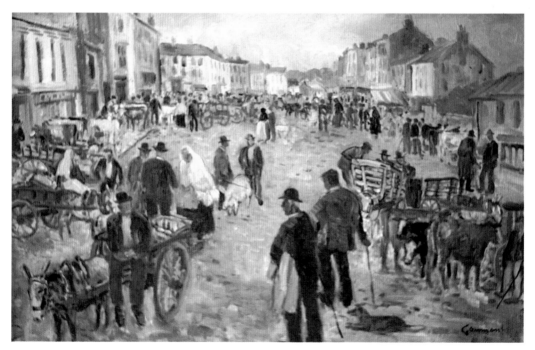

Market day at Cashel, Tipperary

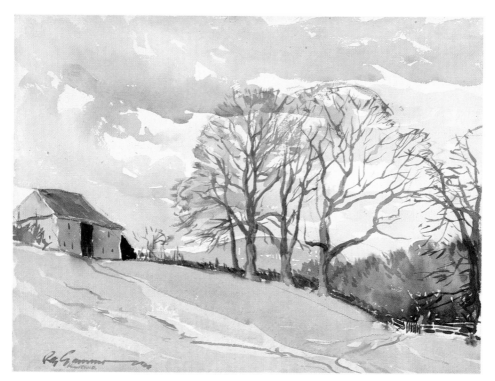

The barn at Hawksfold Farm, scene of my childhood holidays

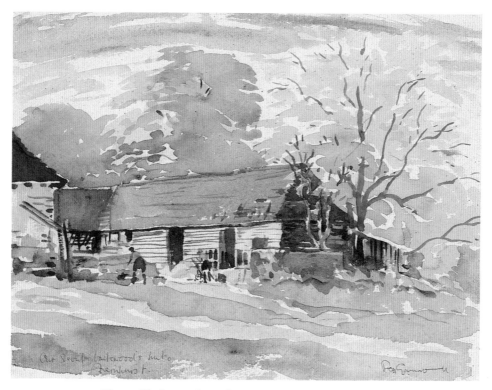

The 1st Haslemere Scout Group backwoods hut at Fernhurst

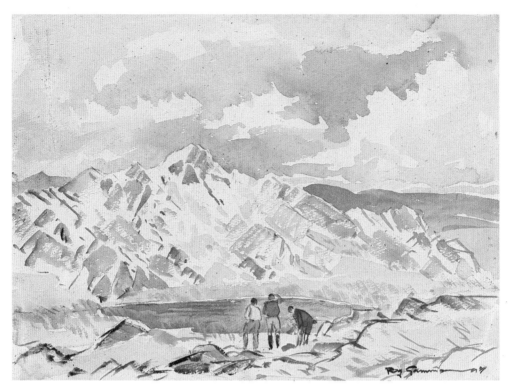

Scouts bathing on Bowfell in the Lake District

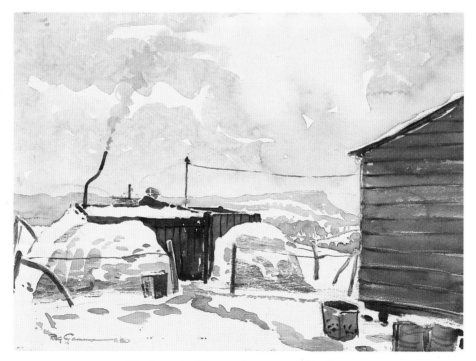

Wartime – the Observer Corps post at Fernhurst

These days of war have brought strange and unusual experiences to many of us. Clad in an old and dilapidated Harris suit that has endured thousands of miles of cycling, and shod with huge boots, I have spent, in company with his lordship's head gardener, many hours by day and night on aircraft observation duty. Surrounded by a breast-high board fence, open to the four winds of heaven, our post overlooks the really important and oldest part of our village – the church, the village green and the school.

These hours of quiet eavesdropping on the life of the village, sleeping and waking, have made me more than ever appreciative (if that were possible) of the good fortune that has afforded me twenty years' residence in a Sussex village. In those twenty years our roots have penetrated deeply, and the old people whose names have been familiar here for hundreds of years have come to accept us as part of the family life of the village. Actually our roots have also been in West Sussex for hundreds of years, and when we settled here one old lady referred with some pride to my lads as the fifth generation of the family she had known. We are therefore not strangers, but true Sussex stock. And looking over 'God's acre' night after night, with the starlit memorials of the old people and the dimly outlined church that has stood there since Norman days, one has an overwhelming sense of the continuity, the wholeness of village life.

It is probable that the men of our village fought against the oppression of Robert the Cruel who held the Manor of Easebourne (of which our village was part) when Domesday book was compiled. His defeat was commemorated in a popular song: 'Rejoice, King Henry, and give thanks to the Lord God now that thou hast overthrown Robert de Belleme.' Through the ensuing years the Luffs and Dudmans, the Shotters, the Bridgers, and the Mellershes, the Osborns and the Burts – yeomen, bellowsmakers, wheelwrights, blacksmiths, tanners, woodmen and charcoal burners – together with many others long forgotten, have all helped in the struggle for freedom. Some of their names are inscribed on the war memorial we can see from the 'post'. And now faced with a fresh menace to our freedom – the second in the lifetime of many of us – gardeners, carpenters, mechanics, chauffeurs, a grocer and an artist, while carrying on their accustomed jobs, share this essential watch on the sky, more than ever convinced that England and freedom are worth our utmost effort.

The blackout has few terrors for us countryfolk, because we are quite used to plunging along unlit roads. But it is a strange experience, as night falls, to look across to the cottages grouped in friendly fashion round the village green. One after another lights twinkle in the windows; then a dark form moves swiftly across and 'that 'ere dratted blackout' is rigged precariously into position again.

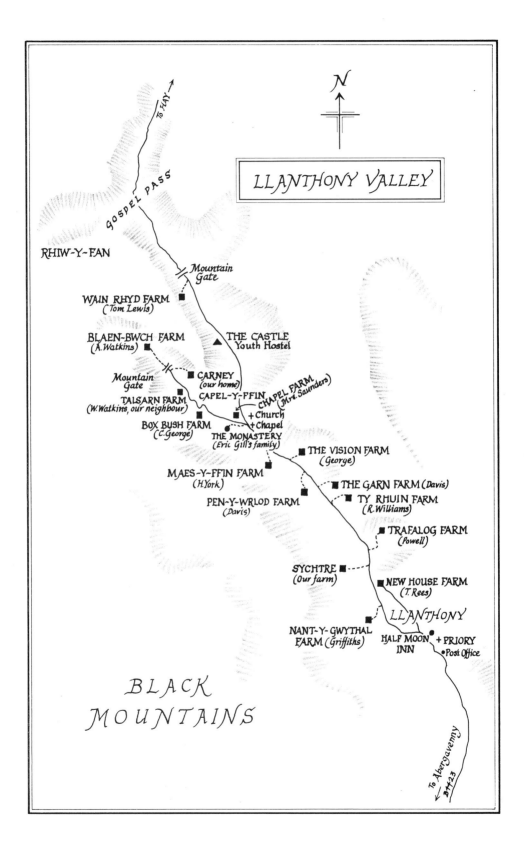

The Welsh Farm

1939 – 1962

On the afternoon of a winter's day early this year I stood looking down across a pleasant little farm in the heart of the Black Mountains, where the counties of Monmouth, Hereford and Brecon link hands. Across the valley, where the line of silver and brown hills rose steeply to hold up the sky that roofed the valley over, were other farms with their colourwashed houses like friendly faces smiling a welcome. Down the valley in the middle distance, grouped about by farm buildings, an ancient church and the village school, was a memorial to the skill and devotion of the old monks who had chosen to build an abbey years ago in this lovely place. West and north from where I stood the hills ranged away like bastions guarding the old road leading over to the pleasant upper reaches of the Wye about the quiet town of Hay. On my right a fine walnut tree leant over the gateway to the farmhouse with its barn and 'beasthouse', stable and granary.

The farmer-owner was with me and we were talking about his farm. He told me of the various crops he had taken from the fields below us, and outlined his plans for their cultivation this year. While he was talking I was becoming increasingly captivated by the situation of the farm and the beauty of the protecting holly hedges that gave shelter from the north wind. We had previously walked over the fields inspecting the boundary hedges and learning which part belonged to him, therefore having to be kept in good repair by himself, and which was his neighbour's responsibility – an important point where sheep are numerous and often roam at will.

We had been down to the lower part of the ground where, for about a hundred yards, the River Ewyas flowed through his farm – an unending and unrestricted water supply. We had been over the buildings and house (unoccupied because he had taken another neighbouring farm), and now we had returned to a vantage point where we could look down over the whole farm. I knew it fairly well with its various little fields, for I had been round it several times before. As we talked a shaft of sunlight broke through the clouds behind us and transformed the farms, the valley and the grey stone walls of the abbey with its golden light. It was a final effort before the sun disappeared behind the mountain, and it set the seal upon my plans. I turned to the farmer and we 'struck hands' as the local custom is to seal a bargain . . . I had bought his farm. It was called Sychtre, which means dry side.

Since that winter afternoon, when the fields looked bare and cold, when the naked trees rattled in the wind and the river was a rushing torrent, spring has touched the whole valley into beauty. My fields have the sheen of bluebells and cowslips over them, and the apple trees are in blossom. The wheat and oats have laid a green carpet over the brown plough land, and 'John Barleycorn' has sprung up in a night. Last year's 'ley grass' is an irresistible temptation to the restless ewes, who seem to make it the focus of their attentions, and the 'bite' down by the river that I was saving for my few ewes and lambs has been well attended by a neighbour's ewes, although they had to cross the river to reach it.

*

Eighteen months previously I had purchased Carney, a ruined one-up, one-down shepherd's cottage, three miles up the valley from Sychtre. 'Mr and Mrs Gammons should see the Carney', said Joyce, 'if they are looking for a cottage.' Betty and I were camping on Chapel Farm and I expressed a wish to Mrs Saunders, the farm wife, to live at Capel-y-ffin. (Financial problems because of the war had forced us to leave Sussex.)

So Joyce, a buxom lass of sixteen or so, pointed the way across the fields to the mountain track leading to Carney. From about 1,600 feet in altitude we looked down on a small, part roofless cottage and stone-roofed barn, almost completely hidden by nettles and with a small walled yard in front.

'Well, if you think I am coming to live here', Betty began, 'you have another think coming.'

'Let's scramble down to look,' I countered.

With a stick I beat down the tall nettles. Cattle had been using it for twenty odd years, and the beasthouse on the end had four feet of dung in it.

'Good for a garden,' I said.

'You are mad!'

Huge stone tiles weighing a hundredweight-plus had collapsed into what had been a dairy with a lean-to at the back. We stood on the first 'winder' step and looked into the only bedroom; the one window was on the floor – one lay down to look out and could only stand upright under the ridge beam, an untrimmed tree trunk. The roof tiles were exposed and had obviously been plugged with moss to keep out snow and rain and wind. A few yards from the house, and on a level with it, a stream of beautiful water burst out from under a huge rock and flowed away down through alders and hazels to the river below. A small 'leat' ran along below the house to irrigate the steep field in time of drought. Here grew mimulus and watercress. The ground fell away steeply and the view embraced the entire valley to beyond Llanthony.

65

A few days later over a jug of cider, I struck hands with Mr Watkins of Talsarn and Carney was ours for two hundred pounds. It was one thing to buy a derelict cottage on a remote mountainside, and another to find a builder to make it habitable.

'Mr Price of Velindre, Mr Gammon, he's a good man, you go to him.' We did, he would and he rode over the mountain on his pony to look. Meanwhile we let our Sussex home and took rooms in the Saunders's farmhouse.

In spite of the war Price could get everything needed. He felled his own trees and seasoned the timber. All the wood for the house was elm with 'coffin boards' for doors (he was an undertaker and builder), and the floors where not nailed down until they had seasoned for twelve months.

In the intervening eighteen months, together with the men, we worked on the building, hauling all materials on a Welsh slide-car a mile up from Capel-y-ffin through a ford, up a one-in-three lane to the mountain gate and so along the mountainside to Carney.

The slide-car and the wheel-car where the only vehicles that could be used safely on hill fields at that time. My neighbour at Talsarn, Mr Watkins, has been hauling hay on a primitive wheel-car pulled by a modern tractor. The humour of such a combination of implements is quite lost on him. The wheel-car has been used in Welsh hill country for centuries and is one stage up the ladder of progress from a sledge. The wheel-car was an advance (at least so far as the horse was concerned) on the slide-car which was a framework on two poles – the rear ends dragging on the ground and front ends hanging from the harness. All three vehicles, having a very low centre of gravity, were very stable on hills and 'banks' – as the sloping fields are called locally – and side-land (mountainsides).

It is something of an art to manage a horse and a loaded wheel-car on steep ground because the car tends to over-run the horse and very few horses enjoy being heel-trapped. Even with a stick thrust between the iron wheel spokes as a 'sprag' the skidding wheel continues to slide forward and only a smart turn of the horse uphill will prevent a kicking match.

I believe there is an old Latin tag, 'every difficulty yields to energy', or something to that effect. I've forgotten the wording, but not the moral. Certainly we had to expend plenty of energy to overcome the difficulties that faced us during our first year at Sychtre Farm. My son Gordon and I worked on the farm together and we started from scratch without a single implement, tractor or horse, at a time when permits had to be obtained for any and every new implement, with months of waiting for delivery. If a U-boat was successful in torpedoing a merchant ship laden with agricultural implements from overseas the waiting period was extended even longer. Our chance of obtaining a new tractor and plough was so slender that we determined to risk the first secondhand one that was offered. My knowledge of cars was pretty sound and extensive; of tractors I was entirely innocent – a very green field for any artful dodger to plough over.

'Old Smith has a Fordson to sell', a dealer said to me one day in the market. I enquired as to the tractor's age and history, receiving a noncommital reply coupled with an assurance that it was a good machine. I went to see 'Old Smith' on the way home and found young Smith who promptly led me to a hoary veteran. If whiskers grew on steel with advancing age as on man, this old tractor would have been a model of historic perfection. Luckily for the Smiths – young and old – I knew nothing about Fordsons then; since I have gained an intimate knowledge.

Smith Minor flooded the carburettor, mucked about with a few controls (while I looked as though I perfectly understood everything he was doing) and seizing the starting handle he gave the engine a swing. A few hesitant coughs and then a devastating roar – the engine was running; this certainly was the Smiths' lucky day. Oh the times we churned that blessed handle in future days, without being rewarded with even a hesitant cough, still less the roar of a live engine. 'How much?' I asked. 'Better see Father', he replied. 'I don't know if he wants to sell it.'

Father was ploughing with a team of lovely horses; he was obviously proud of them and much preferred them to the tractor – I fancy he found them easier to start. I concealed my eagerness to have the Fordson and they successfully hoodwinked me into thinking that they were reluctant to sell it. We returned to the house and I wrote my cheque for £110 – the tractor was mine. The next evening a young driver brought it home shedding wooden road bands on the way and making a grand pattern of spike holes along the tarred highway. Fortunately he met neither police nor highway authority or we should have been fined.

All the valley heard our tractor coming up that evening and we soon found ourselves almost as famous as we subsequently discovered the tractor to be. But in spite of its age it still ran and did a good job. We added bits to it and coaxed it. Some humorist suggested a long stick with a carrot hanging in front might be an aid to locomotion. The foreman at the Fordson depot in Hereford grinned in polite disbelief when we gave the engine number and asked for some spare parts. It couldn't still be in use now, he said. The battle of Hastings where it hauled cannon was so long ago! In spite of him we fitted a new exhaust manifold and fuel system, making full use of bits of wire and odd bolts. The new steering wheel was

like a new hat above an old suit and added dignity to age. It had no mudguards and the huge spiked wheels revolved within an ace of the driver's elbow; so we bought one old Fordson mudguard from the amused foreman and another from a Hereford car dump (also run by Smith). On arrival home we found that both wings where identical and, deciding that two mudguards on the nearside wheel and nothing on the offside would look a bit odd, we added both to our old iron dump.

Take the plough round the farm, the WAEC (War Agricultural Executive Committee) told farmers in wartime, and make your farm produce more. But we hadn't got a plough! Someone suggested that a double-furrow horse plough would operate behind a tractor with a second person to lift it out at the headland. It wasn't long before we were talking business to a man who had an old double plough to sell. He told us where to find it under a hedge on the farm he had just vacated; so little did he value it that he had not troubled to remove it. We found it buried under brambles and nettles, rusty and stiff with age and neglect. Could we fix new mould boards, oil and grease it and make it work behind our 'Lizzy'? We could and did; but the owner's estimate of it rose to five pounds when he found out we wanted to buy it.

If you have watched the tractor ploughman at work you will have noticed that when he reaches the headland (the space in which he turns his tractor and plough when he reaches the hedge) he pulls on a piece of cord and the plough automatically 'trips out', running free of the ground, to turn. On our horse plough this had to be done by hand by the person who guided the plough and drove the horses. We failed to make any satisfactory remote control, so one drove the Fordson and the other operated the plough. Walking behind the plough when pulled by the tractor was pretty strenuous so we rigged a seat across the handles. After that everything went according to plan until the plough struck a large rock; Gordon was somersaulted off his perch and landed on his ear. The stout steel beam carrying the second mould board and share snapped like a dry stick. Thereafter we introduced a green stick into the towing hitch and any sudden jerk broke the stick instead of the plough.

So we ploughed our fields that first year and got our crops in to time, and gave a 'comic relief' to our neighbours who wondered what daft idea would develop on Gammon's farm next. Neither of them had a tractor at that time so our venture with this antique excited their interest more. With the September days came harvest, and then the old bus really came into her own, and not only did a good job for us but helped the national effort.

The demand for more corn and a greater home production made the neighbouring hill farmers plough and sow far more corn than they had ever done in peace time. Few of them had binders to cut their corn and had to rely upon the help of the WAE binder to do their reaping and that often meant waiting after the grain was ripe. So we combined with another farmer who had a binder and the old Fordson went to it pulling the heavy contraption up gradients that gave a modern machine a full load.

At times I expected the engine to melt she ran so hot, and then she would stop in the middle of a job refusing all efforts to restart. No impulse starter here – the handle had to be swung with vigour and the plugs taken out and cleaned – still no results. More fiddling with the fuel system and a clean up of all the oil that found its way into the mag. Another try, and – gosh – she's off – determined not to let us down in a neighbour's field.

Other tractors have carried on what 'Lizzie' began and it was nearly two years before we went to a sale and bought a modern Fordson. One happy day a lorry delivered a spanking new tractor plough that had successfully evaded Hitler's pirates – a helping hand from Canada.

The old horse plough sold down the valley and is still turning perfect furrows. The Fordson rests in the yard of a farm deep in the hills, her engine silenced forever by the misuse of a man who asked too much of her old and battered frame.

'Every difficulty yields to energy' but a little commonsense is a great help.

Neighbour Watkins and ourselves live on opposite sides of the valley. From our superior altitude we can look across each morning to his little whitewashed farm-house and deduce with some certainty, from the activities going forward there, what the day's job is likely to be. We are reminded of the sole advantage of position that he has over us, for when the sun peeps round the shoulder of the mountain it shines on his house thirty minutes before it illumines our home.

But that is his only claim to priority of situation, because the long shadow of the mountain creeps down over the house and barn very early on winter afternoons. Before its chill fingers reach us it has to run on to the ford, cross the river and then slowly find its way up the steep mountainside. Even when we are in shadow the westering sun makes the mountain slopes immediately behind and above us glow with light, and we still catch the reflected glory.

Quite early in our new life here we realized that we should never be lonely while family life continued at Talsarn; and now we have evolved a quite efficient system of communication needing no complicated apparatus. Watkins has truly remarkable vocal powers, developed by long practice over great distances. He can stand in the home field, which commands a view of the whole of our side of the mountain, and control the movement of half a hundred ewes high on the mountainside by shouting orders to Rentle or Bob, his two sheepdogs.

'Get away out, Bob, get away out!' and Bob streaks across the meadow, over the stream and up through the wood. In a few minutes his barking sounds from beyond the mountain wall, and you can see him up the slope of the mountain looking across to the farm for further shouted instructions. Away up higher and out in a circle round the startled sheep he races, turning them all back from straying on to that part of the ground on which the next farm holds feeding rights.

We were soon able to distinguish between sheep-herding and the stentorian yell that made our windows vibrate when he wanted to 'telephone' me.

'Hoi!' and then again 'HOI!' I go round to the end of the house.

'Can you tell us the time, the *time*?' My answer to his request is followed by a shout to the 'missus' to 'put that clock on half an hour'.

My lesser powers don't work the 'telephone' quite so effectively in the reverse direction, and I have to wait for someone to appear before I enquire if the 'missus' is going to the 'Hay' tomorrow (or some similar message), and signify that I shall come across with a commission for him. On days of singular quiet I know that he has probably gone to market, or is 'off from home' with some ewes or yearlings.

Our neighbour is very proud and fond of his horses, and my probation as a carter

extended over a period of months. He and I rode together last winter when we made our way over snow-blocked roads to fetch provisions dumped at a farm down the valley by the stranded motor van. It was then that I sowed the seed that has now come to ripen in his willingness to allow me to handle Flower and Bert on my own.

And today we have been trying to put a decent face on some very second-rate ploughing that the government tractor commenced but failed to finish.

I'm afraid we don't think much of some of the ploughing that the government tractor has done on the banks. I cannot repeat what my neighbour said when he returned from market and saw the battlefield – especially as the young driver had disregarded his instructions and ploughed the field the wrong way, the consequence being that in our attempts to finish his job it has been almost impossible to hold the plough up to its work and prevent it side-slipping down the steep slope. Turning at the ends the heavy plough heeled right over and threw young Trevor Rees on his back when, full of the exuberance of youth, he took a hand at the plough.

Talking of ploughing, I sometimes wonder how many townsfolk know the work that goes into the production of a field of golden wheat – a sight so common to our autumn countryside and never failing to give pleasure to the traveller.

I began to work on my wheat field last September, soon after the former crop had been harvested. I turned into it with the Fordson and cultivator to try to clean off a layer of troublesome, wiry grass, the legacy of a hasty cultivation by the previous owner when he had more to do than one pair of hands could achieve. For many days I tore at that blessed grass. It clogged my spring tines, rolled up under my chain harrow, and forced me to stop at frequent intervals to upend the cultivator, roll back the harrow, and clear away the clinging roots.

If you have ever tried to fold and unfold a spiked chain harrow a dozen times in an hour for several hours a day, each time clearing away a tangle of weed from the spikes, you will realize that I did not receive with very good grace a suggestion from a well-meaning neighbour, who looked over the gate at a crucial moment, that it should be ploughed shallow first. I wasn't going to plough that muck in again to suit any conventional idea, and said so, whereupon he departed.

This winter of waterlogged fields, bogged tractors and animals feeding off kale standing up to their bellies in mud prompts me to repeat a good yarn I heard.

In the early days of the war when a farmer could hire a tractor and driver from the government, a very young officer from the Agricultural Advisory Committee advised a Fenland farmer to plough up a certain field. The farmer knew his land and replied that the field was unsuitable. Whereupon the youth, knowing how stubborn 'these ignorant farmers' can be, stated a day when the committee tractor would arrive to carry out the order. He'd teach this chap how to farm!

The farmer invited friends, agents, auctioneers and vets for miles around to see the ploughing and laid on a good lunch for them.

The young officer, tractor driver and tackle arrived and marked out the field, watched in silence by the assembled company. The heavy tractor set off across the field with the driver sighting on his markers to cut a straight furrow. Halfway over the tractor began to sink in, but the driver, conscious of his audience, kept right on. Deeper and deeper they sank while delighted murmurs arose from the onlookers, until finally the driver lost his nerve and sprang off leaving the throttle wide open, and the outfit dug itself into the bog. All the king's horses couldn't pull it out and in a few weeks it had disappeared from sight.

If you know anything of farmers' reaction to officialdom, I need not point out the sheer joy this occasioned for months.

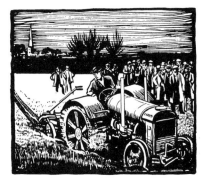

A tough old pasture that slopes steeply up from behind the farmhouse to the mountain fence is yielding to the plough. For years wild thyme, weeds, bracken, gorse and wiry grass have grown on it, and sheep have found a picking there – they will find a blade to bite where other animals would starve and die. But now we intend that it shall 'pull its weight' with the rest of our small acreage.

So the furze was cut and burned, the ant-heaps were levelled and spread; and as I watched our lend-lease tractor-plough cutting two clean furrows and turning the rank herbage under I could not help thinking of the old man who last ploughed it, many years ago, to grow a few potatoes to sell, so that he might pay the 'tack money' due on his sheep.

April and May are exciting months in this farming business. Anyway, they are for us in this hill-district, where we are a bit later with our sowing than some of the easier farming localities. And April this year found us weeks behind with our work so that every fine daylight hour had to be filled with labour in the fields.

On Easter Monday, when other people were riding the lanes and byways, we were drilling kale seed – small, black, uninteresting, little seed that spills all over the place if you lack care when filling the drill-box.

Once the little spoons in the seed-drill have picked it up and emptied it down the tube to fall into the soil just behind the coulter, and the following roller has passed over it – why then you may scrape about and peer at the earth, but hardly a seed will you find.

'Do you think it's sowing thick enough?' we ask one another. We look into the seed-boxes to see how much has gone, and then lead the mare on for a further two rows with the box lids open. Finally we are sure that the precious seed is being regularly fed down the tubes to the earth, and we continue up and down the prepared ridges until three acres have been completed and Polly, our Welsh cob mare, is fed up with this business of continually going somewhere and never getting anywhere.

I think Polly enjoyed a pretty carefree existence before we bought her, and had not been required to do any continuous repetitive field work like that needed when pulling a seed-drill or fertilizer-drill. Consequently she sometimes resents the apparently aimless crossing and re-crossing of a field , and particularly the short turn at each end. In the latter operation her feet and legs get a bit tied up, and then her ears go back and she gives a sly sideways nip at the hand on her bridle.

If it happens that the leader is myself, and I'm dreaming about pictures or some faraway sea loch, the feel of her teeth causes a sudden return to the job in hand – and a slight altercation between us. But Polly is readily forgiven her finger-nibbling habit.

Polly is silent 'in all gears' until she sees my wife go up the granary steps. Then she speaks up, and is rewarded with a bowl of oats in spite of my warnings that we need to keep our remaining oats for next autumn.

When the kale sowing was complete we emptied the drill and carefully saved the surplus seed in case we had to make a second drilling.

No doubt people have heard and enjoyed that real old country song 'The fly, the fly, the fly be on the turmut' – probably without appreciating what the 'fly' might be, and why they were on the turnips. This tiny black hopping beetle attacks small seedlings in dry weather in such numbers that whole areas simply disappear in a matter of hours. Then the field has to be drilled again – sometimes even three or four times before a successful 'plant' is obtained.

Kale seems very subject to attack until it has developed four small leaves. After that it can withstand the 'bob', as it is called in some localities. And that is only one of the pests we have to combat in our attempts to produce milk.

I held some of the seed in my hand. It didn't look much like milk, and yet each seed had within it the life germ of a green plant that will grow as tall as a man and is the best winter feed for milk production.

Many tons of food can be grown to the acre – some to be fed green from the cart, and some to go through the cutter-blower into the silo. There it consolidates into a tight mass and comes out rather like cooked cabbage and having a very high protein content.

When every green thing is frostbound, and the kale in the field is finished, then the silo is opened and the precious milk yield maintained at a time of year when it is most needed to combat the chills of winter.

So it was that we worked on Easter Monday, redeeming the time lost when the weather was against us. And anyone who cycled up our valley saw two funny old country people working with a smart new red and blue root-drill, sowing some of the seeds of those millions of gallons for next winter.

Let us hope those same passers-by this summer will fasten our gates and pay the same respect to our growing crops (including grass, for that is a crop of the highest importance) as they would expect of us in their office or garden or workshop.

The first indication that anything unusual was afoot was a lusty cry of complaint. It came from a large cardboard box standing by the kitchen fire.

'Someone's brought you a baby,' I said as I went across to look at the first of the season's lambs.

'Yes, and the mother hasn't got any milk for it,' said the farmer's wife. 'Such a bother, they are, I don't like these tiddlin's; they follow you everywhere; always about, gettin' under everybody's feet and makin' a mess. But I'm afraid we're going to have a lot like it this year; the snow's been so bad, and fodder so short.'

'There was a young lady near my village a few years ago', I said, 'and she had a bottle-fed lamb – a tiddlin' as you call it – and it followed her even when she went into the village shopping. She tied a blue bow round its neck.'

'Um! well I never,' commented the farmer's wife, and then added 'but I expect she didn't have much else to do.'

The tiddlin' continued to raise her voice. A medicine bottle full of milk, corked with a rubber teat, was withdrawn from the hotwater boiler, where it had been suspended on a string. The milk, tested for temperature and found correct, soon vanished inside Sylvia – we felt it was only fair that the first of a new flock should have a name, so I called her Sylvia.

Throughout that day the farmer's daughter paid considerable attention to Sylvia and fed her at frequent intervals, paying little heed to her mother's warnings. Her lamb – she claimed it as her own – should be well looked after, and Sylvia, pulling at the bottle, indicated her agreement by violent tail-shaking.

By the afternoon Sylvia had found out how to get her rather ungainly front legs over the edge of the box. Up to then she had only been able to look over and make plaintive noises at anyone who came near, and if those appeals were foolishly answered with a 'baa-ing' sound Sylvia replied fortissimo. Now, having discovered that the box which restricted her movements had an edge, it was an easy next stage to hoist herself up and fall awkwardly over – to freedom.

'Ah!' exclaimed the farm wife, 'now you'll soon see; I don't like these tiddlin's , bother 'em. I told you what 'twould be.'

During the following night (this was the Saunders's farm where we were living while work was being done on our cottage) we heard suspicious movements and muffled sounds from below. In the morning we found the farmer's wife regarding Sylvia with a baleful eye.

'Outside in the cot you're goin',' she said to Sylvia, who was scrambling about under the table, her tummy distended with a liberal dose of warm milk.

'Made such a row in the night I had to get from my bed to feed her.'

'I thought it was Joyce's lamb,' said I.

'Only during the day. Joyce doesn't hear anything at night!'

A few days later a fox came down from the mountain early one morning and carried off a weakly lamb, and when the farmer returned from his rounds he brought the bereaved ewe with him. He shut her up with Sylvia and secured her while Sylvia proceeded to sample warm milk and lots of it. After a few such occasions the ewe accepted Sylvia without herself being tied up.

If the dead lamb's skin could have been laid across Sylvia's back, the ewe would have recognized the smell of her own lamb and would have accepted Sylvia without compulsion.

I remembered a story of a sheepdog bitch that nursed an orphan lamb and reared it, and I related this to the farmer. 'Father had a bitch that did the same thing,' he said. 'People came for miles to see a bitch rearin' a lamb.' (There is nothing very astonishing in this, of course; much stranger foster parents have been known.)

Sylvia was the first of many expected lambs, but on this early April day of writing we are thankful that few ewes have lambs running by them, for snow again covers the fields, and every green thing is obscured. The lambs struggle through the wet snow and bleat protestingly at a cruel, cold world. The ewes are so weak that they stumble and fall if they are hurried.

This has been a winter of evil memory in our valley, and we face May month with the eager anticipation of people long imprisoned. All winter it has been a dismal tale of yet one more sheep found dead. Now, with the coming of May, we hope it will be a tale of sunshine and frisking lambs.

It is with some diffidence that I prepare to write of quiet country things, of birds and beasts, and hillsides glowing with the slanting rays of early spring sunshine. When I remember the ordeal through which so many of you in the towns and cities are passing it would seem almost insolent to mention these things of country delight were it not for the letters that prove how acceptable a link is our *Cyclists' Touring Club Gazette* in these times.

Let me assure you that the country folk, who contributed to your pleasure in happier days, and who are now busily ploughing and sowing for victory, are by no means unmindful of those whose work is less congenial and leads them into greater danger from attack. When bodily weariness bids us stop and 'call it a day', we plough another furrow, or turn an extra sod, to gain a bit in case tomorrow is wet or frost and late snow hold up our work.

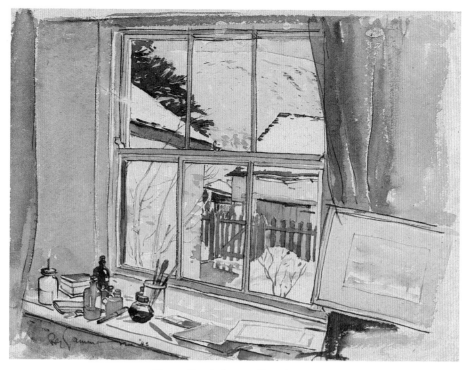

My studio window at Chapel Farm

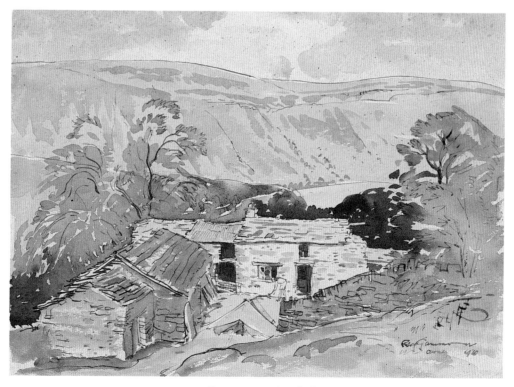

Carney, as we bought it

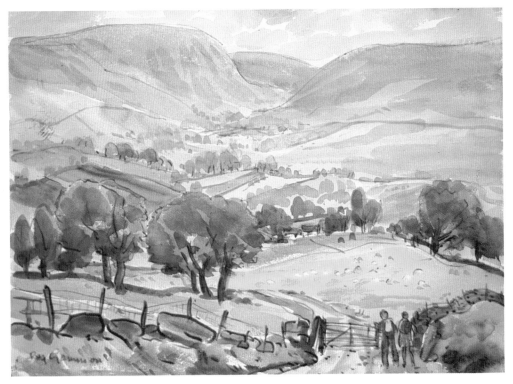

Llanthony Valley and Tom Lewis's farm from the mountain gate

Sychtre Farm before alteration

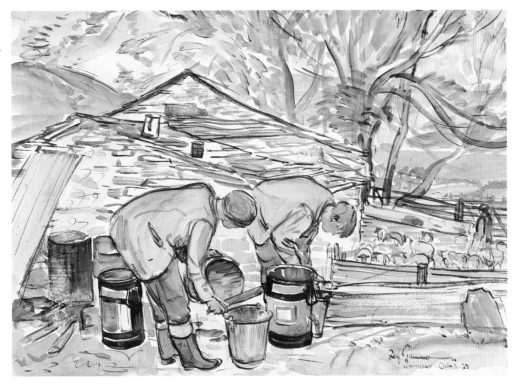

The brothers Ivor and Gordon Watkins mixing sheep dip at Talsarn

Dipping sheep – our neighbours David Griffith, Reggie Williams, Trevor Rees and Jim Gwilliam

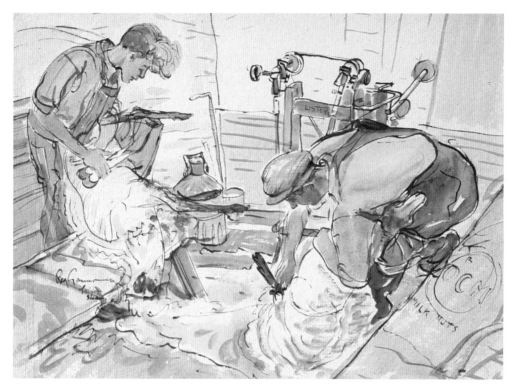

Hand shearing (left) and machine shearing

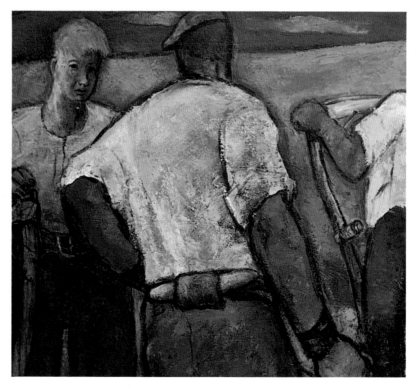

Three mowers with scythes

Said my neighbour, Reggie Williams, one early-summer's day, 'We shall be gatherin' on Wednesday, and I'll be along about six o'clock. If you do bring the bitch we can try if she will work.'

'I shall be ready,' I replied. 'When do you shear?'

'I shan't shear until next week, but Griffiths is shearin' on Thursday, and I reckon you will do yours on Friday.'

'Yes, I suppose I shall.'

There is nothing that Reggie does not know about sheep. His knowledge of these intractable quadrupeds is simply bewildering to a novice like myself, and the unerring skill with which he can pick out of a mixed flock a certain ewe or lamb is uncanny. My own knowledge of sheep is just negligible. Sometimes I can manage them and make them go where I wish; at other times they rouse me to a pitch of fury that makes me wonder why on earth I ever bought a sheep. One of these days I shall offer to sell the whole lot to Reggie (if he arrives at the right moment) at a 'knock-down' price, but he won't take my offer – he is too good a neighbour for that. Instead he will help me out, order me about, and tell me what I ought to do.

'Mind, I don't want to interfere, but if I were you I should ...' and I do it, knowing that the master has spoken and 'orders is orders'. I did shear on Friday, although it was a nuisance because we had some hay ready to be gathered!

Ten days before the shearing the ewes and lambs had been brought to the river for washing, a process that takes some of the grease and dirt from the fleece before it is removed from the animal. The wool staplers examine the fleeces they buy, and dirty wool is paid for at a lower rate per pound. So the river is fenced in, a log or platform thrown across a deep pool, or a dam erected to make a pool, and the sheep are forced to enter the water. Some come rushing down and leap far out into the pool in an attempt to jump across. Usually it is the old hands that try this; others have to be thrown in. Standing on the log or dam side, helpers equipped with long-handled 'paddles' force the animals beneath the water and steer the artful dodgers, who make at once for the exit, round and round the pool until they are thoroughly soaked and the thick fleeces stand out in the water.

Occasionally a well-known 'breaker' comes along, a hardened old sinner that has been chivvied out of many a field of oats or ley grass. Suspicious of any new move, she comes down the chute ready for trouble. 'Here's that old white-faced cardy,' says someone. 'Give the old devil an extra swim for luck.' And the trouble she expected arrives on time. Having run the gauntlet she scrambles out on the far side of the pool, shakes the water from her fleece, and glares defiance at her persecutors, for she is ready to lead them and their dogs a dance at the first opportunity.

''Tis like it says in the Bible; the old devil entered into they pigs, and I reckon he goes into some of these old ewes.' Such was the opinion of one old hill shepherd hereabouts.

After washing, the sheep were returned to the mountain until the weather was suitable for shearing , and it was for the shearing gathering that I was ordered at six o'clock on Wednesday. Tess accompanied me to the mountain gate, and my neigh-

bour arrived on time. Together we followed the mountain wall as far as the next dingle, where we picked up any sheep that had 'drawn down' from the tops.

Tess, a slender silky-coated sheep bitch, was on trial before purchase, to see how she worked the sheep. She has a decided liking for rabbits, a bad fault in a sheepdog, whose one job is to round up sheep. This evening she helped me to move the sheep along the lower slopes of the mountain, the other helpers spreading out in a wide circular movement that reached to the crest of the mountain. One went along the crest for a mile or more, and with his dogs drove all the sheep through the heather and whinberry that grows in a tangled mass on the tops, in the direction of a dingle leading down to my farm. At one time I could see him silhouetted against the evening sky and faintly hear his voice urging on the dogs to find every ewe and bring her on.

My job was to prevent the sheep from returning along the lower slopes as the circle of gatherers closed in above them and drove them down the dingle. For a long time I waited there, holding the few ewes and lambs already down in check until the others should appear over the crest of the hill. I could see and hear nothing of my companions, and I had leisure to enjoy the little pattern of fields below the farm-

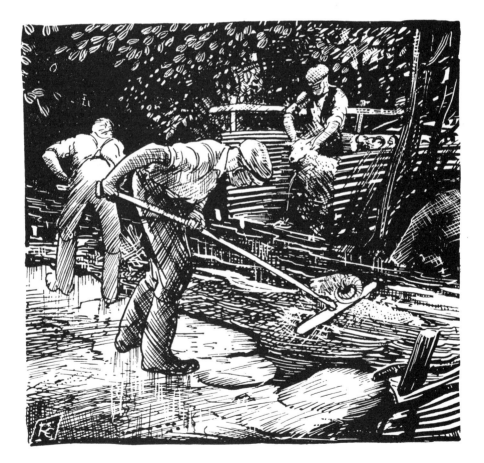

house stretching away to the road that was my bit of this beautiful valley. I wondered what it was like when the other small farmhouses now lying in ruins below me were occupied, and each man had his grazing right with sheep on the ample mountain pasture. I looked away across to the old abbey, to the ancient church and the inn, and tried to picture life in the valley when the abbey was occupied and travellers came not on cycles or cars, but on foot or on horseback. I was recalled to the present duty by my neighbour's voice calling to his dog.

'Get away down, Don; get away down! Don, come here; Don ...' (Don was doing the wrong thing, and the tempo of my neighbour's voice was rising.)

He called to another unseen neighbour, 'Those ewes are drawing back along below. I don't know where Gammons is.' (I am mostly 'Gammons' hereabouts)

I was jerked into the present world and set Tess to turn the ewes that had now come streaming over the brow of the hill towards the dingle. Together we stumbled over rocks and pushed through bracken as high as my head, until the whole flock converged on the mountain gate above my land, with helpers shouting and dogs barking to make sure that none escaped notice.

Here, while the dogs kept them in a bunch, we parted them out. My own we turned into my ground; any strays to go up the valley were taken by neighbours going up, and those to go down went down. Thus they are passed on from farm to farm until they reach their owner for shearing, and that owner may be miles away over the mountain.

Almost hourly the fields change colour as summer passes. From a distance one can name a crop with certainty; the pale grey-green of oats, light golden-brown of wheat and the near-white of a field of ripe barley.

When the evening sun sends long shadows slanting across his cornfield, the farmer stands looking over the crop. No 'book-learning' can help him to determine when the crop is ripe and ready for cutting; only his knowledge of that particular field and the experience of years can supply this.

Five-thirty on a July morning. Duchess has just sauntered up to the gate, punctuating her approach with bellowing roars to her calf imprisoned in the barn.

The valley eastward lies in deep shadow. The mountain rears up skyward like the bastion of a huge castle edged with the silver light of early morning.

The shadow of this mountain still lies over our farm, but high above the sun has already touched the young whinberry and the grey rocks with a golden light. The shadow is retreating into the valley with quite incredible swiftness, and before we have prepared for milking the whole farm is in sunlight.

Betsy, Topsy, Nancy, Juliet and the rest of our small herd are all lying content, cud-chewing in the home meadow. Milking and breakfasting proceeds with a minimum of wasted time, and by eight-fifteen the churns are awaiting the collecting lorry some ten miles down the valley. Meanwhile Gordon has inspected the silo and announces that the temperature is up to 130 degrees so a good load must be added.

Here I had better explain that the silage is made from green oats and vetches, cut young, trodden firmly in a concrete silo, allowed to heat up to 100 – 120 degrees, and then covered with a good weight of earth.

The air is filled with the scent of honeysuckle and hay as we drive the tractor down to the field, turning the cows into the new ley grass on our way.

The oats on their tall straws give a kind of death quiver as the keen knife severs the stalk, and their fall to earth brings the beautiful clinging purple vetches tumbling down. It seems almost sad to be cutting such a lovely crop in the full vigour of its growth, but that is the way with making a crop into silage.

Tom comes up the field with the letters (including my copy of the *Gazette*) and gives his opinion that there is a 'devil of a good crop, man; never bin nothing like it on 'ere before I warrant'. We inform him that twelve loads have gone into the silo and this is the final. The remainder must be harvested like hay.

The heavy crop is cut, loaded on to the trailer, and taken up to the yard to be again unloaded and pitched up into the silo.

The whole operation of handling this green stuff is very hard work indeed. We had planned to clear the load before dinner, but when the lady of the house appeared and announced that it was twelve-thirty and dinner was ready we downed tools and made a break for it. Then the gooseberry pudding and cream and coffee that rounded off the meal nearly torpedoed our good resolutions – but we shook off our lethargy.

'If you horse-rake the hay we'll finish off loading this,' I said to Gordon.

'The cows must be taken off the ley grass', he replied, 'but I'll do that when I get Polly for the rake.'

By three o'clock the hay is raked and we decide that it is ready to rick. So while Betty gathers the rows into cocks we dig out our home-made Crossley-Ford four-wheel trailer and prepare the rick site.

We finished loading our trailer just as a voice called again – 'I don't know if you people want any tea, but it's twenty past five'. Did we want any tea! We dropped everything and ran to it.

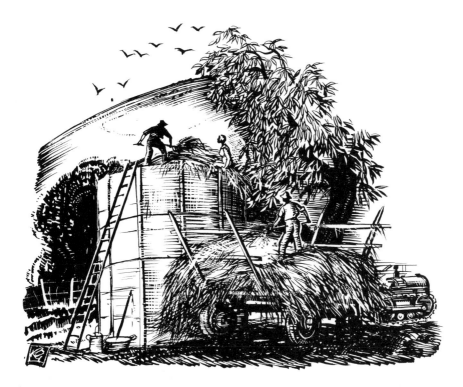

The weather forecast was good – the first time for weeks – and the news mainly about holidays and sporting events. 'Why the heck don't these people get some work to do,' said Gordon, cutting himself another huge chunk of cake.

'But, dear, it's Saturday afternoon you know.'

'What difference does that make?'

'Well, people have a holiday.'

'Do they! I haven't noticed it myself.'

Seven-fifteen pip emma! The cows have been milked and turned out again. Now to unload the trailer and begin our rick.

'What about that calf for old Pembridge?' says Gordon. 'I want the milk that he's taking from Duchess.'

'If I help you with this second load', I say, 'you two can off-load it while I take him up in the trailer and go on to attend to my goats at home.'

Halfway through loading, the suggestion is thrown out that we might finish the cutting of the oats and vetches so that the weekend sun can dry them. It will be a moonlit night!

The calf is safely delivered after almost jumping from the trailer halfway to the farm, and I return home to discover that Penelope has two newly born kids.

Returning to the farm about eleven pm I find that several more swathes of the oats had fallen to the cutter then 'bad light stopped play'.

Wearily I grin to myself. 'I think we'd better knock off now,' I said. 'After all, it is Saturday afternoon, and people have a holiday.'

Not long ago I said that I intended to get more out of my farm than hard work. I was not referring to returns in cash value. Much of that, I find, is the result of shrewd dealing; and I have discovered myself to be as clay in the hands of the potter when I enter into transactions with my neighbours; almost invariably they get the better of me. So I give up the unequal struggle against their superior powers of indicating weak spots in my produce, live or dead, and the fact that there is so much similar and better to be bought for even less than they are gen- erously offering me – an aberration on their part due entirely to their neighbourly feelings towards me. Only on the rare occasions when I have something which they badly want, and I don't care tuppence whether I sell it or not, can I hold out and feel that I have come near their standards in the art of buying and selling.

One of my neighbours, a brusqe old farmer of seventy, whose rough exterior hides a kindly and helpful character, badly wanted to rent the feed on my five-acre clover field for his milking cows last spring, when the extra ploughing had made him short of grass. I heard about this from another neighbour who had been commissioned to find out my reaction (that being the usual method of procedure). Having expressed my willingness to let the field if the price was right, I avoided the old man for some weeks until we met by chance in the market. We discussed the calves, as I was wanting a calf to rear, and he pointed out the one he would buy. I knew he was right and bought it. We went over to the pigs – 'a terrible price, man, but what can we do without a bit of bacon in the house in winter?' Suddenly, when the psychological moment arrived, he said, 'What did you think to do about that field?' 'Field?' I countered, 'Oh, the clover seeds – why, did you want it?' 'Well . . . I thought to run the cows in there at night. Mind, it's bare in the middle and they'll do it good.'

'Um, and what did you think to give for it until Christmas?' said I.

'Well, 'tis thin in the middle; six pounds, that's what 'tis worth.'

'Oh, I thought about twelve pounds was a fair price.'

'But they'll do it good man; you think it over.'

He patted me affectionately on the arm, and as we parted I felt the first round was about equal. Some days later he returned to the attack, and after a few feints offered me eight pounds, which I countered with ten, saying that if it was worth so little I'd take the hay crop from it first and then let it. This was too much and off he stumped leaving me a little undecided where the honours lay. Actually we did take the hay crop to the value of at least forty pounds, and our own ewes are now grazing the 'lattermath'. But, I repeat, this was exceptional, and my bargaining is usually for something that I desperately need and they know it.

It is surely one of the prime mistakes of modern life to measure the return for labour spent in terms of pounds, shillings and pence alone. Certainly it is where work on the land is concerned. I'm sure that any money I may get for my wheat when it is threshed will not outweigh the pleasure I derived from the cutting of it one glorious August day. From the cold days of winter, when we looked at it with anxious eyes, fearful that the crop was going to fail, wondering why the ground seemed so lightly covered with the young growth, we watched it grow in strength and beauty . . . At haying time we noted how suddenly the ears of wheat appeared green and slender on the tops of every stalk. One day the field looked as it had done for weeks, but the next day thousands of ears of wheat had thrust upward to reach the sunlight. Since then it has filled out and ripened, taking on the full beauty of an English wheat field enhanced by the background of hills.

'That wheat will come to cut any day now,' said my neighbour. It came as a bit of a shock to me that I must drive the tractor round and round until this golden harvest was severed from the earth that brought it forth, so that it may be carried to the barn ready for threshing.

My neighbour cut a lane round the edge with a huge reaping hook of a type used in this valley to cut whole fields until a few years ago. That completed, we set the binder in and soon widened the lane between the hedge and the standing wheat by a further five feet, with a fine sheaf lying at intervals of every few yards. Now and again the binder string would break and a stentorian voice reached me above the roar of the Fordson and the rattle of the binder – 'Whoa!'

As I stamped on the clutch and looked back, the man was already off his seat and at the side of the binder waving the frayed end of the string at me. 'This war-time string again,' he shouted. 'Just come and take a look here – a great lump stuck in the tension spring.' Whereupon I went round to look and make a suitable remark about the string, assisted in threading the needle again, and on we went.

The day was perfect for cutting, with great billowing clouds that sent huge shadows racing across the valley fields and up the hillside. As I drove the Fordson down the edge of the wheat the whole valley lay before me, with the sunlight playing hide and seek among the old abbey buildings in the middle distance, the long, straight wheat stalks falling heavy headed on to the canvas transporter that carried them to the sheaf board, the fine sheaves casting from the machine every few yards. Now I experienced a sense of intense pleasure that I cannot convey in words. As we proceeded myriads of winged insects were disturbed from the wheat, and dozens of swallows and martins constantly glided to and fro.

A cascade of sound breaks in upon my dreams. As I reach out a reluctant arm to clamp down on my alarm clock, I scowl at the clock face. Five-thirty on a fine autumn morning!

'Well, this is it,' I say to myself. 'You said you could manage on your own. So now you'd better get out and prove it and produce some milk. And produce it quickly too my lad, because it's got to be on the road by half-past seven.'

I tumble into my green battledress, put a match to the Calor stove, force my boots on, gulp down a scalding cup of tea, seize the hurricane lantern, and stagger out to the cow-pen by six am. The feeding round was done on the previous evening, when I also set the cooler, the churn, the strainer, and a bucket of washing water ready.

I glance along to see that the chains are hanging ready to tie, and make my way out into the semi-darkness to collect the cows. Stumbling through the orchard to an adjoining field where they have been lying out at night, I wonder how they'll take to this early morning ramble, and, still more, how they will go into the new cow-pen to which they were introduced yesterday.

That introduction took two of us a considerable time to accomplish and was not without incident. Topsy walked into her allotted place, sniffed at the food suspiciously, stepped into the manger, reared up over the manger wall into the feeding range, and went by a back way into the yard whence we had brought her a few minutes before. Nancy followed Topsy, improving on her 'act' by carrying away some woodwork, walking through a wooden crate which had transported young pigs by rail, and jumping a five-foot fence *en route* for the farthest corner of the farm. Charlotte, having been bred and pampered from youth by a lady, walked in and stood lengthwise in the manger, steadfastly refusing to budge or to remove her hindquarters from Juliet's face.

That all happened when Gordon was there to help me, but now Gordon has gone away, leaving his father to play a lone hand with Topsy and co, until he returns next week with his new bride Margaret to preside over the farmhouse affairs in their future home.

By instinct rather than by sight, I find my way across the field calling as I go. 'Hoy, hoy; come long, come along!' Buttercup answers me with a bellow, but I don't want her; nor do I want Megan, Pansy or Daisy, all of whom now come up out of the darkness to see what's going on at this unearthly hour – and all of them being heifers and yearlings, ripe for a bit of fun.

Topsy's larger bulk appears, followed by the other three milkers, and we all make our way into the orchard. Here the assembled company remember that there are

fallen apples to be had, so wander off to search beneath the trees, entirely disregarding my blandishments (and finally my execrations) and the fact that the expensive concentrated food is awaiting them inside.

One at a time I am able to work them up to the gate, and they make for the cow-pen door. Topsy sets a good example by going straight into her place. Juliet commences to eat Nancy's food, while Nancy dodges off into the darkness of the yard in search of her calf, who she fondly imagines is still in the barn, though in actual fact he was sold last week. When all are finally inside we have a short rodeo together, deciding where we shall all go, and with the aid of my bit of hazel stick I emerge from the fray the winner. Now there is peace, each animal intent on the food before her, with only the sound of her munching and the rattle of the chain about her neck.

After carefully washing and drying udder and teats I settle down to milk. The high-pitched note of milk striking an empty and resounding pail soon changes as the pail rapidly fills and a real 'bead' comes on the milk. Milking, when you have an easy milker, is a soothing kind of occupation and your mind is free to wander; but I have repeatedly noticed that the animal knows at once when attention is not on the job in hand. Up comes her leg, and only a quick action on the milker's part can save the bucket of milk.

After quite a short time you become adept at squatting on a little stool and holding a large pail of milk between your knees, remembering always that it is not you but the milk that counts. If a kicker lands you in the gutter it does not matter so long as you keep your pail of milk unharmed!

And so I sit under them all in turn – Juliet first and while her food lasts, for she has tender teats and needs to have her attention taken during milking. Charlotte comes next – a devilish hard milker, with teats like leather. Then Nancy, a pretty young lady in red and white, and finally Topsy – sleek and black, with eyes to match her coat, she fills my pail to within a few inches of the brim.

As I milk I whistle, and I am sure they like it. I intend to experiment with various tunes, and maybe if I whistle a hymn tune Juliet may cease to swipe me on the ear with her tail every few seconds. On the other hand Paganini's violin concerto or bits of the Tchaikovsky in B flat minor, as whistled by me, may send the milk yield up by gallons. As I finish – about seven-ten – it is daylight, and the beauties go out into the top pasture on the new ley grass. The milk is cooled and the churn stands at eight and a half gallons. On a light wheeled frame I trundle it down the lane to my neighbour at New House Farm.

'Well, how is it this morning?' he greets me.

'Oh, I'm up a bit this morning; eight and a half gallons.'

'Well done,' he says. 'You know there's nothing will beat a bit of new grass for makin' milk.'

One eventful morning I sent off nine gallons, but then a bad night of storms and wind brought my score tumbling down again to seven and a half. An even daily supply is most difficult to maintain, for one is dealing with living creatures, not machines. And so it goes down the valley in the car of my kindly neighbour, to meet the collecting lorry that transports it into a South Wales district.

In the early hours of an autumn morning the rain was drumming down upon our roof. Through the half opened window we could hear the rising tempo of the river as it increased in volume fed by the small white-crested torrents that were everywhere dashing down from the mountains.

Morning light was long in coming, and when at last we could see our vision was restricted to a few yards. The rain clouds hung low in the valley and we were completely cut off from our neighbours by the clinging vapour. The voice of the river filled the valley with its sound. Summer was being literally washed out, and the autumn floated in on the swollen streams, dripping trees, and sodden harvest-fields.

Down by the ford, where the holiday children had arranged a bridge of stepping stones across the shallow summer river, it was difficult to edge along the rocks between river and hedge, and quite impossible to use the stepping stones. Wine-coloured from the peat of the mountaintops, the water was swirling around and over the stones. Soon, if the rain continued, the stones would be forced along the slippery riverbed and crash over into the pool below the fall.

Along the riverbanks above the ford, where the dainty grey wagtails spent so much of their time during the nesting season, the water is running strongly, bending the trailing branches and overgrown vegetation to its will. The birds have not been seen for some days now and we shall not see them again until spring returns, calling them from the slower-moving rivers and the coastal districts, or from tropical Africa, where they have wintered. The swirling water has now flooded out the nest where they raised their brood, it was so low down in the bank.

Upstream, where the farmer has constructed a stone wall to form a sheep-wash, the river is rushing through the narrow sluice with great force. In the early summer, when sheep-washing is being done, a sheet of corrugated iron is thrown across the opening and, reinforced by a few poles and rocks, it is strong enough to hold up the water and form a deep pool. Wisely the farmer has removed his sheet of iron before the flood carried it downstream.

Few things are more fascinating than exploring a stream, especially when it is in flood. Children love messing about by a stream, and the interest seldom lessens with age. Quite the reverse is often true, because a more mature knowledge of the countryside adds to the happiness of the exploration.

When the rain slackened we scrambled upstream to the waterfall – 'our waterfall' we liked to call it. It has a personal touch for us, being so near the house, and we like it for its seclusion. Often friends have set out alone to find it and have not been successful, because the quiet river above, fed by numerous streams from the

mountains on either side, gives no indication that it is about to hurl itself over into a deep, tree-lined crevasse. The splashing water, muffled by the trees, is almost inaudible until one stands on the brink.

On this occasion we approached from downstream, a wet-foot journey, leaping from rock to rock or gingerly crossing the soft patches to avoid sinking ankle-deep in the black mud. This way the sound of the fall gradually increases. The sides of the ravine gradually close in, and the trees interlock overhead until a bend in the river brings one face to face with the wall of earth and rock over which the water falls.

On a hot summer's day the restless pool is very inviting, and we have enjoyed many a shower bath in the flying spray. But today the air was too chill after the rain to attempt any antics in the pool. Instead, I took my colour box and set down in paint the impression the scene made upon me.

While I was painting, a buzzard came sailing into the trees overhead, but quickly saw us and flew on. A dipper came speeding upstream and, alighting on a stone, curtseyed to us many times before it too went on its way.

The painting finished, we scrambled up the steep bank and, looking back, saw a young grey wagtail fly up and perch on a shelf by the falling water. Evidently one of the family still lingered by the stream where it was born. Soon it will depart and leave the river for the dipper and the heron and ourselves to enjoy its wild winter moods of flood and icicles.

A neighbour came the other day 'to look for some pigs' (as they say hereabouts). In other words, he wanted to buy some pigs, so we went across to the building, forced our way in among the seven vociferous youngsters, and there struck a bargain.

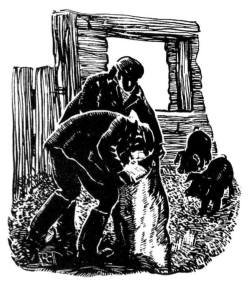

He could, he said, take one up in a sack on his pony, and send his son on his bicycle for the other. But a bagged pig and a bicycle are apt to become awkward companions; as, indeed, are a mettlesome pony and an excited porker, especially when the pig is rising five months old. So I undertook to deliver them in my car at an early date.

Two days later, on a day when a deluge seemed imminent, and all other work was at a standstill, we decided to deliver the pigs.

'No need to bother about the trailer,' I said. 'They will go into two bransacks,' bransacks being open and airy, 'and stay quietly in the back of the car.'

It is always a decided advantage to have two persons to put a pig into a sack. I held each lady up by her hind legs while Gordon manipulated a bag, securing the mouth with string. The two victims tried sack-walking while we got Polly and the cart to take them down to the car on the road, and sounds of murder came from the pig-cot.

Just then a tall figure loomed through the mist of falling water and informed us that he had our new shorthorn bull in the cattle lorry down the road at the opposite end of the farm. We had been waiting a fortnight for delivery of the young aristocrat and they had chosen this deluge of a day to bring him!

'Well, there's only one thing for it,' I said. 'Put the pigs into the back of the car now, and let's hope they won't eat their way out of the sacks and rip up the inside of the car while we get the bull up the lane and into his box.'

Down on the road the two piglets were bundled into the long-suffering Austin. The large doors of the waiting lorry opened, and Gilwern Major rolled the whites of his eyes as we looked in at him.

He was in a highly excited state and sweating badly. The journey, his first in a lorry, had put him into a mood for rough stuff with anyone handy.

The driver, well used to handling animals, went into the lorry and spoke quietly to him, and slipped aside to avoid a vicious kick.

'All right my lad! If that's the stuff, we'll have an extra rope.'

He got a rope from the cab, looping it around Major's horns and taking a turn over his nose.

'Now untie the halter, sir.'

I untied it. The bull hesitated a moment at the top of the ramp and then shot out

into the road like a flash, to be swung round by the strong hand holding the rope.

After a few minutes he slowed down, and Gordon and I started up the lane with him. How he resented the restriction of that rope round his horns! But we should never have held him by the halter as he bucked and struck around trying to climb the banks of the lane. When he stopped, his tail lashed from side to side like an angry cat's, and each renewal of activity came in a bound that very nearly pulled Gordon off his feet.

Before we had reached the upper gate to the lane he had sobered, and he walked into his new his new quarters without trouble.

'He's a beauty', said Gordon, 'and I expect he'll mark all his offspring with that white star he has on his forehead. I think we'll give him a drench to prevent a chill; he's sweating a lot now.'

We drenched him, gave him a feed, and left him quiet.

After sprinting back across the farm to the car I was greeted by a pig's nose pressed to the inside of the rear window. 'If she once gets out of the car, I'm done,' I thought. 'My only hope is to get into the front seat and slip another sack over her without breaking up too much of the interior fittings.'

I cautiously wormed my way through the half-opened door and knelt on a front seat, facing the suspicious piglet, and slammed the door behind me. The pig, having eaten her way out of the sack to freedom, trampled her sister still in sackcloth, and investigated all that was movable with her nose, was ready to resist all attempts to re-bag her.

Why hadn't I let young Pembridge take the confounded pig home on his bicycle, or put a fine line on its leg and driven it, Irish fashion – anything rather than have the darned thing scrambling about in the back of my vintage (1930) Austin!

I scratched her behind the ear. She wedged her rear between the seat back and side and 'woofed' at me. A bit more ear-scratching with one hand, and working my sack into position with the other, a short and violent rodeo in the confined compartment, and her forehalf was in the bag. After that it was like pulling on a sack in the school sports, and eventually a length of string secured the top.

I opened a window to let out the steam; and was sorry for what, in my exasperation, I had called the pig.

How blessed is he, who leads a country life,
Unvex'd with anxious cares, and void of strife!

DRYDEN

The old *Dun Angus* nosed her way through the long Atlantic rollers. A stiff west wind made her dip and shudder and rise again in a manner most embarrassing to confirmed landspeople. But we counted ourselves fortunate to be aboard, with the prospect of a day on the largest of the three rocky Aran islands off the Galway coast.

'God save you now; 'tis lucky ye are,' we had been informed on the previous evening. 'The boat only goes twice a week, and she wint today. But isn't there a special party goin' tomorrow! Wait now, while I find the captain for ye.'

The boat had been chartered by 'the party', and when we reached the quay in the morning it was obvious that only a fraction of the assembled 'party' and their relations could ever hope to be accommodated on that small boat. It is typical of the hospitality of the Irish that the 'two English gintlemen who had cycled all the way from Sussex, bedad, to see Inishmore' should be welcomed to join the overflowing 'party' while many distant friends and relatives were left disconsolate on the quay, and that we should have to insist on the secretary's acceptance of our fare – one shilling and sixpence return and nothing for the bicycles.

The boat grounded a few tantalizing yards from the quayside. After much pounding of engines and hauling on ropes and shouting, we were able to scramble hastily ashore.

One heard only the soft Irish tongue: English is strange and unnatural to them.

The clothes worn by these Aran folk would give a Saville Row tailor a heart attack. The cloth, woven in the cottages, is home made into garments of utility, with little regard for shape or fit. But how well their ill-cut clothes and weatherbeaten features fitted into the fabric of the bare wind-blown island. Those coats and trousers, veritable family heirlooms, had been patched and re-patched until the originals had been totally obscured. A white-sleeved short coat over a blouse, ankle-length blue trousers, with a coloured woven girdle and a heavy black felt hat, constitute the general costume of the older men. Some of the youngsters have tam o' shanters and blue jerseys. The women wear the rich red voluminous skirt so common in Connemara, indigo stockings and coloured shawls.

Footwear favoured by the islanders is the native pampootie, a rawhide sandal, reminiscent of man's earliest efforts to cover and protect his feet. Pampooties are kept soft by soaking them in a bucket of water at night or walking into the sea whenever opportunity offers – hard and dry they are uncomfortable.

Wheeling our machines – which, by the way, attracted considerable attention – between groups of these picturesque people, we felt that the ancient spirit of Ireland

was concentrated here. Driven constantly westward by the impact of modern methods and life, the best of Irish tradition, speech (not that we understood that!), dress and customs have sought refuge here in these islands.

That these islands are composed of limestone rock was amply proved by a bicycle ride to Onaght, at the western extremity of Inishmore. There is only one narrow road and, unluckily for us, three jaunting cars packed with our erstwhile sickly, but now wildly exuberant, friends got away first from Kilronan. They progressed mostly at full gallop, and their course could be plainly traced from afar by a cloud of white dust that obliterated everything. When we emerged from the dust and overtook them, their drivers decided (quite wrongly) that we were challenging them to a race. To the accompaniment of howls and cheers we, fools that we were, strove to win.

May I never race again with an Irish jarvey on a narrow, untarred, limestone (or any other) road. I remembered Mr Punch's joke about the Irish cart driver, going full gallop down a terrible hill, assuring a terrified English passenger 'Bedad y'r honour, the mare will be all right af the near wheel doesn't come off – but sure, an' I believe it wull!'

When we finally staggered past the leading car, and the cheering died away behind us, we were white with dust from head to foot. And we felt that we had swallowed half of Inishmore. But worse was yet to come, for in our moment of triumph my wretched back tyre let out a hideous fizz-z-z! As we were investigating the trouble the cavalcade roared past, cheering and jubilant. We retired behind a wall, sadder and wiser, to repair the one and only puncture of the whole fortnight's tour.

There are thousands of miles of limestone walls dividing up this small island into little fields, giving the effect of a beautiful grey-and-green patchwork quilt. Successive generations of inhabitants have picked up these rocks from the fields; and many future generations will be able to do the same. There is rock everywhere. Only incessant labour has made it possible to cultivate any of the shallow soil to grow potatoes and rye.

95

It is natural that few trees grow on the island, but the people boast of the many varieties of wildflowers, and certainly the lichen-covered rocks, the heather-clad hillsides and the little carpeted fields are extremely beautiful.

At one place men were busy burning the dried seaweed and obtaining kelp, which is used in the manufacture of iodine. The weed is gathered in autumn and spring, put into stacks to dry in the wind and sun, and burned in pits on the shore during summer. Kelp, dried fish, pigs and sheep are taken to the Galway market or exchanged for turf to burn. There is no peat on the Arans, and the small vessels that bring over turf take back the exports.

Returned to Kilronan we were in time to witness the trussing of two pigs *en route* for Inishman by curragh. Having stepped into one of these coracle-like, round-bottomed boats, *sans* rudder, *sans* keel, and about as navigable (to me) as the tin bath in which I crossed the duck pond in my youth, I can well understand the care taken in trussing up a pig before putting to sea in its company. A false move or a stumbling step and the wretched boat rolls under one like an inflated bathing ball. The curragh is a survival from the dim ages of water transport – a very light wooden framework covered with canvas and treated with hot tar. It is simple, but very serviceable where landings and moorings are bad, because it can be lifted out of the water, turned upside down on the shoulders of three men, and easily carried to a safe place. Curraghs are parked, bottom up, in rows between low stone walls, and look like huge black beetles in little stalls. The oars used to propel these light craft are bladeless sticks working on a fixed single thole-pin – cumbersome in appearance, but marvels of power in the hands of an Aran man.

Later we were privileged to go into one of the little thatched whitewashed cottages. Simplicity is, of course, the keynote, with a love of colour evidenced by the brightly painted cupboard and old lustre ware. Highly coloured chromos depicting the Last Judgment or some similar subject speak of their faith.

During the day I had stopped to admire and sketch some old stone crosses built into a roadside wall – memorials of a former age – and had left a pair of valued binoculars on the wall. I returned half an hour later, but they were missing and I cursed my carelessness. Such glasses would be a prize indeed to an Aran man. We asked the priest what we ought to do. 'Never fear,' he said. 'They will be handed in.' They were. On our way to the quay in the evening a dozen folk told us that the glasses had been found, and the captain handed them to us as we boarded the boat.

Such are the folk of Aran – islands that boast no locks or keys. As we steamed eastward in the twilight towards the twinking lights of Galway town, and the islands fell astern floating in a golden haze, we vowed that someday, and soon, we would spend a week on Inishmore.

Island girl, Aran

Making a pampootie, the islanders' cowhide sandal

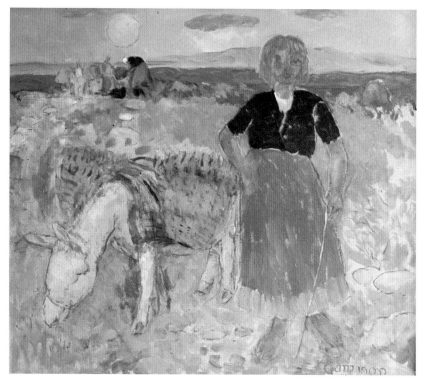

Young Irish girl

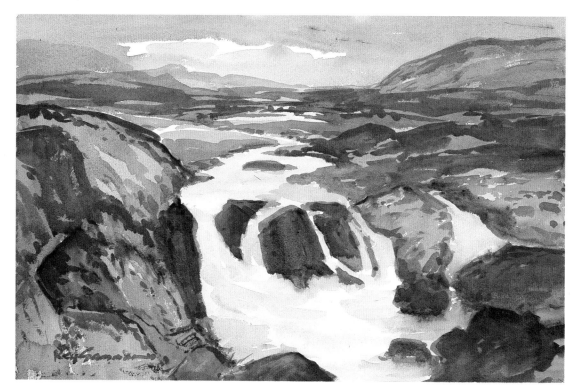

Waterfall on Tim Healy Pass, Kerry

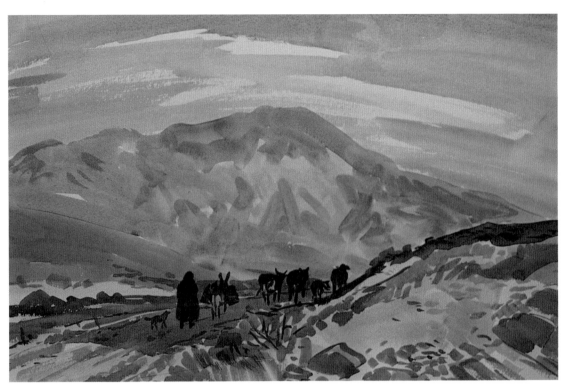

Near Leenaun, Connemara

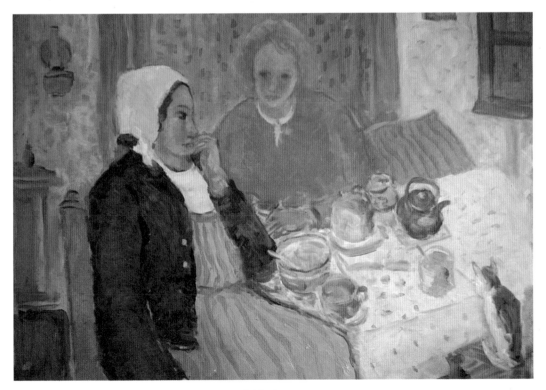

Irish sisters at tea

On the road to Kerry

Planting potatoes, Kerry

It is mid-September and Tom Powell the farmhand is leisurely 'drashing' a road-side hedge with a cascade of leaves falling around him. The long drought will make for an early leaf-fall. Pastures are brown and the ground is too hard for the autumn ploughing. Cattle crowd round the water-trough, when the old tank, not often used today, arrives to refill, and the strongest push in for the first drink.

Another neighbour has just been in to confirm what we all expected, that the prices at the autumn sheep sales are terribly depressed. The 'down' farms have no grass, and hesitate to add to stock already short of feed. Many of them are feeding the hay designed for winter use. In cottage, farmhouse and manor house the shortage of water is serious and many springs have dwindled and died away.

Through it all the water still flows freely from under the rocks close to our house, less in volume certainly, but in unending ample supply. So it has continued time out of mind, and in former days cleansed the dust and sweat from the garments of Father Ignatius and his followers. A huge slap-stone by the spring on which the monastery washing was rubbed and pounded was still there when we took over.

A spring is surely a greater wonder than all the moon-rockets – I never cease to marvel at the gift of pure water. A glass of water should stand before the altar at every harvest festival.

Now October has come to the hills, and during brief intervals of sunlight the dying bracken glows red and brown replacing the eternal green of summer.

Mist in the morning, white, wet and all-enveloping, holds mystery for the birds, and they remain silent, suspicious of the strange world darkened ere it became light. Only a green woodpecker gives a short outburst of his familiar yodel from the depths of the wood.

Down the lane nothing can be heard above the voice of the river running over the ford in a brown flood fed by many streams of white water pouring off the high ground. Every hour for weeks past the sound of running water has never ceased; one had been conscious of it even inside the house.

A blackbird, surprised at his picking under the hedge for breakfast, flies off and the noise of his scolding is magnified in the mist. The birds and animals move with caution these mornings. Our goats will not venture far from the buildings and seek human companionship and protection, alert always to any sound or movement on the hill. The hens are confined to their quarters in safety from foxes.

Personally, I find these mornings restful and we live in a world of our own – until we turn on the radio.

Much of the best honey, I believe, comes from the true heather or ling to be found on moors and commons everywhere. The flowers are tiny and vary in colour from pink to deep purple. The leaves also are very small, have no stalks, and grow close against the woody stems. It is these leaves and the whinberry that give the attractive red-brown colouring to the hills in winter.

The honey obtained from the heather or ling is so thick, almost a jelly, that it will not leave the cells except under pressure. The bee-keeper therefore cuts the comb from its frame, places it in a press (rather like the old ledger press), and forces the honey through a straining cloth into a container, whence it is strained again into jars. All the work that the bees put into forming the cells is thus destroyed, and new cells have to be formed each season. When the pressing job is on the whole house seems sticky, and feeling sometimes runs high with the lady of the house, but the sight of a golden stream of honey in the bottling-on process always calls an armistice.

The October gales usually outwit me and get going before I remember to place a heavy rock on each of my hives. The wind increases during the night, rain lashes against the window and I lie uneasy in my bed wondering if it will hurl the hives over the wall into the field.

It happened again last week and in the morning, with the brittle ash twigs snapping off and leaves whirling around, I secured each hive with a flat stone. Re-housing and pacifying several thousand bees who have been violently ejected from their home is not my idea of fun and games. And if it happens in October, when all self-respecting bees have sealed up all the draught holes in their hive and settled in for the winter, their tempers are even more touchy. The old practice of wintering straw skips in a 'bee-hole' in a wall had much to commend it but it is not possible with modern hives of course.

Now they are safe – unless the ash tree falls on them, and that nearly happened last year when a huge branch split off. Except for an occasional examination of the top covering for moisture they can remain undisturbed until the spring.

The wind may roar through the wood and crash among the bare branches; the dark sky may let loose a deluge that will fill the white fountains coursing over the rocks and into the foaming river below, but no sign of a bee will appear and the hive seem dead.

And then on a day of sun and warmth the city awakens and they come out for a brief flight like children enjoying the morning break. Then I know that my colonies are strong and healthy, only waiting the call of spring to resume the wonderful reproduction of their kind.

Behind the barn door was hanging a flail in perfect condition, the shining wood telling its own tale of frequent use for beating out the grain from sheaves laid on the barn floor. We had just fixed the small threshing drum and the portable engine to drive it, no threshing machine having ever operated in that barn before. All corn had been threshed out in the ancient manner with a flail – almost unbelievable – but our valley is like that. We still do much hand work, although mechanization is slowly creeping in via the war agricultural committees and government tractors.

There is a great satisfaction in working with your own hands to win the food you eat – to cut and haul the wood that warms your house, to bake your own bread and cure your own bacon. With work to do and the strength to do it, the old yeoman blood that lies dormant in many unsuspecting folk, even after generations of town dwelling, shows itself when their feet are firmly planted on the good earth again.

One of my farmer friends was very amused to discover the two Land Army girls loaned to him 'making up' with powder puff and mirrors behind the barn door before begining work on the threshing drum. That anyone should attempt to 'doll up' for such a job as threshing tickled him no end, as well it might, for it is about the hardest, filthiest seasonal occupation that falls to the farmer. The dust and rubbish that pollute the sweet country air in the immediate neighbourhood of the thresher have to be experienced to be believed.

'How did they work?' I asked.

'Marvellously!' he replied. 'I never thought two girls could have stuck work like it. They got us out of a tidy hole when I didn't know where to get any labour.'

I was pleased to hear him say it. Countryman and city girl had come to understand and appreciate one another more in those few days of labour on the threshing than they would have done in years of meeting on short annual holidays. We have heard a great deal in past days about townsfolk and countryfolk coming to a closer acquaintance, and I think it is pretty obvious that the conditions created by the war are speedily bringing about that much desired result. The evacuation of the mothers and youngsters began it. The demand for labour in country-sited camps and on farms broadened the scope and embraced a wide and diverse circle of workers. Quite often the charming lass, breeched and gumbooted, who skilfully handles the roaring Fordson, and ploughs a beautifully straight furrow through the stubbles, only saw the country from the saddle of her bicycle, or her boyfriend's tandem, for a few glorious hours at weekends or annual holiday. A farmer was to her often the funny old codger who had objected to the tandemists lighting their primus in the shelter of his newly erected cornrick.

The average farmer is (or was) always a bit suspicious when a well-meaning

townsman comes along and offers to help with haymaking or harvest. He doesn't like to see a fellow in his field holding a pike, to which are hanging a few straggling wisps of hay, high above his head and advancing towards the cart on which he himself is loading. A pike has a nasty way of sticking into a loader's hand or arm if it is given a second thrust upwards as he bends to lift the hay into place. I have been present on such an occasion, and, knowing both parties to the adventure, have poured oil on the troubled waters. It is often difficult for the townsman to understand that there can possibly be a right and wrong way of doing such a simple job as haymaking, or handling such a simple tool as a fork – or pike, so called in my country. The ease with which a farmhand lifts a huge pitch of hay, keeping it all on the fork, and depositing it at exactly the right place on the load is very deceptive. It is the result of long practice, and when it has been continued throughout the hours of a long summer day only trained muscles can stand up to the strain.

We have a weekly rendezvous with the grocer at a farm a mile down the valley, and this adds a few interesting items to our homely diet, besides affording an opportunity for a neighbourly exchange of news and gossip.

One evening as we left the house the mist lay in the valley like a creamy lake, leaving our homestead upon an island of rocks, and a lovely autumn evening sky was our reward for living high up on the mountain. Every sound was stilled, and except for the voice of the river below where it slid over the smooth stones of the ford and then splashed over the fall into the pool we moved in a world of silence. As we descended the mist wrapped around us, and the startled ewes, brought into the pasture to meet the eager rams, moved off at our approach.

The grocer's van was late in coming, and we waited in the warm farm kitchen. After an hour anxious customers from neighbouring farms had gathered.

'Alderton do never fail,' said one. 'The only time he's missed to come was on that snow last winter but one.'

'Something strange he doesn't turn up,' replied another. 'For sure something's hindered him.'

'I do hope he'll bring my sugar', said a third, 'for I'm clean gone out, and the threshin's tomorrow. I shall be fair ashamed if there's none for them.'

Faces brightened when the sound was heard of the loaded van crossing the bridge to pull up at the farm, and we stood round in the lantern light to receive our rations. As we walked back with loaded rucksacks our borrowed lantern made ghostly moving patterns on the grass, and a giant shadow on the mist repeated every movement of arms and legs in a grotesque fashion.

But the shadow gradually faded as we climbed the hillside, and when we passed through the yard gate the goats bickered a greeting. Flush had her nose to the door whining with pleasure, and the winking stars above laid a smile of welcome on the face of our home.

As I have mentioned before, the least popular of all the annual events on a farm is threshing. Seldom indeed does anyone on the farm look forward with pleasure to the arrival of the threshing drum. Harvest and threshing are just pure hard graft, and though harvest may be pleasant and enoyable when the weather is favourable threshing is anything but pleasant, be it wet or fine.

It is true that the combine harvester, which reaps and threshes out the grain in one operation, has eliminated the need for stacking and subsequent threshing, but such expensive machines are as yet the toys of the large farmers. We bought our threshing drum for two pounds plus a dead hen and an egg. A few repairs made it serviceable for ourselves and neighbours. All the 'small beer' farmers – and they are still the vast majority of Britain's farm folk – cut, stook and carry the corn either into a barn or to a stack in a field, where it awaits the arrival of the threshing gang. And for them it is not fun, but serious and hard work.

The dreadful weather which persisted throughout October turned the approaches to our farm into deep ruts. On the hard road surface the threshing drum was a lamb, but once we hitched the Fordson on, and started up across the plough track, the wretched thing became as unmanageable as a dead elephant. We 'gained' across one field (as local jargon has it), but halfway up the next, where the gradient increases, the small front wheels sank into the mud, and the Fordson used her power to dig in. We got a chain, set the tractor on firm ground, and tried to tow it from a distance. Again the tractor dug into the soft earth. For an hour we tried various dodges, helped at frequent intervals by heavy rainstorms, until, frayed in temper and plastered with mud, we towed the swaying drum back to the main road.

Our only hope was another approach over a neighbour's field, where no plough had turned the tough old sward for many years. Here our luck held, and we finally

arrived at the home barn covered in mud and glory, to set up ready for threshing the stored grain.

It is the custom here for neighbouring farmers to help each other on occasions that call for extra labour such as shearing, dipping, and threshing. In the same way we occasionally lend or borrow implements that have only a short seasonal use. In the case of ourselves and two neighbours we have joint ownership in a fertilizer drill, an expensive implement for a small farm in comparison with the amount of use to which it is put in a year, but one which turns a laborious and filthy job into something approaching a pleasure.

We are a community of small farmers. High labour costs are uneconomic, and normally we carry on the work of our farms as father and son (or sons) without paid labour, and so, when it is imperative to have extra hands, as at threshing, we exchange labour for labour. And where we gather to the job, whatever it is, the farm wife prepares food for all – if I really wanted to offend a neighbour it would be enough to go to help him, take my own food along, and not sit at his table.

Milking was hurried through in the morning, and all hands arrived in good time. The usual engine having failed at the previous farm, our neighbour Trevor Rees brought his tractor, fitted with a pulley to make sure we were not let down. After some preliminary oiling and the putting on of various driving belts on the drum the engine set the fans in motion and the familiar hum spread over the farm. The moment she started up everyone was galvanized into action. Sheaves began to fall on to the drum top, where I stood to cut the string bonds. The owner bent forward and the first sheaf went with a zip into the interior of the machine.

After that there was no let up in the work. With devastating regularity Margaret, Gordon's wife, dropped sheaves about me, which I seized, cut open, and placed for the 'feeder' to put through the quivering machine.

Three helpers at the back were tying all the straw. One seized a great armful as it left the machine, handed it to a tyer, who encircled it with a straw bond, knelt on it to pull it into a tight 'bolting' of straw, and finally pitched it into the bay of the barn to be stacked for future use. This is about the most unpleasant job, because of the dust that is constantly blown out of the rear of the machine, and soon the workers here are black and sweating. From my position on the drum top I could see them laughing and joking with each other as they worked to keep the straw cleared away, although I could hear nothing of their conversation – a rotten job done with a will.

On and on the thing goes, demanding more and more corn, purring when full-fed but rising to angry tones when empty for a moment. The mound of sheaves grows smaller while Griffiths, building in the straw boltings, rises higher and higher. At the front of the drum the sacks of oats multiply.

There was no more welcome sound than the voice that called us in to dinner. Welsh lamb and mashed potatoes, apple tart and rice pudding, and coffee disappeared as if carried away by conveyor belt. A cigarette round, and we went to it again.

By mid-afternoon the oats were completed, and after a brief stop to change the riddles in the machine and drink a cup of tea we resumed, with the heavy heads of the wheat sucking down into the drum like hail on a tin roof. An hour before nightfall we saw that – barring accidents – the job would be completed. Everyone

was tired, but the will to finish won.

In the failing light we closed the barn doors and made for the spring to wash away the sweat and dust. The evening meal was eaten more at ease, and talk was mostly of farms and farming – the failure of the barley this year, the best type of oats to grow and the best district to send to for the seed. Occasionally a tale of past years cropped up – of comedy or tragedy – and the company became hilarious or sympathetic as the tale demanded.

As they departed in the moonlight of a perfect October night, I felt that a year's work had been rounded off. The miller would grind our grain for feeding to the cows, and throughout the winter months, when milk is needed so badly, the milker would see in his pail the result of the ploughing, sowing and reaping of the past months. And so it goes on – a fascinating story without end.

'SALE THIS DAY' reads the notice on the farm gate. We turn in off the highway, down a lane that becomes increasingly waterlogged as we proceed. The string of cars and trailers in front comes to a halt, and someone shouts that it is worse ahead, so we remove our trailer, back our ancient Austin to a convenient spot where we may leave the road without being bogged, and finish the journey on foot.

For this day we have been presented with the freedom of the farm, and it is only necessary to appear determined to purchase the best dairy cow in the sale to be accepted by the local farmers on terms of complete equality. If, however, such is really your intention, as it is our hope today, it is more prudent to conceal that intention behind the smokescreen of a very casual interest.

Lot 1 is usually a collection of old iron. During these war years this heap has assumed an importance altogether unknown before. Sometimes it is sold and the money given to the Red Cross, or the iron to the local salvage-collector. It is chiefly remarkable for the useful bolts, pulley wheels, and oddly shaped but handy bits of iron to be found buried under old tins, broken plough parts and, quite often, old cycle frames. (I have seen some real antiques with up-sloping top tubes and wide gas-pipe handlebars.)

Today's lot is no exception and contains a good pulley for our pulper. 'Old Harris is here from Pontypool,' says Gordon. 'He'll buy it and we can get the pulley from him.'

We wander round the implements parked out in a field, squelching with recent heavy rains, and see many things we could do with.

'Look: a "tushing" chain. That wouldn't be dear at ten bob.'

'What about this root drill? We've got one on order, but this might go cheap.'

'Now there's a thing we do want – a horse-rake. It's a bit antique, but after all it's only used once a year.'

Gordon fiddles with it, and some of the long curved 'teeth' wobble about. Bits of wire support various parts, and the shafts are obviously about to part company with the frame. He turns his back upon it with a snort.

'I say, what about this old mower for cutting bracken and kale?'

'That's a fine tractor trailer we could do –'

'No good to us. Too wide. Besides we don't want one!'

'Look here, we want a cow; let's go and have a look at the stock.'

We make our way across to the yard. The freshly calved cows are tied up in the buildings so that they may be more easily inspected and brought to the sale ring. The 'springing' heifers and cows (those close to calving) are out in the yard, which has been strawed but, owing to torrential October rain, is now under water.

A fierce rainstorm sweeps across as we reach the shelter of the buildings. For a space of twenty minutes everything is blotted out by falling water and the yard is turned into a lake. Even the animals accustomed to lying out all the year – this is a 'bail-milked' herd – become restless and try to find shelter.

Inside the cowpens is bedlam created by several day-old calves bawling to be allowed to breakfast. Their over-full, uncomfortable mothers stand restless and ill

at ease, calling to their offspring and voicing their views of the cowman's daft treatment that morning in leaving them so long unmilked.

From the teats of some of the heavier milkers the precious milk is flowing and finding its way into the gutter. This is one of the penalties of sale day: no one would dream of milking his cows out on the sale morning, for then the prospective buyers would be unable to 'try' a fancied animal, to see if she were a hard or easy milker, and whether she were clean or suffering from mastitis.

We inspect all the fresh calvers, drawing a little milk from each to make sure that all quarters are sound and easy to milk out. We feel the 'milk vein' under the animal's belly leading to her udder: in a good milker it should be of generous size.

If her age or number of calvings is not stated on the catalogue, we examine her horns for 'rings', and, grasping her nostrils, examine her teeth – worn-out teeth indicate age and, of course, cannot chew food to produce milk.

On our catalogues we note down a fancied cow whose back is straight and udder well shaped and not pendulous, and whose body-line is rather wedge shaped, with the deep part behind tapering to a fine dainty head.

The herd is not recorded, so we cannot refer to her previous milk yield – a definite drawback from our point of view.

After a scrimmage to reach the 'caterer in attendance' we secure a cup of tea to round off our sandwiches and await the auctioneer's arrival from the sale of the implements and sheep.

'Well, gentlemen, now we come to the cows. As you know, they have all been bred on the farm and are out-lying all the year. A fine healthy lot, all right and straight unless I tell you . . . Here comes number one. Now what may I say for her?'

We have all crowded into the barn because of the incessant rain. The auctioneer, Mr Rennie, is standing with his clerk on a bale of straw. The animals are brought in, and everyone pushes to get a look.

'Make a bigger ring, gentlemen. I must see what I am selling!'

Several farmers carry in bales of straw and erect a stand for themselves in the rear. The rest of us elbow our way into the centre and wait for our fancy to come in.

The first animal, which we thought nothing of, is knocked down for over forty pounds. We look at each other in dumb surprise. If that is what they are prepared to pay for an old screw our choice will soar away to realms fantastic.

'This is the first one.' Gordon digs me in the ribs and grins.

'Now, gentlemen, here's a lovely animal, a dairy in herself. Start me at sixty pounds for this one. All right, then, fifty pounds. Fifty-two . . four . . six . . eight. Sixty pounds – where she should have started.'

In silence we look at each other. When we turn again the bidding stands at seventy-nine pounds.

Mr Rennie:

'Now Mr Price – another one for you?'

'No!'

'What d'you mean no?' turning to his son taking notes at his side.

'If I'd taken no for an answer, I should never have had him.

Now, fill it up, sir! No? At seventy-nine pounds, then. Once . . twice . . and she's gone – given away at seventy-nine pounds!'

One after another they came into the closely packed barn, but somehow or other we felt that their record didn't warrant such high prices. And when the 'near-to-calving cows' came in, and no one seemed to know exactly when they would calve, as they had been running free with the bulls, we decided, in common with several neighbours, that it was too risky to bid on such slender records.

In pouring rain we walked back over the flooded lane to our car, extricated ourselves from the mire, and turned for home. At Abergavenny the storm cleared and the October landscape was flooded with sunlight.

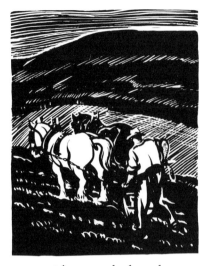

An aching back and 'feet of clay': these are the signs of late autumn, when we bend over the seemingly unending rows of potatoes we planted so gaily in the spring. Who would have dreamed of such an increase? Twenty tubers where only one had been set! Now the task before us is to pick and store them. Not only have we feet of clay but hands of clay, for when the 'bouter' has passed up the row and thrown the potatoes out on either side we pick out those that are exposed, and then dive our hands into the loose soil to make sure that none is covered and lost.

Bobby, the little white mare, was in a wicked mood when we started, and matters were not improved when she was coupled to Tom, whose long and varied career with many masters, including a gypsy, has made him a quiet and willing worker in his old age. She pranced along, with arched neck and flashing eye, always half a length ahead of Tom, planting her feet anywhere but in between the rows, and tugging the 'bouter' from side to side, so that our progress was snake like. This left many roots to be dug up with a fork, a much slower process than with the 'bouter'. So Bobby had to be led until the hard pulling necessary to draw this double plough through the earth had taken the fire from her eye and the spring from her limbs, and she had settled down to pull a steady trace with her partner.

Potato picking by the acre is not one of the farm jobs that arouse one's back-to-the-land enthusiasm to fever pitch. On the contrary one's enthusiasm wanes with the dying of the haulm, and finally expires as the tubers lie cream, brown and red behind the plough. The final sorting is no better, when one's fingers sink into a squishy one that has gone rotten and smells abominably. But the picking, sorting and gathering of the tubers into 'tumps' covered with straw and earth to keep out the winter frosts comes to an end at last, and there are many compensations. The winter supply is then safely gathered near at hand for use when the hard frost binds the earth; when the animals have to be stall fed and the pig kept in luxury for the last few weeks of his short, overfed life before he lies upon the salting-stone in the dairy and then hangs from the kitchen beams to dry into bacon.

The work is tedious and hard, but after a day of backbreaking toil gathering in the spuds a steaming dish of them, all floury and white, appears on the supper-table with a little pat of real butter to put on each, home-made cheese and home-made bread, and some milk to complete the feast. Then the toil of the day is seen in its true perspective. The little devil that has been digging a hole in your back with a red-hot fork seems to abandon his task and you realize once again that country life and work provide the happiest and most satisfying existence you can ever hope

to find. Does not the townsman born and bred strive to escape into the country at every opportunity?

October is a month of ingathering for us: a harvest festival month that sets the seal on the year's work and helps us to look forward to the winter days in which we can take things a shade less strenuously than in summer when every waking hour seems filled with labour. One by one our small crops have been harvested: shallots and onions bunched and dried in the sun, carrots lifted and stored in sandy soil, plums and currants bottled. We have no apple crop here as we had from our Sussex orchard, but we have obtained an indirect harvest of this useful fruit. One of our chief natural sources of food supply this year has been vast quantities of hazelnuts. Earlier in the year the beauty and abundance of the catkins and hazel flowers bespoke a bumper season for the nuts, and such it has proved to be.

Now that the nuts have ripened there is a ready sale for them in the market, together with all the surplus from our garden, and we return with apples for the winter store. We have the satisfaction of knowing that the townsfolk in the districts where iron, steel and coal rule men's lives will benefit from what we, in our small way, have produced and gathered.

Possibly the highest light of our harvesting and marketing is reached when we take our honey, ducks and chickens (with herbs to flavour them) into the Christmas market. The former has been hardly won by bees and beekeeper this cold, wet summer and autumn. The latter have been nurtured and protected by my wife from the prowling and predatory foxes.

Quite a small contribution to the nation's food supply: in the pre-war days of plenty the amount would have seemed ludicrous. But today we derive satisfaction from the knowledge that the little is counted worthy of notice and that our pioneering efforts of changing traditional and ancient methods to suit wartime conditions and demands have not been in vain. We shall try to do still better next year.

Harvest thanksgiving... and our church is filled to capacity. No other church festival equals harvest for uniting our scattered community, and every farm is represented. Differences are set aside and we join to sing the old hymns surrounded by a garden of flowers and produce that almost crowd the vicar out of his pulpit.

There are those who seldom enter church and they stumble up the unaccustomed stairway to occupy a penitent seat on the gallery form; even the stairs are seating room.

The oil lamps, augmented by two pressure lamps, shine down on flowers tied to rails, suspended from brackets and overspilling from the ancient font. What matter if we recognize those huge dahlias, polished potatoes and gigantic cabbages and turnips from the chapel festival last week. What more fitting than to hand across the shallow stream that separates church from chapel the emblems of our thanksgiving. The congregations are almost identical.

When the fearsome bumping and thumping of the beam ceases and the single bell falls silent we 'raise the song of harvest home' until the oak rafters reverberate; and the good vicar reminds us of fundamental truths so easily forgotten... so much comes out of tins!

In the summer of 1843, Hawker of Morwenstow invited his flock to receive the sacrament on the following Sunday 'in the bread of the new corn'. This was the beginning of harvest thanksgivings.

In his youth Tom Lewis must have been tall and strong. He was nearing seventy when I first knew him and walked with the steady, unhurried gait of a hillman, leaning forward and carrying his arms and hands free after the manner of most countrymen.

All his life he had lived with sheep, and always the strength of his arms and the power of his hands had wrested a living from the bare hills. To see him assist a ewe struggling to deliver a lamb was proof that strength and gentleness were wedded in his hands.

Tom Lewis boasted no mechanical implements on his farm. Fields were too steep and small for a tractor, and the narrow cobbled 'fold' led through a three-foot gate direct on to the Black Mountain, rearing steeply behind the house. Tom's only vehicle, a typical Welsh wheel-car, could be manhandled and turned in any space; moreover, being half sledge, it was very stable on side-land ground (mountainsides) even with a load of hay or bracken – and it could be pulled by his short-legged Welsh mare.

A scythe, a spade and a heavy iron bar, a 'hacker' (or hand bill), a stout pair of gloves of soft leather to protect against the steel-tough thorns, a holly hedge 'bittle' cut complete with a handle for driving stakes, a heavy felling axe and a hammer – these were almost the only tools he (or his forebears) possessed or, indeed, wished for. They had remained unchanged for generations.

Most important was his axe. Like the hacker, its edge was so keen that with it one could shave the hairs from one's arm.

With the help of a light horse-plough and a set of spike harrows, Tom worked his acre of arable land and grew oats and potatoes. He was well known for the quality of the white-faced Herefords, which he walked over the Gospel Pass to Hay market for the autumn sales. These, together with some lambs and draught ewes and his wool clip, constituted his entire income. Small wonder then that hours would be spent bargaining to obtain a few shillings more on each animal.

Tom was quiet and reserved, and it was some years before I became familiar enough with him to be asked into the house: we usually met 'on the fold'.

The house was entered from his barn and had no outside door; the single downstairs room was stepped into the hillside, so that much of it was below ground, and the single, tiny window was almost at ground level. In summer one looked out on to a coloured carpet of short-stalked herbage and flowers – milkwort, bedstraw, clover, tormentil, pyramidal orchids, thyme and red-rattle, all at eye level. In winter snow frequently buried window and house in drifts.

A massive open grate and chimney, with a wood-burning baking oven, backed on to the barn, while the rear wall was occupied by a large Welsh dresser. On this were a wide variety of family crocks collected over the years, articles of use and beauty. Underneath were a number of pewter platters relegated to a minor position, when, I suspect, one evening years ago Mother came riding home from Hay, seated behind Tom's father on the cob and carrying in her large butter basket their first china plates.

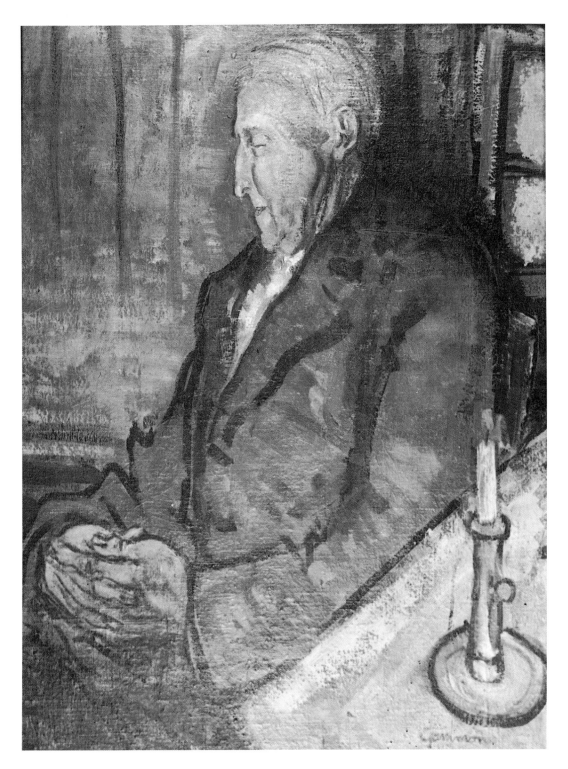

This living room had ash beams roughly axed into shape, with natural saplings cut from a hedgerow tacked across them and whitewashed, forming shallow shelves between the beams, which contained a multitude of useful odds and ends.

Here Tom and his brother lived for years doing everything for themselves, for Tom had never married.

One winter's evening – near Christmas a few years ago – I went to make some drawings of Tom in preparation for the portrait reproduced here. A previous visit at night seemed to indicate that the only light I could expect came from a huge log fire and a candle in an ancient adjustable brass candlestick; so I took my Tilley lantern and hung it from the beams, not without some misgivings, because of its heat near the saplings.

Tom had a wonderful head, unlike any I had ever drawn before, and as I worked I envied the serene peace and quiet maturity of his countenance. This was, of course, an entirely new experience for him, but he co-operated perfectly, sitting relaxed and unselfconscious by the fire.

In the studio next day I set out my canvas to save time and returned in the evening with colours and easel to complete the painting.

His brother met me before I reached the house . . . Tom was ill and had taken to his bed.

To my great sorrow I never saw Tom again. That Christmas as bells were ringing he went quietly 'across the river', without fuss or bother – went, as he had always lived, a perfect gentleman.

On Remembrance Day we walked up into the hills where the silence was broken only by the voice of water tumbling over rocks. Here was no sound of military bands or marching feet: no sound even of Isaac Watt's stately paraphrase of psalm ninety that was being sung in Whitehall and round war memorials on countless village greens that morning.

We had much to remember from 1914 on; but still more to be grateful for, and not least for the companionship of the son that walked with us. We sat in the heather and two white ponies lifted their heads to gaze at us.

A crow flapped into a wind-blown mountain ash on the hillside and broke the silence with its hoarse voice; a pair of ravens flew high overhead holding a conversation as they went intent on some objective unknown to us. A cock grouse spoke from the heather slope above.

We saw no other person in three hours walking, and although our Remembrance morning was unspectacular, it was none the less sincere and memorable.

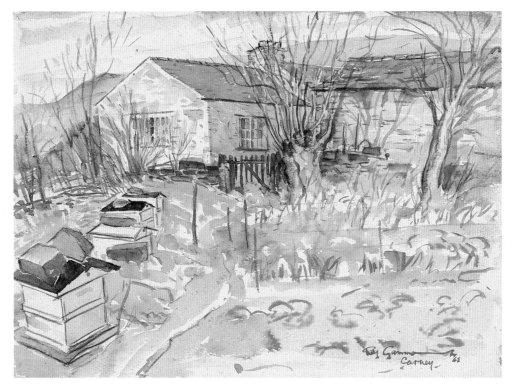

Carney and beehives

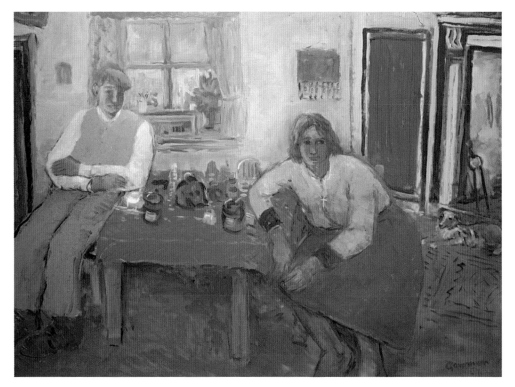

A young shepherd and his wife

Our sheepdog Tess

Our goats at Carney

Relaxed farm worker

Mrs Saunders dressing ducks

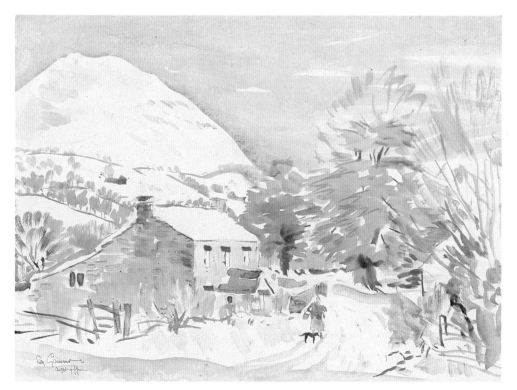

Chapel Farm in snow

Sorrow and dismay spread among the hill farms last week. A young farmer took his gun from the rack and went out to go round his sheep and cattle and to 'look for a rabbit'. He did not return and two went to seek him.

Late at night, in wind and rain, they found him lying across his gun dead. On a rough place he had presumably slipped, and the gun had twisted in his hand and gone off.

'All his delight was to be with the sheep and cattle on the hill,' one said to me. 'He knew everybody's sheep and was shepherding for two other people on the hill all the while. They left everything to him and don't hardly know their own animals.'

'If there was a pony missing he would know where it was. The Black Mountain hasn't missed him yet', she continued, 'but come gatherin' and shearing he'll be missed!'

It was fitting that they buried him by the tiny chapel at Pen-y-Rheol, on the hills he had tramped in storm and calm, using his skill as a hillman as much for others as for himself. A vast crowd gathered from far and wide to pay their last respects.

I remember a poignant poem of the '14 war, 'Lost in France':

> *He had the plowman's strength*
> *In the grasp of his hand.*
> *He could see a crow*
> *Three miles away,*
> *and the trout beneath the stone.*
> *He could hear the green oats growing,*
> *And the sou'-west making rain;*
> *And the wheel upon the hill*
> *When it left the level road.*
> *He cou'd make a gate, and dig a pit,*
> *And plow as straight as stone can fall.*
> *And he is dead.*
>
> SIEGFRIED SASSOON

As I write, almost the whole country is snow-bound; roads are blocked and wires down; pipes are frozen and emergency fuel is being distributed; train services are delayed, buses cancelled, and electricity supplies cut off.

That is the measure of disturbance to town and city life caused by a heavy snowfall. In the country, problems are different, particularly in hill country. We have no pipes to freeze: our spring gushes out from beneath a huge rock, and on bitterly cold mornings the water feels quite warm to the hand, the temperature being appreciably higher that that of the atmosphere.

Trains and buses and telephones do not unduly trouble us – though admittedly the homeward bus last market-day did deposit our valley passengers some ten miles away from their farms, with no alternative but to walk that distance over snow-covered roads carrying their laden baskets.

Experience has taught us to be prepared with fuel for heating, but in any case we can take the axe and cut down a tree or find limbs torn off by the gales.

Snow-blocked roads affect a small number of us who produce milk and have to take it to the collecting lorry. We bolted two Anderson shelters together for a sledge and transported two days' milk three miles down to Llanthony to meet the collecting lorry. For the rest, an unshod horse can find a footing where shoes would cause the snow to ball up under its feet.

All these things we can take in our stride. Our chief anxiety is for the animals, especially the sheep, who are never taken into shelter unless ill.

'You can think yourself lucky not to be a ship farmer, my man,' Watkins said to me one day this week. He has over a thousand sheep on the ground here – some out on the mountain, and the ewes on the lower ground where they can be watched. But, wherever they are, every blade of grass is covered with ten or twelve inches of snow, and in the hollows and dingles there are drifts of anything up to five feet.

Nevertheless, the sheep seek out the little tufts of grass under overhanging rocks; on the hill they eat the gorse, and by the river they strip the bark from the ash trees and greedily cluster around when holly boughs are cut and thrown to them. Some find places where the snow is thin, and scrape it away with their feet until they can nibble at the scanty grass.

If the sheep can be kept moving, searching along the hillside, they will usually survive a bad spell without undue casualties, but when they bunch together under a wall or in a hollow, and become drifted over, their fate may be very different. Then they can only be saved by searching with the sheepdogs and digging in likely places.

It is suprising how long sheep will survive in a snowdrift. My neighbour has saved them after they had been buried for a month, and I have been told of sheep that were alive after seven weeks. Huddled together, they gradually eat the wool from one another, and are often released in a naked state.

Three years ago, when we had a long spell of frost with a heavy fall of snow that cut us off from outside communication, I walked to the ridge of the mountains west of my house. In all the great expanse of mountain everything was snow and

ice. Even the verges of the fast-flowing little streams were frozen, and not a blade of grass was free of its sheath of ice. In the midst of that wilderness were two mountain ponies, so starved that they allowed me to walk up to them, whereas normally they would have galloped away at once.

Of course, they belonged to some farmer who, by law, should have taken them off the mountain by a certain date, but whether they missed the round-up or were deliberately left to fend for themselves they were too weak to be taken down. I have no doubt that the ravens found them later and existed many days on their frozen bodies.

When my neighbour said I was lucky not to be sheep farming he had seen my cows housed in their new cow-pen, dry and warm, with an ample ration of balanced food and sweet hay to eat. He could not help contrasting their lot with the scanty fare on which his own sheep had to exist. But our objectives are different. He keeps many ewes to bring lambs in the spring, and wethers on the hill to grade out for food. I want cows so well kept that they maintain their supply of milk higher in winter – when it is most needed – than in summer.

He crams as many head of sheep on his land as possible, trusting to luck to see him through the winter with his sheep still on the hill. If the winter is bad he stands to lose some sheep; if it is mild and open, his ground in spring is dotted with little new-born lambs. I have to consider carefully how many cows my land and accumulated stores will feed through the winter – and feed well enough to keep up the milk.

In both cases a continuous spell of frost and heavy snowfall keeps us well occupied during every hour of daylight, attending to our stock, whether we walk the hill in deep snow and biting wind or feed and milk the cows in dry and comfortable housing.

Extraordinary energy is displayed by some of the smaller animals collecting and storing wild fruits in autumn. Some enter ricks and barns to 'cash in' on the produce of humans; but most make small caches of nuts or haws or seeds. It is fairly certain that some such stores are subsequently forgotten and remain to sprout and grow.

A pair of wellington boots left in an old car were found to be full of nuts. The nuts were emptied into a basket, which was placed on the bonnet while holes in the car bodywork were being filled in. Two days later the mice had refilled the boot. The hazelnuts were taken right away, the boot legs thrust one into the other and in a few weeks they were again full of sound nuts.

During eight weeks of the severe 1946–7 winter my car was drifted over by snow in a gateway half a mile from home. Inside I had two bags of cattle cake cubes which I had to transport home piecemeal in a rucksack as conditions permitted. By the time I had carried one hundredweight I realized that someone had taken some from the second bag because the top was loose. Hidden from view a hole had been torn in the sack and cubes extracted.

I found them distributed all over the car; under each seat and in the door pockets. I lifted the bonnet and neat rows were arranged along the chassis and between the plugs on the engine; anywhere that afforded a shelf held a cube. It took me a long time to collect all my precious concentrated food.

I still wonder what instinct compelled the mouse (or mice) to move all those cubes to imagined safety from what must have seemed to the tiny creature an unexpected and staggering luxury.

In the half-light of a December morning a row of dead geese and ducks were hanging heads down from a clothes line behind the farmhouse. They swayed to and fro in the cold wind, with wings splayed open and necks stiff: the trampled snow beneath was spattered with their blood. The sanguinary operation had been performed by the 'boss' at first light and the birds were hung to 'drain'. This was 'feathering day' on a Monmouthshire hill farm, a week before Christmas and with food still rationed. These birds had survived the onslaught of the wily hill foxes and had come to their appointed end.

They were carried into the 'cot', where a large fire had been kindled, and thereafter the feathers began literally to fly. Seated on opposite sides of a large bath, in which they placed several geese to keep warm, mother and daughter stripped the birds with precision and speed. With brief pauses for food and tea, the work continued into the small hours of the following morning. Relays of poultry were carried in, plucked and stubbed and turned over to the women in the house to be dressed. Everything was festooned with downy feathers.

Relatives from over the mountain had arrived at an early hour to assist in this annual 'feathering' festival and everyone took intense pride in the whole operation. Dressed birds were firmly skewered into the correct shape with white peeled sticks cut from the hedge, garnished with selected colourful portions of their interiors and decorated with sprigs of parsley and thyme. The boss had spent hours preparing skewers, and woe betide him if they were too thin and broke in use.

By evening the dairy shelves were stacked with pink and cream and yellowish bodies cooling off and setting firm. I was ushered into the sanctum to share in the housewife's pleasure and pride at such a harvest. But my part in this adventure came next day, when poultry was taken to the Christmas market at Abergavenny.

My car and trailer replaced the antique high-wheeled trap and allowed a much later start than was usual. However, habit is strong and, in spite of my feeble protests, a five am start was insisted upon. We drove down the valley in wind and rain with war-dimmed headlamps, pushed another passenger into the car and crammed a huge bath, full of pink carcasses, into the trailer at Penywrylod.

In Abergavenny chaos reigned outside the covered market, horses and traps, cars, vans and trailers all inextricably jammed together as close to the market entrance as possible. People carrying huge baskets hurried in, slipping on wet stones and stumbling through a sea of paper and horticultural refuse. We grabbed baths and baskets, fought our way into midstream and the flood carried us inside.

Half blinded by the sudden brilliance of undimmed lights and with a large bunch of holly penetrating my rear parts to goad me on, I staggered after my hostess, who was parting the crowd by the sheer force of her impact and a tin bath held well in front. Reaching the far corner of the large building, she triumphantly deposited her prizes before a portly dealer, who was already surrounded by a veritable mountain of pink flesh.

'There now', she began, 'aren't they *beautiful* birds, Mr ... ah ... ? (She forgot his name in her agitation.) I've never 'ad better.'

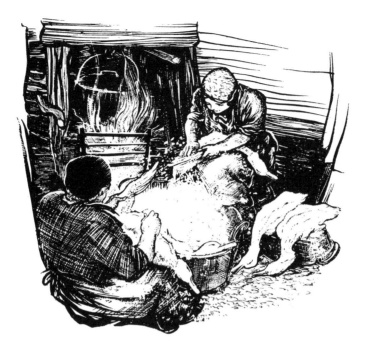

But he was too shrewd to be drawn like that.

'Morning, Mrs Saunders. I've got a lot o' stuff already, but I expect I can just manage yours. How many have you got?'

She avoided direct answer.

'What will you be giving . . . ?' He bent towards her and there followed a conversation in urgent whispers punctuated by surprised 'Oh's!' and understanding 'Ah's!' and 'I see.' Finally I heard:

'Ah well, I s'pose I must let them go at that – but I thought to make more, indeed I did!' He chuckled and seized hold of the precious birds to pile them on the scales.

The weight determined, my hostess referred to a much-thumbed twopenny ready-reckoner.

'Let me see, that will be . . .' Her voice dropped to a whisper. He had already cast up mentally, correct to the last penny, and nodded his head in reply. He pulled a bulging case from his pocket, and in greatest secrecy the notes changed hands.

With a final look at the birds, which now topped the growing pile and had shed some of their glory and decorations, we turned to leave.

'Now I'm bound to have a cup o' tea, Mr Gammon. You come along of me.'

In a street facing the cattle market we went through a low doorway and entered a private house. I had seldom seen anything less like a café. A narrow, dimly lit passage had several small rooms leading off, each crammed with steaming humanity, drinking tea and eating. Passing a tiny hatch, from which this widow's cruse of tea seemed to pour, we came to another den in the very bowels of the house and squeezed ourselves into two chairs.

The lengthy wait for tea was amply compensated by the flow of conversation.

Everyone knew everyone – I was the only stranger (not a little embarrassed, incidentally) and my part in the general scheme was glowingly exaggerated. I was interested to know the price her birds made after so much effort, but the nearest I got was an impression that, in spite of her final shot at the dealer, they had made more than expected.

Stories of former Christmas markets were exchanged over the teacups. It was not unusual, they said, to set out at three am by pony and trap, or on horseback, with loaded panniers. A walk of ten miles carrying a large, heavy basket was as little to them as fifty miles by car is to us now. The all-important thing, I learned, was to be there waiting whenever the market began, because a huge crowd gathered and rushed the doors as they were opened. The strongest member of each household literally fought his way in, spread a white cloth on the nearest bench and dumped a trussed bird in the centre of it, thus staking a claim. The remainder of the produce for sale was then brought in and the rest of the day was spent bargaining and haggling to obtain the final ha'penny a pound. But things were better now, they agreed. Dealers were ready to take up everything, poultry, eggs and butter, holly, silver-painted twigs from the hedgerow and multi-coloured honesty seeds. Honey was worth its weight in gold. Baths and baskets and boxes were empty.

We finished our tea, regained the rain-soaked street and after a round of shopping we set off home, with my car loaded to its limit.

I realized afterwards that to the Saunders and other farming families like them Christmas was bound up in this one event – the tremendous effort and labour of preparing and selling poultry. It is a tradition that has come down through the years. I have been to many Christmas markets since then, have stood with my own honey to sell, and one year I saw women in tears at the end of a long fruitless day when no one wanted to buy their birds at any price – meat rationing had ended.

A good market or a bad one – this is *their* Christmas day; when it is over, Christmas for them has ended. But they have contributed their share to both the farm income and the Christmas spirit.

Boars' heads and peacocks, swans and herons, were highly esteemed when Christmas in 'Merrie England' was really a season of feasting and merriment in manor and farmhouse.

A bishop of London once placed 1,700 herons before his guests. And when Margaret, daughter of Henry III, married a Scot at York, the archbishop fed more than a thousand knights and varlets (from Henry's retinue) on 600 fat oxen.

I wonder what cooks today would say to skinning and roasting a peacock, carefully replacing the skin and feathers and gilding the beak for serving up? I suppose they worked it off with bouts of jousting and plenty of rough play – they must have needed some corrective, judging by the records of Pepys and other diarists.

In wartime every farmhouse was allowed to fatten and kill one pig a year; the larger families were given permits for two. This was balanced by the surrender of all bacon coupons, but you will readily understand that this was an exchange you did not object to if you ever sat down, hungry from a ride, to home-cured ham and eggs as opposed to the commoner rashers cured for quick sale and consumption.

Our meat is salted and dried so that it will keep for a year or longer. There are naturally some parts of the pig that cannot be turned into ham or bacon, and those are shared round to various neighbours, who return the gift in kind when killing their own pigs.

Throughout the winter, while the season for killing and salting lasts, there is a constant flow of fresh pork, each farm arranging to kill at a different time. Several pigs are then 'benched' at each farm. Added to this, a fat ewe or lamb is shared, and I have heard that when occasion demands it a beast is killed. This however is probably infrequent and may be occasioned by lack of winter fodder, a frequent trouble in a mountain valley.

As I have mentioned before, it is the custom to give and return free labour when washing, shearing, dipping, threshing and other seasonal jobs are being carried out; and every free labourer is 'on the house' for meals, and sometimes for sleeping quarters. The amount of food consumed on these communal operations is just staggering. The work is hard and long – overtime and extra pay don't come into the picture with communal labour – and the worker is worthy of good feeding.

I have myself faced and defeated a huge pile of bacon and liver and a mountain of potatoes and greens, followed by enough rolypoly jam pudding to sink a battleship. But, believe me, such a meal is not ill placed after a morning spent in catching for six or eight accomplished shearers. A Welsh wether takes some catching, even in the bay of a barn, and catching is only half the tale – holding the brute and handing him over the rack to the shearer is a certain cure for a dyspeptic appetite.

A few days before Christmas a flock of field-
fares came flying over the house and settled
among the trees along the hillside. Snow-
birds, the local folk called them – a warning
of hard weather to come.

Two nights after snow came settling on
ground dry and hard; a heavy fall banked
into deep drifts by a hustling wind. We
awoke to the uncanny silence that deep snow
brings to the countryside, and with one bed-
room window obscured by a drift from roof
to ground. Snow had drifted under the door, and through the keyhole a long pencil
extended to the heavy curtain, where eight bucketsful had collected.

Outside, the porch was clean swept by the wind, but in the yard a semi-circular
drift had formed from the low barn roof to the ground, obscuring the door.

Fortunately, I had brought a shovel into the house to meet an emergency like this,
and at eight o'clock I began digging my way down into the barn encouraged by
hunger bleatings from the three goats.

Built into the hillside, the barn floor-level was two steps down from the yard and I
cut through five feet of snow to the door. Inside everything was drifted over with a
powder of snow and it was ten o'clock before I finally reached my goats with hay and
oats, milked them and returned to the house with warm milk for breakfast. Our
home-cured ham received a severe setback also after hours of digging.

Afterwards, a further spell of digging made a way to the henhouse with bewil-
dered hens still on their perches.

My goats and my dog enjoyed the snow, frisking about like schoolchildren, but
hens go crazy in snow and would flop into drifts and freeze to death if allowed out.
So I cleared their run and fed them with warm mash.

On the mountain the next day I made my way carefully over sloping ice-rivers,
formed where water rises to the surface and spreads down the hillside. The sun was
hot on my back and the snow softening under its influence.

Rabbit tracks crisscrossed, leading up to an old badger's sett; a fox had investi-
gated each entrance before returning along the hillside and making down towards
my mountain wall.

I sat in the sun with the whole valley to beyond Llanthony in view; not a sound
came to me except the soft sighing of the river far below. This sound is always
present and turns at times into a crescendo as rocks and trees are bowled along by its
force. We know then that for a few hours the ford is impassable and we are isolated.

My binoculars showed Bill Pembridge working some sheep down towards a
hill-gate leading to Box Bush farm. Slipping and sliding he made down towards the
farmhouse to call and tell his neighbour Cliff that he had collected some ewes off the
hill for him.

I could not see him enter the house but the thin pencil of smoke from the chimney

suddenly became a real 'smother'. The fire had been stirred to 'hush up' the kettle and although I was a mile distant I could almost hear teacups rattle on the table.

'Have a cup of tea now' is a blessed and frequent invitation in our community: and not to be lightly turned down after a tramp on a snow-covered mountain.

Christmas day dawned clear and bright and we awoke to a scene of extreme beauty impossible to translate into words. A standing invitation to share Christmas day with Harry and Jo York at Maes-y-ffin was always accepted with – 'if it snows we will walk down'.

Snow usually made the steep hill-road to our home a hazard even to the land-rover: better far to 'tog-up' in wellingtons, with old socks tied round the tops to keep the snow out, and make the two-mile walk across the fields.

The companionship of our friends – kept at the farm by care for the animals – was not to be lightly turned down; to say nothing of a turkey cooked with a pound of farm butter in its interior and garnished with home-cured ham and other notable items.

Walking where the windswept grass was showing or plunging through drifts – my wife treading into the steps I made – we arrived to a farmhouse welcome, barking dogs, purring cats, a huge fire and exchange of presents. Does it matter if we played kids' games and thrilled at the voice of the queen, or wept over 'Mary's boy-child'? What is Christmas if not different from other days?

Later, we walked home under a full moon sailing in a clear sky.

Well you mid keep the town an' street,
Wi' grassless stwones to beat your veet,
An' zunless windows where your brows
Be never cooled by sway'en boughs:
An' let me end as I begun
My days in oben air an' zun.

WILLIAM BARNES

Writings from the West Country

From 1962

Since the far-off days when your grand-
father (or father) vaulted into the saddle of
his Ordinary, and almost as often pitched
from that same seat on to his proboscis,
things have changed a good deal on the
road.

Cycling literature of past days was often
illustrated with pictures of those intrepid
pioneers, with legs thrown over handlebars,
coasting downhill at breakneck speed. A
single plunger brake kept them on this side
of paradise.

What an adventure cycle touring in
Devon and Cornwall must have been perched on the 'backbone' of a fifty-two-
incher with a solid pram tyre! Those of us who came to cycling with lightweight
safety frames and pneumatic tyres can have little idea of the awe-inspiring decli-
vities some of those coastal hills must have seemed from such a height. Moreover,
the narrow lanes and road were innocent of tarmac and inches deep in mud or dust
– with here and there a brick left by some jovial carter when he jacked up to rest his
team on a hill.

A writer in the 1750s declared: 'Cornwall at present has the worst roads in all
England. A greater part are intolerable, remaining in the same condition in which
the Deluge left them.' And if you had been travelling into Cornwall at that time
you would probably have journeyed in a gigantic wagon on tremendous wheels,
high and broad, with a canopy of rough canvas. Six or eight horses pulled this
'flying wagon'; and the driver, clad in a homespun smock, rode or walked beside
them cracking a long whip.

You would have travelled by day and by night, having taken your own bedding
for sleeping in the vehicle. Rate of progress was 'slower than a walking funeral', and
the journey from London to Cornwall occupied about three weeks, which must
have given everyone ample time to look around. Added to this were various
minor excitements such as crossing deep
fords, avoiding highway robbers, and sick-
ness and often death on the journey. It was
not without reason that simple folk made
their wills and had prayers said in church on
their behalf before leaving. But the wagons
have gone, and now your wheels roll over a
fine road towards Bodmin.

Cornwall is full of ancient history or
legend, and you find yourself leaving the
highway to delve into the remote past. At
Tintagel Miss Florence Nightingale

Richards, keeper of King Arthur's castle, gave us the key to enter and explore. If you are not interested in reconstructing the scenes and stories of the past, Cornwall will withhold much that will make your tour memorable.

Holy wells abound in Cornwall, and one, a few miles out at Altarnum, was favoured for the cure of lunacy:

> The water running from St Nunne's Well fell into a square plot, which might be filled at what depth they listed. Upon this wall was the frantick person set to stand, his backe towards the poole; and from thence, with a sudden blow in the brest, tumbled headlong into the pond, where a strong fellowe tooke him and tossed him up and downe, alongst and athwart the water, until the patient, by forgoing his strength, had somewhat forgotten his fury.

After this they took him to church and sang masses over him, giving St Nunne thanks. And then: 'Hobeit, if there appeared small amendment, he was bowsened againe and againe while there remayned in him any hope of life or recovery.'

All over Cornwall are barrows, cromlechs, sacred stones and prehistoric remains. The well-known Men-an-Tol holed stone was credited with curative powers, and children were made to crawl through the hole nine times against the sun as a cure for rickets. Undoubtedly older generations believed and practised legends and customs which had their roots in the dim past.

These thoughts and memories came to me as we cautiously slid down the tilted road to Cadgwith one afternoon in September. We kidded ourselves we knew the hills were steep. Hadn't we toured here many times before the mad days of war! Believe me, someone has added a bit to the top and delved some from the bottom of every one. Or are we that much older and stiffer?

Helston was a teaming, sweating mass of humanity afoot, in buses and in cars. Was it the famous Furry Dance, I asked someone. He looked at me in pity. 'No', he replied, 'just Saturday morning.' It was too much for such simple countryfolk as we, and we purchased our few needful possessions and fled.

'Poldhu', I said. 'Let's go down to Poldhu cave. It used to be lovely – and grand bathing.' It was still – with natural shelters to undress in, sea anemones and darting fish in the rock pools, and a clean calm sea to bathe in.

And so on to Cadgwith where brightly coloured boats were drawn up clear of the incoming tide. Two men were cleaning fish by the small stream that flows into the sea here, and the gulls were wheeling about our heads ready to clean up any offal tossed aside. Several others were just messing about in their boats, with friends looking on. Two young artists were at work, and they were soon joined by a third who couldn't resist the combination of figures and boats.

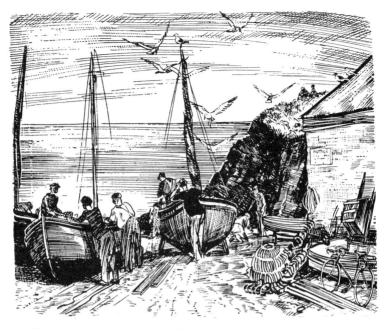

That was Cadgwith years ago; it is Cadgwith today. It has its link with great adventure – for the lifeboat that now serves its seamen is that same *Guide of Dunkirk* which, built in 1940 as one of the results of an empire-wide effort by the Girl Guides, went straightway into the jaws of death to rescue brave men while the world held its breath and prayed for Britain.

South of the Helford river there is a whole network of lanes, among which one may soon become gloriously fogged. The old first-left first-right idea for an afternoon's ride would lead you heaven knows where. But if, like us, you don't mind wandering about and letting things soak in a bit, what does that matter in such surroundings?

*

April was in the sunshine but January in the wind that swept across the Cornish peninsula at Easter, and as usual one could take no liberties with the weather so early in the season. But a west-facing, cliff-encircled bay was sheltered and warm and once the sun turned the corner of the cliff we were able to sit and sketch or paint in comfort.

Three grey seals evidently found the bay to their liking and every morning as the tide receded and left weed-covered rocks exposed, they clambered out of the water and lay in the sun. They seemed surprisingly restless; not from fright because they made no attempt to depart, but rolled from side to side, raised their heads, waved their tails in the air and moved around on the rock. One wonders if they were using the rough surface as other animals use a scratching post to rub off an old winter coat.

The cliff path to the beach was lined with gorse in full bloom – a glorious fire of gold and yellow scenting the morning air with a pungent aroma.

At evening the sun slipped down into a sea-mist and the fog siren from the lighthouse at Land's End began a nightlong warning.

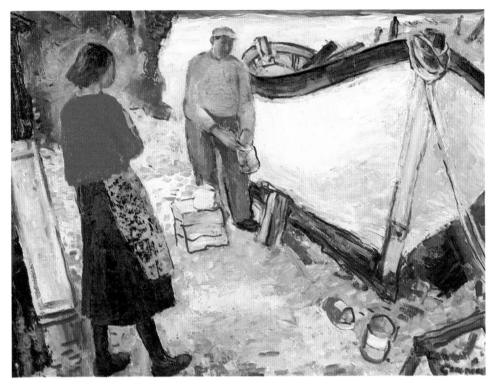

Painting the white boat

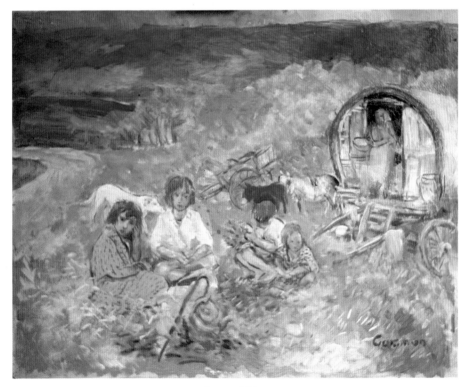

Gypsy children

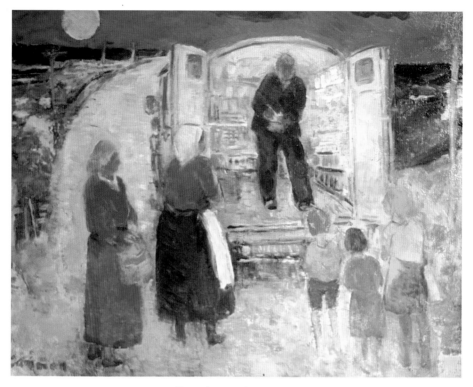

Grocer's van, Sutherland

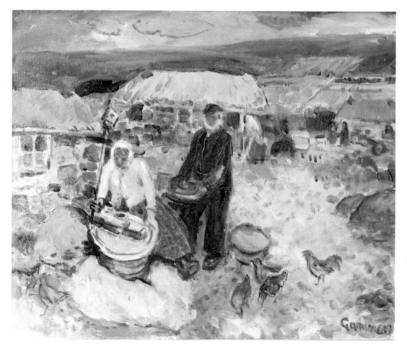

Grinding corn with a quern in the Hebrides

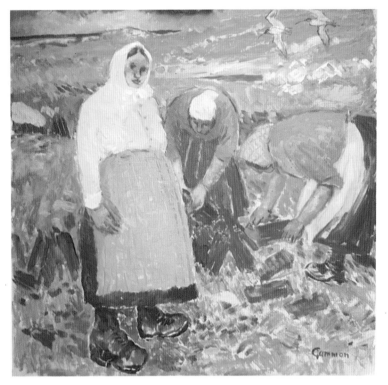

Stacking peat on Lewis

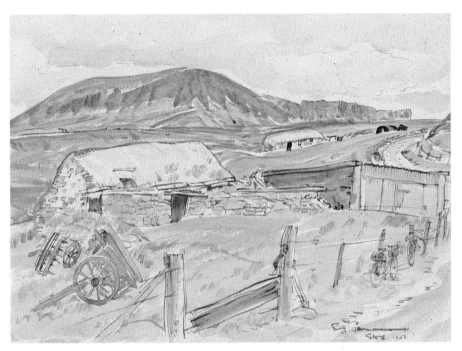

Black house on Skye

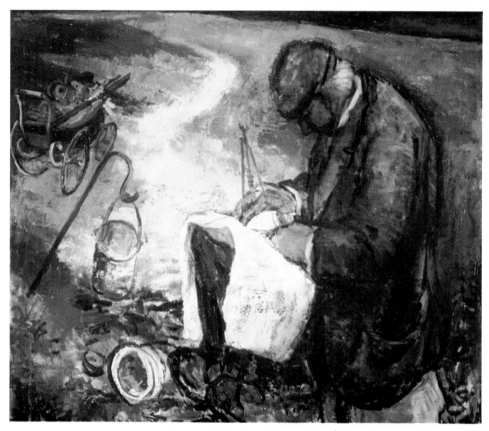

Tinker riveting china with hand drill, Perthshire

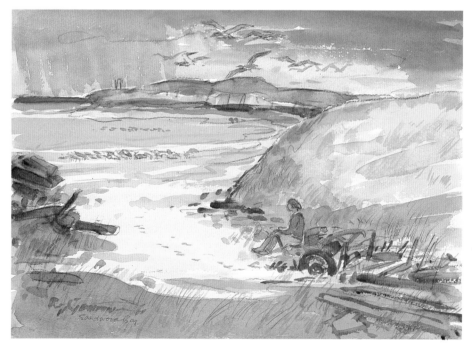

Sandwood Bay and Cape Wrath lighthouse

On an August evening in 1263, King Haco's Viking fleet anchored in a bay near Oldshore Beg on the extreme north-west coast of Scotland. On a January day in 1900 at Sandwood Bay, a few miles north nearer Cape Wrath, a lone shepherd named Sandy Gunn surprised a mermaid. Of the former incident no contemporary account exists so far as I know, but of Sandy's meeting with the mermaid we have an authentic record in G Douglas Bolton's *Scotland's Western Seaboard*.

Donald McLeod, a hotel proprietor and a friend of Bolton, went, as Bolton relates, 'armed with a batch of my most searching questions, interviewed the shepherd, whom he had known for many years, and thus obtained every detail of his meeting with the mermaid. It is from the shepherd's answers that I have been able to reconstruct the strange and unusual account'.

The gist of Sandy's story is as follows. With his faithful collie he left his lonely Sandwood cottage to look for his sheep, and having located them decided to return across the smooth sands. As he approached a ledge of rock, he saw something reclining there. His dog was 'very uneasy' and kept close in.

The shepherd crept to within twenty yards and to his amazement saw that he was looking at a mermaid. 'She was very charming. Her figure, so far as it conformed to human standards, was almost perfect . . . She was busy arranging her curls which lay in untidy profusion on her creamy skin.' Suddenly she saw him. He was terrified; she was slightly resentful. But he noticed her 'short white hands and broad powerful fish-like tail' before he discreetly withdrew under her steady gaze.

Although these two incidents are separated by over 600 years, this wonderful bit of coast is still so remote and inaccessible that one feels anything might turn up even today.

From the shoulder of the hill we looked down on the loch and the ruins of Sandwood cottage, and agreed that we had never seen any dwelling so far from a neighbour, so entirely enclosed by moorland and hill. But the walled enclosure and green patch round the cottage were evidence of a one-time happy and successful crofting life.

We scrambled down steep sand-dunes, sinking ankle deep and filling our shoes with sand, out to the wide floor of the bay. An amazing place – well worth the strenuous walk to reach it. Timbers and boxes, and all the usual wreckage that the great Atlantic gales throw up, littered the shore. The remains of a plane lay rusting where it had made a forced landing during the war – so remote, that even the RAF could not salvage it.

The tide was out, and the flocks of oyster-catchers, black-backs and gulls were wading along the water's edge. The silence was broken only by the soft sound of the waves and the voices of the birds. The solitude on shore and hill was complete and wonderful on the beautiful June day. One can only guess at the transformation that must take place when Atlantic gales raise great seas to pound against the huge rocks and race hungrily across the floor of the bay – swirling round the high sandhill we saw there. We returned to Droman, tired but delighted, and demolished a lobster that might otherwise have been sent to Billingsgate.

Skye may be a misty isle but it has a magnetic quality which makes the cyclist return again and again. Your shoes are often filled with water and as often dried out again by a brilliant sun; your small tent turns aside a concentrated deluge in the night, but by morning the mist is balanced on the mountain tops or idly lazing in the sunlit corries – and all is forgiven in the present glory of mountain and sea loch. You cannot escape the spell of Skye once it has fallen upon you, and it seems equally impossible to exhaust the interest and charm of this Hebridean island.

My wife and I cycled north out of Portree to explore Trotternish, the broad finger of land sheltering north Raasay and South Rona from the fierce Atlantic storms.

A mile or so of excellent road lured us on, and then – a quagmire studded with lumps of rock, and gangs of cheery roadmen and laden lorries that spewed water and mud from the holes as they cluttered past. The expedition was nearly called off in face of such opposition; but we were assured that the first few miles were the worst and that the road improved as it went north. So we dug into it and hoped the whole truth had been told.

It was in fact a half truth. By Loch Fada and Loch Leatham the weight of our camping gear dropped us frequently into potholes with a shuddering bang.

That evening we camped under the aegis of the Old Man of Storr and reaped an ample reward for our exertions. At a turn of the road, just past the Old Man, we came upon a disused quarry with a handy little workman's hut, its door unlocked and a path leading down to a spring of water conducted through a short pipe.

Above the shallow quarry, where huge rocks detached from the Storr lay in confusion, were green patches completely sheltered. Here we erected our small tent. Our cycles went into the hut, and capes were hung to dry. We have seldom camped with such a wide prospect.

Leaving our tent the next morning we took the coast road northwards, pausing at Invertote where the Lealt river crashes through a deep gorge and over a waterfall to reach the sea.

All the way the seaward view is glorious, and the westward view is dominated by a backbone of rugged mountains culminating in the jagged peaks of the Quiraing. It was in this wilderness of rocky pinnacles that the northern islanders used to hide their cattle when raiders and robbers beached their galleys on the shore. Today the black-faced sheep wander unmolested and the grey-blacked hoodie crows and ravens watch for the weakling lambs.

We saw Duntuilm castle through a mist of fine rain which enhanced its obvious strength as a former Norse fortress. Beneath the castle down on the shore is a large cavern hewn from the rock where the castle galleys (boats) were kept, and leading to the water is a groove cut in the rock as they were drawn down for launching.

Dunvegan is pregnant with the historical life of the island and for over nine

centuries has been the dwelling of the Macleod of Macleod. The portraits of former chiefs gaze down on you from the walls. Their charming and graceful ladies, with high satin bodices enhancing their beautiful and shapely shoulders, compel one to stand silent and awkward at the unseemly intrusion upon their privacy. Even the wicked chief who gave his unwanted lady a feast of salt flesh and then dropped her into the awful rock dungeon to die of thirst and starvation betrays little of his cruelty in paint. The attraction of her successor is apparent.

We rode south to overlook Uig and its sheltered sandy bay. The damp sea-mist dispersed, and tempted (as always) by a secondary road we turned back north-east to follow the River Rha over the windswept moors.

At the edge of the Quiraing the rough track tumbled out of sight among a mass of rock and bog, and with acute hairpin bends went sliding down between the jagged peaks. Passing the old burial ground at Kilmaury, we rejoined the southward road and proved again that in a country of such beauty a road should always be travelled in both directions. That evening, in clear June light, we sat by our small tent and wondered what secrets Skye still held hidden.

*

As we steamed south-west from Mallaig, the 'snowy sands of blessed Morar' had as a glorious backcloth a wild tangle of mountains into which few roads have penetrated. Our ship slid quietly down the loch and landed us on South Uist at eight pm.

We knew from earlier experience of camping on the northern island of Lewis that the only hope of shelter for a small tent was a depression or a knoll of rising ground. There are no trees or hedges to serve as windbreaks. Before long we found

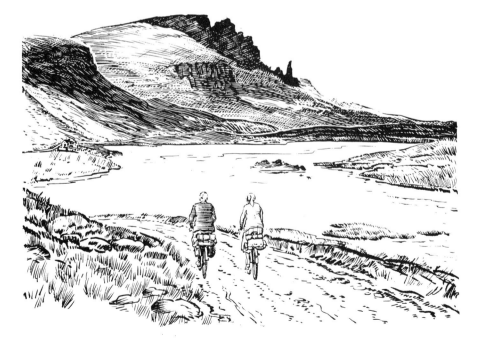

a sheltered hollow, with heather to lie on and a small loch of intense blue water at our front door. I went across to a solitary building to seek milk and water.

Next morning I met the whole family – Shaun the Post (he drives the post van as well as running his holding) and several 'little steps'. Shaun waved farewell to us as we rode northwards into the teeth of a relentless wind. There was no shelter and no respite. Tall yellow iris were blown over until they almost touched the water out of which they grew; the flat green leaves of the white waterlilies were lifted off the surface of the lochs. On Loch Bee a hundred swans were sheltering in the lee of the road causeway, and many more were on the water at the seaward end of the loch.

These islands are treeless and bare. In winter great winds carry spume and salt spray far inland, and even in summer the sheaves of corn have sometimes to be tied together and weighted with stones to prevent them from being blown across the island into the sea. On other days you can walk over the flower-strewn machair enveloped in the sweetest scents of earth and the very peace of heaven. Pipits and ring plovers run before you, corncrakes call from the growing corn, larks soar with joyful song, and oyster-catchers range the dunes and shore in search of food.

The depth of soil covering the rock is so shallow throughout the western isles that horse ploughs cannot be used. The drawing below, made on Skye, shows the cas-chrom or foot plough. The right foot pushes the steel-shod beam through the soil and the handle is then used to lever the soil up and turn it over.

Flora Macdonald was born on South Uist, a fitting birthplace for a brave and fearless woman. The remains of her small cottage are marked with a plaque.

Throughout the morning we pushed the wind aside until an old cottage gave us shelter to eat our lunch. We had planned to get across the North Ford and camp for the night on North Uist but were warned on no account to try to cross without a guide. So we returned to put up our tent in the shelter of a roofless house down on the foreshore.

I dipped water from a small loch, and, as we were travelling light and without a stove, began a search for wood to make a fire. Not a stick could I find until I came

upon the local dump and there retrieved several small pieces of boxwood and – believe it or not – a discarded German concertina. In its most melodious heyday, the squeeze-box never made sweeter music than the singing of our kettle and sizzling of bacon and eggs.

Next morning we literally walked the plank from a small jetty to a swaying motor boat, and, as it threaded between innumerable islets, realized how dangerous it would have been to attempt that crossing on foot.

On our return journey on the ferry there was a considerable wind blowing and this was about the most exciting bit of sea-going either of us had ever experienced.

In the halcyon days of youth, before war had bred scare and more war, we shared the freedom of the road with many interesting characters.

Some, let it be admitted, were rogues and vagabonds, always ready to turn another's misfortune to their own advantage, alert to 'knock off' anything that could be sold for a copper or exchanged for a meal provided unwillingly by a nervous housewife in a lonely cottage. If we happened to be repairing a puncture miles from anywhere, one of these unsavoury gentlemen of the road would appear and make a scarcely veiled demand for 'a copper for a bed, guv'nor' in a whining tone. And if one were alone and of peaceful nature, 'the copper' was usually the line of least resistance.

At the other end of the scale there was the occasional tramp who shunned the notice of his fellow travellers – an educated man who had taken a wrong turning, gravitated to the road, and solaced himself as he journeyed by reading Homer in the original Greek.

I remember one bearded old chap with all his worldly goods packed into a sack, together with several old tyres and inner tubes, odd bits of cloth and bones – anything that would fetch a copper from that shrewdest of dealers, the rag-and-bone man. He shared a roadside cup of tea in his smoke-begrimed tin at a lonely spot in the Grampian crossing. The weather was stormy, with thunder rumbling in the hills.

He was going, he said, to see Lord Somebody-or-other who was in Scotland for the grouse season, and who would find him some work because he had on one occasion told our tramping friend to come to him if ever in need. We sympathized, and wondered if his Lordship would leave his grouse and whisky to listen to an old man in rags.

Suddenly a sharp crack of thunder sounded overhead, and large drops of rain fell on us. The old man was terrified. Gathering up his stick and tin and traps, he went off up the road almost at a run. With his ragged overcoat flying open in the wind, and a battered hat crammed over his eyes to shut out the vivid lightning that

split the heavens in two, he presented a memorable picture.

On another occasion we had erected our tent in a pleasant Herefordshire orchard rather late in the evening. Just in time to get snug and make a late meal from the good things like eggs and butter, fruit and cream, that could be bought freely from a farm hostess in those happy days, we turned in and slept as good cyclists should. We also awoke, as good cyclists should, early and ready for the adventure of another day. A few yards from our tent door was a conical heap of old sacks, and I could have sworn that they were not there the previous night.

After breakfast, when we were packed and ready for the highway, I went and lifted one of the sacks.

'Ullo!' said a loud, husky voice. 'Wotcher want?'

I dropped the sack like a hot coal, and stepped back.

'Sorl right, guv'nor', went on the voice, 'only me and the missus.'

We pushed out of the gate.

'Heavens, two of them under those awful sacks,' said my wife.

In direct contrast to the good-for-nothing tramp was the roadfarer who had something to sell, or who offered to do a job of work – wood-sawing or the like – in return for a square meal: the wayfarer who makes a genuine effort to gain an honest copper always has my sympathy.

We were crossing that wild stretch of the Cardiganshire moors south from Strata Florida some years ago, when we met such a tramp. Stanley Baron, my colleague, wrote of him:

> He was lying, hand under head, gorgeously outstretched among the coarse grass tufts.
> 'Bore da!' said I.
> 'Lor lumme!' exclaimed the figure, rolling over – 'you did give me a turn, chum, and no mistake. Borrer dar, eh? Well, borrer dar to you, Cockney!'
> Stripped to the soul, I too lay down . . .
> 'Ah, what am I doing, and that's a fact. All I knows is I set out o' Tregaron this mornin', and lumme, I ain't see a 'uman since, 'n just as you come along I was thinkin' you aint go' no dough, Cockney Billie, but lumme boy, you don't 'alf see some country.'
> 'Aye', said I, 'and you won't half see some more before you are out of these hills.'
> 'Don't you worry about that, chum,' said Cockney. 'I'm a 'iker, I am, and I'll be bumping Aberdovey on Whitsun Monday all right.'

He was bumping (selling) laces, nutmegs and rush flowers made from the white pith of peeled rushes. Before we left him he confided his dream of prosperity – to get some well-paid work for a month or two, buy a portable wireless and an old pram, and knock all those gramophone beggars clean out of business.

In the north country I saw a real old-time tramp with tattered coat and battered hat scarcely concealing long uncombed grey hair. He was sitting by the wayside and appeared to be binding rags round his feet before replacing his outworn boots: were his feet sore? I doubt it, they would be hardened by constant walking. Moreover when a man's life almost depends on his ability to keep on the move he learns how to care for his feet.

Years ago when tramps were ubiquitous they could be useful extra hands at haytime and in autumn harvest. One of our family jokes when I was a boy recalls a familiar tramp whose odd job would be rewarded by a coin and bread and cheese which he ate in the barn. Soon he re-appeared –

'I've agot this lil bit o' bread left, missey, could I 'ave a crumb o' cheese t'gaw with un?'

A short break and then he returned to tap again on the door:

'Can't meak un meet, missey, give oi a bit more bread av you pleas.'

Inability to 'meak un meet' continued until he and honour were satisfied.

Incidentally 'Old Jack' sometimes sat as model to Gunning King of Harting, a *Punch* artist, and I have in my volumes a perfect portrait of him in the dock appealing to a sceptical bench.

But one night a vagrant (as authority then termed them) having obtained leave to sleep in the barn was found with a stub of guttering candle alight in the straw-filled barn. He was soon on the road again, with a flea in his ear.

John Clare observed the tramp in his day:

> He eats, (a moment's stoppage to his song),
> The stolen turnip as he goes along:
> And hops along and heeds with careless eye
> The passing crowded stage-coach reeling by.
> He talks to none, but wends his silent way,
> And finds a hovel at the close of day.
> Or under any hedge his house is made.
> He has no calling and he owns no trade
> An old smoked blanket arches o'er his head,
> A wisp of straw or stubble makes his bed.
> He knows a lawless law that claims no kin -
> But meet and plunder on and feel no SIN –
> No matter where they go or where they dwell
> They dally with the winds and laugh at Hell.

Companions of the road – have they passed for good?

A glowing report in our local paper of the Shepton Mallet 'Darts and Shove-ha'penny League' encouraged me in the idea that we had come to the right locality.

If 'shove-ha'penny', then the odds were I might somewhere find them gathered round a backgammon board – and what could be more appropriate? We have but exchanged the eternal hills for the continuity of village life.

Before we had time to explore half the boxes we had packed so carefully, the vicar called to welcome us as friends and neighbours – our garden joins his glebe land.

Almost as he departed, pleased, I suspect, to find us villageous folk, the school-mistress came with a gift of flowers and an apology that she had not brought us tea on the day we moved in because of absence on a refresher course.

'As soon as we saw your land-rover', she said 'we knew we had some down-to-earth neighbours!' She and her family living in the old schoolhouse are separated from us only by a corner of the churchyard and a wicket gate.

But even before our removal van was empty, came several friendly chaps with their own particular axes to grind – the butcher, the grocer, the baker and that useful combination, the 'co-op' – all anxious to be of service and with tuppence off this and that to tempt the lady of the house.

How we laughed . . . and how they stared when we told them that for twenty years our provisions had come once a fortnight to the mountain; that we had baked our bread; killed a pig and cured our bacon; produced our eggs and milk and vegetables.

But who said our villages have become unfriendly?

'Tes they jackdaws y'know,' explained our Mrs Rimes arriving breathless and a little late. 'Their oud sticks got all twined up in the 'ands and scretched the face of un as they went round; tes going to cost fifty pound to do en up . . . seems a lot of money, doant it? . . . but I shall be glad for un to be put back, I keeps looking up at church clock and ee's not there.'

Guiltily I agreed, having enjoyed watching the birds building in the tower. But they are also building in the vicarage and schoolhouse chimneys. At dawn they

arrive with green twigs wrenched from the
elms, or large dry sticks twelve or fifteen
inches long.

Alighting on the chimney with the stick
held crosswise some time is spent in a vain
effort to get into the pot with it. Frequently
it is dropped and slides down the roof, no
attempt is made to retrieve it and the bird
flies off to get a fresh stick. This may be
shorter or held at an angle which allows the
bird to dive head first into the pot.

What goes on inside can be guessed at
because piles of sticks and plenty of soot
bounce out into the sitting-room below. This nest building had been proceeding
for days on end and our friends are awaiting a man with a long ladder to put a wire
cage on the pot.

Meanwhile every morning the male sits on one pot encouraging his wife in the
task of completely blocking the chimney. When chance sticks get wedged across
inside to form a platform then a jackdaw home will have been built and the pile of
sticks may well equal the height of a man.

My arrival at our village baker's (usually for a small white loaf and one ounce of
yeast; my wife continues wholemeal home baking), often coincides with a crowd of
youngsters buying sweets. They are already behind time, but determined to spend
what Mum has given before rushing in at the school gate.

Knowing my village manners, I enter behind the riot and wait, while Mrs
Moore assists in the choice from a bewildering variety.

Some half-dozen or so transactions, involving a dozen or more young finan-
ciers, have to be completed in time to allow entry at school – anyhow before the
first hymn is over – so I subside into my corner until the hurricane sweeps out into
the road and the door closes with a shattering crash.

By this time I've forgotten what I want (fortunately this kindly Scotswoman
knows) and have wandered back through more than sixty years.

A bent old woman kept a tiny bow-windowed shop in Sheep Street, Petersfield;

we clanked up four stone steps in our hobnailed boots and burst in through a door with a spring-hung bell that jangled like a fire alarm. No chance of stealing a march on Auntie.

But what an assortment! Yards of boot-lace liquorice; bags of sherbet with a liquorice 'straw' to suck it up; aniseed balls and the toffee she made in foot-square slabs and broke up with a claw-like pincer screwed to the counter.

For the girls cupid's whispers – heart shaped and bearing such thrilling messages as 'I love you' – were closely rivalled by jelly babies.

We bought more sweets and less paper than today, which was no doubt less hygienic. But I dare swear we enjoyed our sweets just as much.

On an April evening several herons were sailing over a wood in mid-Somerset. The sunlight shone on their silver-grey plumage and, marvelling at the ease with which so large a bird seemed to sustain itself in the air, I remembered that its average weight is only about three and a half pounds. With its wide wingspan it can soar to great heights, especially when pursued by its arch-enemy, the peregrine falcon.

I pushed my way through the tangle of brambles and slopped through the waterlogged ground beneath the trees in a vain attempt to find their nests. I felt pretty sure they were attached to a heronry because they always nest in congregations. As many as eighty have been recorded in one tree; the noise they created when young were at the nest must have been deafening. It seems strange that these long-legged, seemingly ungainly birds should choose to nest in the tallest trees, but they can in fact perch with the ease of a rook. The young, being reared at such an altitude, are helpless until fledged enough to perch and fly.

Henry VIII made a statute prohibiting the taking of herons other than by hawking or by the longbow on penalty of half a mark; and the theft of a young bird from the nest merited a fine of ten shillings. 'He does not know a hawk from a heronshaw,' was an expression of contempt when falconry was a noble art practised regularly.

May I put up my little noticeboard again? I have noticed the rubbish spoiling our lovely villages and remember the litter on the hill road in Wales – so much so that I took to carrying a spade in the land-rover to have other means than bare hands to bury some of the most offensive chunks.

The worst of it is that some of it won't lie down, even though it is dead and buried. Recently I found a savoury cache scattered over a considerable area – tins, bottles, cigarette packets, peel and so on. An attempt had been made to bury it and even the turf had been replaced – a perfectly clean job when the car drove off. But dogs and foxes and badgers have a keen sense of smell and it is the work of half a minute for any of them to pull away the turf.

Then the ravens and crows find it, and as even they cannot eat tins, and take only passing interest in paper bags and orange peel and bottles, they only help to scatter what the rightful owners thought they had carefully buried. Better to tuck it under a large rock ... Best of all – *take it home*.

We welcome everyone to our countryside, but let's keep it clean.

There are other aspects too of the behaviour of some townsfolk in the country that are still puzzling and annoying to the countryman. My neighbours are apt to offload their complaints on to me and, honestly, at times I cannot find answers.

Why do some folk drive their cars into fields without a word to the owner and leave their refuse behind; and climb over stonewalls and hedges to reach the river instead of seeking a gate, always to be found somewhere to allow entrance?

Why was a hill-gate left open, allowing ponies to get to the hill, where a day was wasted rounding them up? And why break down the footbridge over the river that is dangerous to cross in flood?

'I seen him get in and off across the field,' said one farmer. ' "Shout at im" the boy said, but I let him walk a bit to do 'im good, then I hulloed, "come you back" and showed 'im the gate so as he could get in proper. They do no harm so as they would use a gate and shut it.'

Well ... will you? ... but perhaps you do.

Ideas about the so-called 'good old days' are apt to be modified by the facts revealed in the letters and diaries of folk who lived through them.

It seems certain that the daughters of prosperous country gentlemen in the sixteenth century were regarded as assets to be used and married off to the benefit of the family fortunes. The famous Paston Letters inform us that when Elizabeth, a young daughter, refused to marry an ugly widower of fifty she was for nearly three months '. . . beaten once in a week or twice, sometimes twice in a day, and her head was broken in two or three places'. This was her mother's treatment – a supposedly highly religious and able woman! Not a pleasant picture of family love. Love seldom entered into marriage then and children were often pledged for life for financial gain.

More pleasing is this, from Kilvert's diary, 1870: 'Mr Allen . . . brought me as far as Hay in the rumble of his most antiquated, most comfortable old yellow chariot on C springs, very broad and heavy, and able to carry 7 people . . going up hills, we had before us the antiquated figure of the old coachman against the sky and amongst the stars . . .'.

In 1874 he visited William Barnes, the Dorset poet, then over seventy years of age. 'He wore a dark grey loose gown girt round the waist with a black cord and tassel, black knee breeches, black silk stockings and gold-buckled shoes . . . long, soft, silvery hair flowed upon his shoulders and a long white beard fell upon his breast . . .'. A charming and true picture of a splendid country poet.

News of congestion on the road with car and coach processions miles in length remind me that there are compensations in being able to recall the quiet roads before this madness overcame us. My youthful days were spent on a farm where the only engine I knew was Mr Seward's traction engine that periodically pulled into the farmyard with the threshing outfit. Everything was done with horses. When the vet came he drove up in a spanking gig, and the doctor had a groom, with a cockade in his topper, to care for the horse while he made his calls.

The pride taken in his team by the farm carter was only equalled by the care with which he oiled their harness and shone the brasses. These brasses were the carter's own property and if he moved to another farm he took them with him. There were face-pieces of many patterns, coloured horsehair plumes set in brass sockets for fixing to the headstall. One particular piece was fastened to the bridle to show on the horse's forehead and was an amulet used on harness for many centuries. A favourite piece represented three crescents and there is a precisely similar design to be seen on the harness of horses in the Assyrian room in the British Museum.

Perhaps the latten bells were the climax of the dressing of the magnificent old-time carthorses. These bells were set under a leather hood and carried on the horse's collar, the hood being variously decorated by tooling on the leather or with brass studs and a coloured fringe draped down over the bells. Three or four sets, with four bells in each, were tuned into harmony, and the effect as the team made its way along a quiet country lane must have been very beautiful.

The latten bells served a definite purpose, apart from their artistic appearance. It was necessary for the great broad-wheeled wagons to travel down narrow lanes where two vehicles could not possibly pass, and the sound of the latten bells warned any other carter about to enter the lane from the opposite direction to wait at a wide part of the road until the approaching wagon should pass. There are local records of opposing carters who ignored the warning bells, came face to face in a lane, and fought out the right of way. I guess they would both fight well, for the loser would have to back his wagon to a passing-place – a far from easy task.

I have before me an old photograph of a wagon team such as I have described, with the carters wearing their Sunday best – richly decorated smocks and tall light-coloured toppers. Smocks have entirely disappeared. I remember an old Sussex man of ninety from whom I tried to get a smock years ago, but without success; all had been torn up. The smocking served the dual purpose of decoration and drawing together the loose portions of an unshaped garment into something approaching a fit. They were serviceable and warm, and had considerable rainproof qualities.

A short time ago I gave a lift to a little old countrywoman returning from market. Heavily laden with a huge basket, and a coloured kerchief, she was struggling up a hilly road. The kerchief interested me very much as a survival of a common practice years ago of carrying the results of a day's shopping or the personal necessities of a holiday visit in a coloured handkerchief about a yard square.

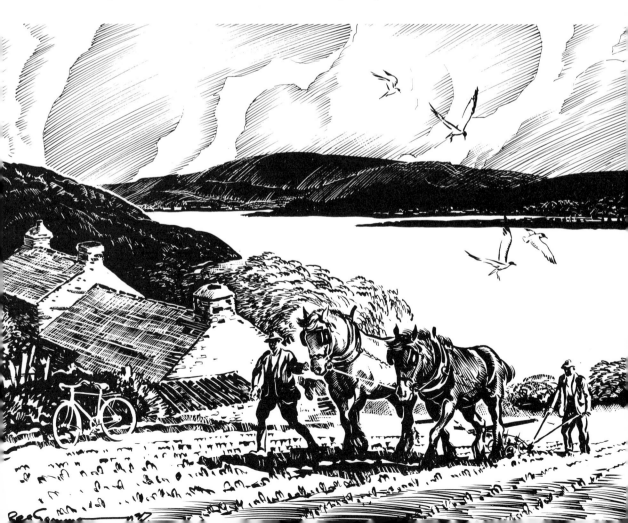

With me bundle on me shoulder,
Sure no man could be bolder,
For I'm off to Philadelphia in the marnin'.

The singer's bundle would be a coloured kerchief. As a boy I have shared in the countryman's midday meal carried in a red kerchief, with a little wooden cask of home brew, together in a plaited straw basket. When he sat in the shelter of a hedge in the spring sunlight to rest and eat, his brilliant red kerchief was opened out on his knees as a tablecloth. In exact imitation of my tutor I used my pocket-knife to cut a 'thumb piece', and I tasted his home-brewed beer – not at all to my liking, although I would have died rather than let him see it. In both ends of his cask was a piece of glass, and it was my delight to hold it up to the light and look through to see how much liquid remained.

The mechanization of our farms has largely released the agricultural worker from relentless toil and poverty, but it has swept away many picturesque, if less efficient, practices and ended customs that were the very staff of England for many generations, that gave beauty and character to our land.

In the hills and dales where farms are often remote and where small fields make large implements impossible or uneconomic, labour is still exchanged at periods of peak work like harvest and threshing and shearing of sheep. On a hill farm we used to gather to the job whatever it was and the farm wife prepared food for us all.

The custom made for good neighbourliness. We were an independent lot; jealous of our freedom of thought and action; occasionally there was a 'dust-up' between neighbours; but when the good wife in her wisdom placed the participants side by side at a shearing dinner the influence of good food and drink soon dissolved the issue and neighbours not speaking were again on the best of terms. Many things *have* been gained by change and increase of production, but on the human side I believe the loss may prove irreparable.

Errigal is the most mountainy mountain you will find in our islands, and Muckish, its near neighbour, looks for all the world like a slumbering, prehistoric monster replete after a meal. At his feet lovely fast-flowing rivers and small loughs, more than anyone can count, reflect the intense blue sky and fleecy clouds. There are grey rocks and small green fields, multitudes of wildflowers, and shining white cottages thatched with marram grass. And over all a wind that carries the scent of the sea to every part.

Over the moors we made our way to Ardara – a town built on a hill if ever there was one. The houses almost stand upon each other's roofs, so steep is the main street.

In the Derryveagh mountains we looked through the broken windows of a home-stead where the timbers and thatch had fallen in. The simple essential articles of a home were still there – a table, chairs, an Irish dresser, a beautifully shaped wooden cradle on rockers, a tall butter churn with wooden plunger, a scrubbing brush and other things half-hidden by rotten reed thatch. But a swallow flew in and out of the gaping hole in the roof feeding her young – so it was still a home.

I wondered why the quite useful furniture had been left to rot and subsequent enquiry suggested that the old people may have died of tuberculosis and no one would remove or use their goods for fear of infection.

On a day of superb beauty we left Dungloe and cycled through the Rosses. This is a district of huge grey boulders and small cottages scattered without apparent reason here and there about the landscape. Innumerable minature loughs, set in the vivid green and brown of the moorland, were starred with waterlilies. The tiny enclosures that pass as fields were (it was June) a perfect carpet of flowers. And the road undulated across the broken ground reaching out to the distant mountains, giving frequent glimpses of a deep blue sea and indented coastline.

Beyond Gweedore we faced the huge milk-white quartzite mass of Errigal. We rode south along the Dunlewy lough, and the boreen (by-road) climbed round the broad base and gradually ascended to the moorland saddle giving fine views of the magnificent Derryveagh range and Poison Glen, and later of Wee Errigal and Muckish (the pig's back).

In evening light we cautiously slid down the stony track to camp by the Calabber bridge, where even the midges could not dim a glorious day.

Some years later we toured the area by car. As we drove up the pass through the Poison Glen in Donegal, a man came hurrying up the steep hill path to the road and waved his stick for us to stop.

'Are ye goin' over the pass?' he asked excitedly.

'We are,' I replied.

'Will ye take me up?' . . . and without waiting for my answer he scrambled into the back seat.

'Me ass has broke out on me and is on the road a moile or two doun. I bought him last week and the devil is on him to get back home, so he is.'

'Are ye enjoyin' yer holiday?' he shouted at the back of my neck.

'Yes, but it has been cold and windy.'

'So it has . . . and there's that Yank chap flying round the world . . . I was listenin' to the wireless and be-god he's still up there and asleep . . . I wouldn't do it for a million – sure I would not!'

'Are you a Yank?' he bawled at me.

'No English!'

'Ah, I t'ought ye might be . . . have ye been here before?'

'We cycled up here twenty years ago,' I said.

'My God, did ye now. I wouldn't cycle up here for a million . . . no, I would not.'

We had driven about two miles by this time and my wife, suspicious that the nearest bar was his objective, asked 'Where is the donkey? We haven't seen him yet.'

'Och – he'll be furder along the road . . . do ye see that house?' he asked indicating a derelict thatched cottage in a waste of moorland. 'A millionaire lived there, and he died and his son bought five public houses wid the money.' The idea of owning five public houses so overwhelmed him that he fell silent for a space.

We rounded a bend and there, half a mile ahead of us, was the donkey quietly grazing. Its owner spotted it at once . . . he gripped the back of our seat and leant over between us.

'Arra ye b . . . !' he shouted. 'Arra ye so-and-so, now I have ye, be-god so I have!'

My wife covered her ears as he continued to express his opinion of all asses and this one in detail over the half mile.

When the donkey finally heard him shouting, its ears shot up and, although hobbled, it tried to run.

He leapt out of the car and ran before it waving his stick. 'Whoa! ye something . . . now I have ye!'

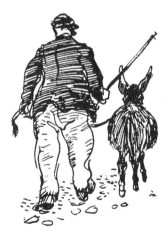

He handed me his stick while he bent down to untie the hobble and fasten the rope round the animal's neck. Then he stood like a warrior by his steed as I produced my camera. The expression on his face sent my wife into fits of laughter.

'Good luck to ye, sir, and may ye enjoy your holiday.' He turned to the expectant ass, 'Get up ye b . . .', gave it several clouts with his stick and they set off home at a smart trot.

Half a mile later I had to stop the car, we were both so convulsed with laughter. It couldn't have happened anywhere but in Ireland.

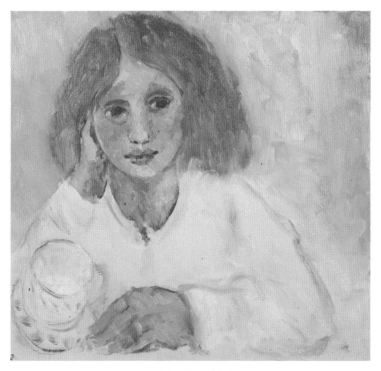

Girl with red hair

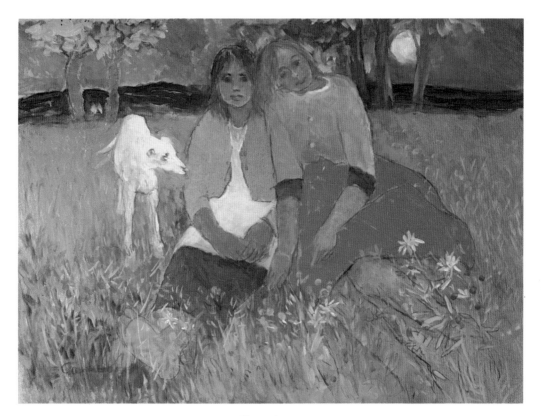

Gypsy sisters

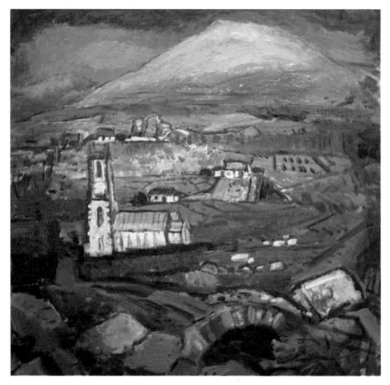

Errigal Mountain, County Donegal

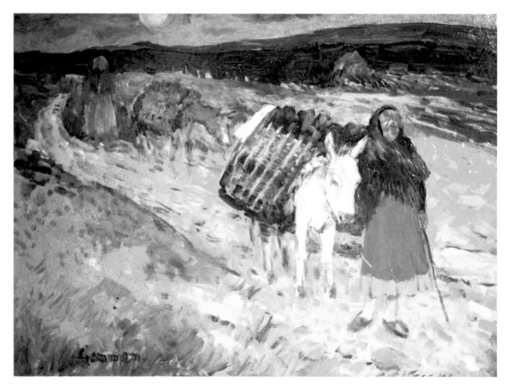

Homeward with the turf

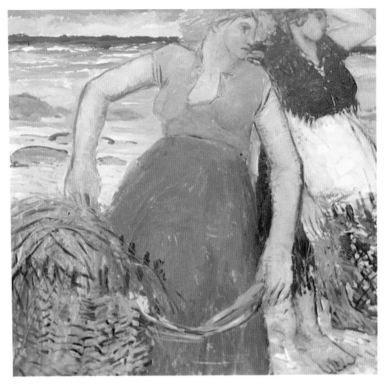

Gathering seaweed, Galway

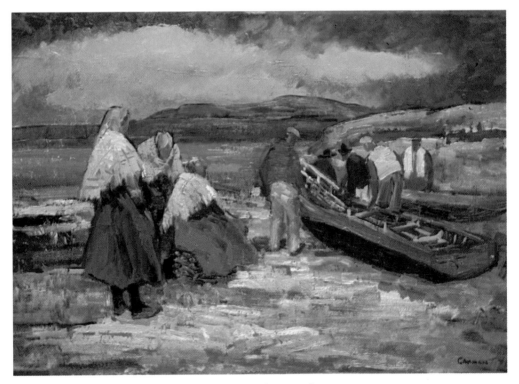

Launching the curragh

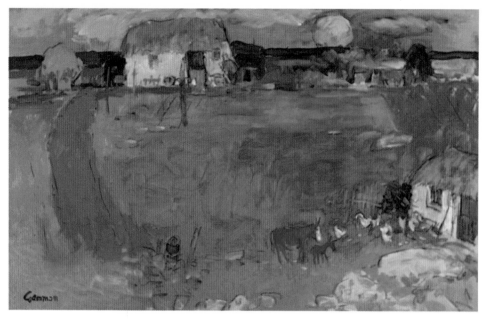

Kerry landscape with blue donkey

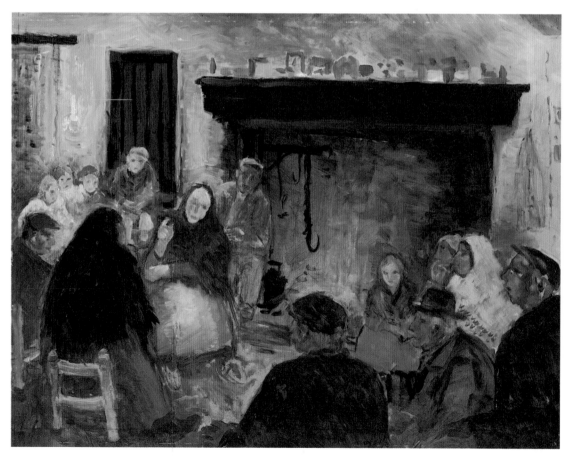

Tales of Donegal

Eire is full of surprises. The past interlocks with the present so that the events of St Patrick's era might have happened yesterday. Time ceases to be of any account. Every second Irishman one meets is 'great at the talkin'' and always has a tale to entice away what little desire one has to leave.

'Will ye wait now, while I tell ye of the night McCarthy's lion bursth out av his cage at the circus... Shure now wasn't there the great roarin' baste and the people all schreamin' and jumpin' out av their seats ontil the sargint pushed im intil the "gints" behind the polis sthation and shut the door on 'im...'

It was a wonder I ever left Achill after an evening of tales like that one many years ago. A wonder I am not still sitting round that turf fire, smoke dried and ancient, listening to tales of Grania O'Malley, pirate and plunderer of Elizabeth I's ships.

'She moored her navy of curraghs below her castle on Clare island and, passing the line through her chamber window, bound the end to her wrist and slept ready for any alarm.'

'She married her second husband, Sir Richard Burke, on the understanding that either could dismiss the other after a year. During that time she garrisoned all his castles with her own followers and one night shut the door in his face! What a woman! I reckon he was glad to be rid av her.'

You may, perhaps, include in your Irish tour 'heaven's reflehe-hex, Killarney' because you remember your grandparents singing that once-famous song. Whatever your reason I hope you go to Killarney on a market day. Any reflection of the heavens is apt to be somewhat muted in the dung-coloured pools of water in the streets – but the teeming country life is typical of Ireland and wholly delightful.

The yard of the Arbutus Hotel, which lodged and fed myself and the Cyclists' Touring Club party so royally a few years ago, was stiff with men, horses, donkeys, carts and pigs, which overflowed all down the street. Men climbed on to carts to poke up somnolent pigs and subject them to a critical examination prior to making a bid much less than they intended to pay. Others stood around holding captive huge antique hogs by a length of rope tied to a hind leg. The whole length of the street was lined with little red-painted carts: some with donkeys unharnessed and tied to a wheel, others more prosperous with a fine horse between the shafts.

Among themselves the Irish love an argument conducted with courtesy. Seeing a grand fight in progress, a returned emigrant is reputed to have peeled off his jacket and 'Tell me now', says he, 'would this be a private foight or can anyone jhoin in?'

For typical Irish humour I always remember the report in a local paper of a funeral where a relative of the deceased stumbled over a grave and broke his leg – 'this unfortunate occurrence', wrote the reporter, 'cast a gloom over the whole proceedings.'

Winter nights in the country are filled with the sounds of wild creatures, and cyclists, to a greater degree than almost any other traveller, can listen to and disentangle those sounds for their enjoyment.

Unless walkers have trained themselves to tread lightly, they are unlikely to hear or see very much of the shy creatures who use the darkness as a cloak for their activities, for the sound of a footstep is more disturbing to nocturnal animals than the scarcely audible swish of a well-inflated tyre on the road.

A short stay in the London area in November left me with a sense of the constant noise that goes on day and night – a mingling of sounds that effectually prevent one from enjoying any real contact with nature. At the same time I was impressed with the indifference shown to humans where man and nature came so much into contact.

A jay in Kensington Gardens allowed me to get closer than any other woodland bird would have done – and when it did fly a short distance in a leisurely fashion it was without the harsh, raucous protest that the wilder watchdog of the woods always makes. The ubiquitous sparrows hopped around my feet and almost on my board as I was painting by the lake, and the gulls and mallards and swans came up to be fed. Moorhens flirted under the evergreens by the waterside, entirely disregarding the people who walked by. To a countryman it seemed unnatural for the birds to be so confiding.

In the country at night one hears more than one sees. The noise that a pony can make blowing and stamping as it shelters behind the house wall is quite unpredictable: while the ghostly coughing of an old ewe sends shivers down one's spine. Familiarity with the cause of the outburst makes little difference to the total effect when heard without warning in darkness. The ponies and young stallions roaming free on the mountain fight and squeal horribly and the donkey's bray is a sound common to Ireland but seldom heard in other parts.

Camping in Kerry we had a gentleman donkey hobbled in a tiny field ajoining. When night fell he remembered a lady acquaintance across the narrow estuary; he called to her and she answered, obviously in the affirmative. Thereafter the soulful, longing messages that passed between those separated lovers made us long for morning light.

Out on the road the cyclist may be lucky enough if there is a moon to identify creatures crossing the roadway. Often such a crossing is preceded by little rustlings and squeakings in the undergrowth, and then a mouse or a rat appears at the edge of the tangled grass, and hesitates a moment to test the safety of that broad expanse of open road that offers no sort of cover.

An owl hunting on silent wing gives small chance of escape to any rodent caught on a modern high road. A squeal from the rat and a triumphant screech from the great bird marks the end – and the feathered friend of mankind can be seen outlined against the pale night sky with the rat held firmly in her claws.

The silence of a November night is often broken by two or three gruff barks from a dog fox. He listens for an answer from his lady, and it comes as an eerie, blood-curdling scream ripping the silence of the woodlands and making one's hair fairly stand erect. The vixen's invitation as we hear it echoing in the great hills is astounding and terrible, far worse than the screch of the hunting owl.

One of the humbler woodland folk is the hedgehog. He snuffles and grunts about among the leaves on milder nights, picking up a good living on slugs and dead mice, and lapping up any milk the cat may have left in her saucer outside the door. But a keen frost sends him underground to curl up for the winter.

Overhead the migrating geese converse as they journy south or west – voices in the night that must have sounded like spirits from another world to the simple folk of former years who knew nothing of the marvels of migration.

In the stillness of one night in Wales great rocks came crashing down the valley, eased from their place by the thaw of recent days. One unaccustomed to living in the hills would be startled by these 'things that go bump in the night'.

The bark of a dog on a distant farm – the sudden muffled crowing of a cock in the henhouse disturbed by a rat – the anxious bellowing of a cow separated from her calf – the testy, complaining chatter of a starling roost where the birds festoon the treetops and jostle each other on the swaying twigs – all are sounds of a winter night. They may be heard by any cyclist willing to dismount and quietly remain silent in a country lane, or any restless sleeper able to lie still and listen.

The best country seat is undoubtedly the seat of a good bicycle. A good saddle is the very essence of cycling as you may well know if you have ever endured the exquisite torture that a bad one can inflict in a day's ride. Indeed, a perfectly good saddle may be sheer purgatory if it has previously been shaped by a posterior other than your own; all the applications of hot damp cloths to the re-shaped leather will seldom alter the fact that there is a bump where there should be a comfortable hollow. How well one remembers the few occasions when it was necessary to borrow a bicycle or (worse still), in days of youth, to hire one from the local dealer, then to 'put the saddle right' and proceed to ride it.

Nowadays, I suppose, cycle hiring is almost a thing of the past, but what dreadful things some countryfolk do still ride. Our old postman staggers up and down laden with letters and parcels, on what is certainly the worst cycle in Britain, with the deadliest saddle that ever upheld the weight of a man.

The leather is fixed to the springs by the point only: its rear corners seem to flap idly in the wind while the old man fumbles with the mail. And just what happens to the leather top when he mounts, I have never been able to determine. I can only presume that he sits on the bare springs, with the leather on one side like the flap of a riding saddle. The rest of his machine, with a rear wheel doing duty in the front and entirely without a serviceable brake, is in keeping. When he wishes to dismount he sidles into the bank, sticks out a foot, and brings himself to a standstill in a series of wild bumps into the bank and then half across the narrow road, to return again to slide a pedal-less spindle into the soft earth – an efficient sprag which stays the machine as he tumbles off.

When the wheels refuse to pass the remains of the brake shoes, and wobble from side to side in the forks, old John borrows a 'sponner' from me and we do what we can. But always in a day or so 'the old bike is all about again: she won't steer, mister. The handles are loose or something'.

Once he discarded it halfway on his round and left it lying in my open shed by the roadside for a fortnight. I thought he had at last really parted from this dangerous derelict, but I was wrong. Another borrowed 'sponner' was tried, and still the wretched thing fills me with dread whenever I see him come plunging downhill towards me with handlebar festooned with parcels.

H A Kirton, the tricyclist, whom I knew in my youth in Sussex, had a favourite cycle saddle mounted on a wooden base and frequently used it to sit at table. Incidentally, I made a rough sketch of the idea and sent it to *Cycling* magazine many years ago. Kirton rode with me (I should say allowed me to ride with him) and encouraged me to cycle, and Mrs Kirton's preparation of 'speed food' – rice puddings, fruit, cream, etc – is still a delightful memory.

Returning to his lonely farmhouse near Wisborough Green one wild evening, we lost a race with a heavy thunderstorm and arrived drenched with both perspiration and rain. Nothing would do but we must shed all our clothes in the scullery and go outside for a shower-bath before a rub-down and supper – the only time I remember dancing naked in a thunderstorm.

How many delightful hours have been spent in this, the best country seat. And what scenes flash into the mind of the cyclist who has a few well-worn saddles to his credit. Hampshire lanes, first traversed when the passage of a car was a rare occurrence and tarmac was almost unknown; when the March winds raised a whirling cloud of dust and April's gentle showers washed the dust from hedgerows and made things sweet again. Sussex lanes and roads travelled in haste on a saddle of a famous vintage, long and narrow, responding to the eagerness of youth, and the lively buoyancy of Constrictor tubulars and wooden rims.

Mudguards were shed, lamps taken off, toolbag chucked away, and tools carried in a pocket; only a spare tubular wound around shoulder or under the saddle was permitted to add weight.

Then the saddle broadened, and the austere spring had a coil in its length. The rider's tail went down a shade, and his eyes took note of the landscape instead of being wholly fixed on the road immediately ahead.

There are still other country seats. The deep heather on a high moor makes a perfect well-sprung armchair. Indeed, for a warm summer night you'll find nothing more comfortable beneath a stifling roof. The settle outside a country pub, with the sound of bees and the scent of honeysuckle and roses. The parapet of a packhorse bridge, where the trout are idly fanning in the stream below. Or even a seat in the pool beneath a waterfall, where you can enjoy a natural shower. They are all country seats according to your mood. But still the best country seat is the perfect saddle on a good bicycle.

February the second – Candlemas day – and well supplied with legend and lore.

> *In Yorkshire ancient people say:*
> *If February's second day*
> *Be very fair and clear*
> *It doth portend a scanty year*
> *For hay and grass, but if it rains*
> *They never then perplex their brains.*

Few people remember or speak of Candlemas Day now, but formerly hiring fairs were held then when farm servants were hired for three months or a year.

Inns did a roaring trade as bargaining between master and manservant or maid-servant continued throughout the day. Dressed in his best smock, the carter, carrying his whip or wearing a knot of whipcord in his hat, and the shepherd with a tuft of wool displayed, sought a master for the coming season.

The bargain struck and the 'ernest money' accepted, he added a bunch of coloured ribbons signifying to all that he had found a new master.

The shilling which clinched the hiring bargain was as binding as the queen's shilling that a new recruit accepted from his recruiting sergeant. It was known as 'God's penny' in the north, and on Sunday after the fair labourers of the dales usually attended church and placed the coin in the collection – unless the landlord of the local got it first.

When the day ended the servant returned to work on the farm and live in the farmhouse for the stated time. And a jolly hard time some of them had under some masters, with poor food and long hours. But such masters soon became known and at next hiring word went round and the tyrant returned home on Candlemas Day alone with no one to exploit.

Huge cattle trucks and small horse-trailers, cars of every vintage, decrepit vans... and ponies. Ponies in singles, ponies in droves; riding ponies, entire ponies, suckers, yearlings and brood mares; ponies neighing, ponies kicking and biting; stallions tied to prevent them leaping the high rails; hundreds of ponies in fenced enclosures. A dense crowd of folk of all ages and types swarming round the pens into which the animals had been herded.

This was Chagford pony fair.

The auctioneer entered his box and there was a general movement towards the ring. A dark-eyed gypsy boy, agile as a monkey, wormed his way through the crowd and climbed to the top of the high fence for a free grandstand view of the sales ring. A thin red-faced man in a wide-skirted check coat, cap tilted over one eye and carrying a short cane led Lot no 1 round the ring.

'Three-year-old mare. Gentlemen: wot may I say, forty guineas? Forty guineas I'm bid, forty-one.'

As a big man led a lively unbroken stallion into the ring it lashed out viciously at a pony entering. Its owner, a wisp of a man, turned like a tiger on the big man – 'Tie that something so-and-so up afore it 'urts somebody,' he snarled.

And I noted an RSPCA inspector followed him out to see the suggestion carried out. One after another the animals came from the sales ring to be sorted by the inspectors into individual buyers' pens.

Abergavenny horse fair is a mild affair compared to this herding of largely unbroken moorland ponies straight off Dartmoor and later in the day someone was kicked on the head – I'm not surprised in such a free-for-all.

From time out of mind people have lived, worked and loved, suffered, fought and died, on Exmoor. Even today it is remote and wild and much of it is unapproachable save on foot, or by cycle or pony. It was a royal forest in Saxon times, and now it is a national park.

The sun shone as I cycled steeply down between great trees to the main Porlock – Minehead road. I wondered how the Lorna Doone coach carrying visitors between Minehead and Lynmouth was ever taken up and over the top by five sweating horses. (The fifth horse was a cock-horse, or trace-horse, ridden by a postilion and kept in Porlock to assist the coach up the hill.)

There is a story of an old coachman and his guard on this holiday service, which used to operate on two of the steepest hills in the West Country – Porlock and Countisbury. As the loaded coach began the descent into Lynmouth, the coachman would pull up and call loudly to his guard: 'Didst thee zee to thiccy king-pin bevore us did zet out, Tom?' 'Aye, thet oi did,' Tom would reply, and on they would go down to the Blue Ball Inn.

There George would pull up again with a great flourish and to-do. 'Art sure didst zee to thic king-pin as I told 'ee, Tom?' 'Aye, oi did.' 'Oi doant believe 'ee did, Tom, and I aint takin' my passengers down thic dangerous 'ill wi'out zeein' to 'un meself!'

The coachman would crawl under the coach and, after a considerable hammering and banging, reappear holding a bent and battered king-pin in his hand. 'Damme, Tom, what did oi zay?' he would bawl at the apparently vacant-looking guard. 'A foine thing en us'd 'ad a haccident wi' all us volk aboard.'

Pocketing the mangled king-pin for future use, George would proceed confidently down the one-in-four gradient to Lynmouth, there to receive with self-righteous gratitude, the generous tips offered by the somewhat shaken passengers. When the last passenger had disappeared into the nearest teashop, the two artful dodgers would split the booty over a pint.

I trickled on down to Lynmouth, where I heard something of that terrible August night in 1952 from folk who took a hand in rescuing and caring for victims of the flood disaster.

But heroism and resourcefulness are innate in Devon folk. It was a traditional defiance of danger when a duty had to be done that culminated in a remarkable episode of rescue work on a similar night of gale and rain in January 1899.

At seven pm that winter's night a message had come to the lifeboat coxswain that a ship was in distress and driving ashore at Porlock Weir. The sea was so rough that it was impossible to launch the lifeboat from Lynmouth, so they set about taking the heavy boat by carriage to Porlock.

With twenty horses, most of the men and women of Lynmouth took picks and shovels, skids and lanterns, and started up Countisbury. At midnight, they were at the top and striving to keep their flickering lights going in the gale and rain. When they came to a lane too narrow for the carriage they dug away the bank and went out on to Exmoor with the carriage while the boat was heaved from skid to

Reg Gammon
LYNMOUTH – 1933

skid through the lane. If you know Porlock Hill, imagine a heavy lifeboat being
steered round those corners in darkness and rain. Yet those heroes and heroines
accomplished it. Drenched to the skin, and without waiting for food, they
launched the boat from Porlock at six am. They put a crew aboard the distressed
vessel and twelve hours later got her to Barry on the Welsh coast. What a feat!

Years ago I heard that story from the gallant coxswain himself, George
Richards, and on my return this year I had hoped to call on him again, but I
learned that he was sailing fearlessly into his final anchorage and that only the
vicar was allowed to visit him.

I walked the most perpendicular road towards Lynton, turned left at the top to
Brendon, and so along the Lyn river to Malmsmead, where I sat to sketch the
ancient bridge over Badgworthy Water. I was in no mood to hurry through that
lovely valley, because I was recalling episodes from *Lorna Doone* as I pottered
along. I went into Oare church and sat alone, reconstructing the wedding, the group
by the altar, imagining the treacherous shot by Carver Doone through the side
window and Lorna lying prone upon the altar steps.

Dusk was falling when I climbed the steep hill out of the valley where wind-
blasted pines stood gaunt and ghostly against the sky. As I reached the main road, a
sudden gust of cold wind made me shiver . . . and was it only my fancy that a band of
Doones went riding over the moor? I slipped into 'top gear', streaked across the
moor, and dropped down to Porlock to the comfort and safety of an inn.

Sunshine and quiet weather continuing day in, day out, through October and into November, with only an occasional lapse, has brought joy to even the oldest inhabitant who always vows:'Us'll have to pay for it, you mind.'

A marvellous season, and if pay for it we must, it will have been worth the price. I drove across Somerset and Wiltshire into Hampshire the morning after the first rain for weeks and the November colouring on the trees was rich and beautiful – gold and ochre and red-brown glowing against the dark green of evergreens and yews.

Work on the farms was well advanced; already a fleck of green covered newly sown fields and the waving clattering cutter-bar had come into its own again scything off the hedge-top and siding-up with a 'short-back-and-sides' effect. A good labour saving when the knife cuts clean and the tangle of thorns is cleared away.

My preference is for an old hedger and a well-laid hedge; no easy task, believe me, to lay an uncut, neglected hedge. I tried it once on a roadside hedge in the Llanthony Valley and thought I was doing well until my neighbour Reggie Williams came along and took the 'hacker' out of my hand, put on my thick hedging gloves and did a bit. Too much mechanical cutting there would be disastrous because the hedges have to withstand mountain sheep, and an elephant has nothing on an old ewe when she can see green on the far side of a hedge.

It is an art to slice partly through a growing sapling, bend it and lace it between the stakes so that sap can continue to flow and a live hedge results. No mechanical cutter can do that and displace a skilled hedger, any more than a machine can build a drystone wall.

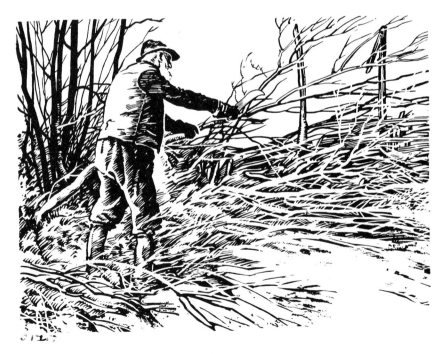

While the farmer 'lower down' flattens his hedges to save labour, the hillman knows the value of his walls and hedges as windbreaks. When winter sweeps across the hills, when the wind cuts like a whetted knife and sleet drives in horizontal rods, a hill farm devoid of shelter would be a sorry place.

As night falls, the sheep make towards a wall or hedge bank, and often returning at night, walking close to the mountain wall for protection and guidance in the darkness (no street lamps on the hills), I have come on animals lying close under the wall, dry and warm. A shuffling just ahead indicated a ewe moving out of my path – a somewhat ghostly experience to anyone unused to the ways of the hills.

The worst enemy of the mountain walls and hedges is often violent wind which blows away thorns laid as capping, or clean carries away stop-gap thorns in hedges. A hungry mountain ewe only has to be able to see through a small hole to push through it and start a new adventure.

The art of hedging, and the popular hedging competitions, will not disappear from the hills whatever may happen on farms lower down.

There are not now many roadside verges where the ubiquitous roadman does not ply his hook or run his mechanical cutter and sweep all before him. This is a case where I much prefer a bit of untidiness because he mows down flower and weed alike. Not a berry is left to add colour to the roadside in 'red November', not a seed head of thistle or knapweed remains to feed the small birds much in evidence now.

Where there is a common or untrimmed roadside and plants have been allowed to bloom and seed and die the tits and finches abound. The goldfinches are most colourful and it would have been difficult to have invented a more apt collective term than a 'charm' of goldfinches. They are very tame and one can stand a few yards from them without in the least disturbing them as they extract the seeds and send the tiny parachute floating away on the breeze without its seed base. Pliny wrote that they bear animosity against no living creature but the donkey which eats off thistle heads!

I knew one Sussex loafer who boasted his skill in capturing 'goldies' by liming thistle heads. They were sold to 'a genneman from Lunnon' who periodically visited 'the local' for that purpose and who doubtless made a handsome profit on them as cage birds.

Protection laws have long since put a stop to this and other cruel practices with the result that these delightful birds are widely distributed and numerous.

Winter is the best season to visit the woods. If one moves quietly, not slashing about at plants with a stick – as so often happens – or alerting every creature with the smell of tobacco, the wood will prove alive with animals and birds.

I lived for twenty years surrounded by Sussex woods, remnants of the great forests that were felled when iron-smelting flourished in the weald. And I spent much time just wandering in these now silent woods, training myself to move quietly; never to tread on a dead stick and shatter the silence, or break off a trailing branch; ready instantly to 'freeze' on sight of any wild creature and just watch.

I gradually trained my eye to see what others walked over – the footprint of a fox in the mud; I knew the scattered pine cones ripped apart by squirrels from those that the crossbills had dropped in whole condition after extracting the seeds.

Every empty hazel shell had a story to tell. The woodmouse drills a neat hole to extract the kernel; the nuthatch splits the shell into equal halves, as my father taught me with my pocket knife; but the squirrel leaves bits of broken-edged shell where he has feasted. There is a book to read in passing down a forest ride.

Hedgerows are also full of interest for the observant walker. The narrow way I passed down one winter's day was buried deep in the residue of autumn's glory; decaying leaves and herbage had spread a protecting blanket over the 'darling buds of spring'.

A mixed company of tits filtered through the bare hedgerows. Two blackbirds scattering the leaf-drift in their search for food flew off as I approached, and a jenny wren scolded me from an ash branch.

But the tits disregarded me and, twittering among themselves, continued to examine every crevice for insects hiding in the fancied security of rough bark or stone wall. Nothing escapes the acrobatic blue tits. Hanging upside down or right way up to feed is all one to them.

A family of long-tailed tits, keeping together as usual until the breakup in spring, fluttered in and out of the bare hedge like wind-blown leaves on long stalks, keeping level with me with no sign of fear or concern at my intrusion. From the time of leaving the nest until the following spring the long-tails – sometimes twelve or fourteen youngsters – remain in perfect harmony sharing the same roost, a perfect family party. All were intent on finding almost infinitesimal morsels of food. They work all the winter-shortened hours of daylight to fend off hunger in the long darkness of winter nights.

Earlier in the day I had watched two starlings splashing in a puddle of water – they will do this with obvious enjoyment even when the pool is ice-fringed. And

when you see a bird taking its morning bath you may be sure that food is plentiful and bird-life pretty good. The spring water, running from the hillside by the cottage in Wales where we used to live, was always a bathing place for the birds when everything was sealed by frost and ice. A vigorous shaking and combing of feathers always followed.

My lane emerged from between tall hedges to cross open downland country where a ploughman was simultaneously turning five furrows of rich brown earth. The air was alive with rooks and gulls following hard behind the plough and missing nothing in the way of food that was exposed.

Some of our birds, like the now rare corncrake, have suffered from the mechanization of our farms, and still more are threatened by the destructive chemicals used to increase cropping and combat pests.

But the rooks and gulls safely take their toll behind the five-furrow plough just as in the days when a team of oxen plodded slowly before a huge wooden plough turning a solitary furrow. And the winter flocks of plovers wheel and form shapes and patterns in the sky overhead.

All my life I have been fortunate enough to live very near hills and downland, and now a ten-minute ride takes me on to Creech Hill to overlook much of Somerset in a wide sweeping view. Here on winter days high above the valley where

The last red leaf is whirl'd away
And rooks are blown about the skies

that same wind sweeps the chambers of the mind.

One looks down on a countryside with the old and decaying washed away and young wheat springing in a new year's fields. Sometimes one is lucky enough to enjoy those winter days of rare beauty and gentle warmth, when a lark forgets the season for a moment or two and mounts on high, singing as in the spring.

Here on the hill the air is sweet and pleasant; reassuring sounds of home and farm life come sharp and clear from below.

And final pleasure – to return to one's own fireside, or that farmhouse or small pub where one is welcomed, warmed and fed in traditional country fashion.

Surely a fitting end to a winter day.

I turned off the road, tired of being hustled by passing cars, resentful at having to adjust my thoughts to their presence, and climbed a stile leading to a field path.

The winter sun was warm on my back, but a sharp easterly current of air made me button up my jacket to the throat and frequently dab my near-freezing nasal organ with a kerchief.

Where the path turned south to follow a stone wall that effectively countered the wind, I turned face to the westering sun to thaw out. This was the spot to rest awhile and eat my apple – a ritual observed always on a winter walk.

Every autumn I visit a fruit farm in mid-Somerset and return home with several forty-pound-weight bags of apples to store for winter use – Bramleys for cooking, Laxton's Superb and Cox's Orange for eating, in that order.

We have an old circular stone stairway in the house, unused now except as a store, and apples keep the winter round in perfect condition. A Cox starts the day well and blessings are called on the folk that grow them.

My aged mother bequeathed to me a pearl-handled silver knife which her mother always used when peeling her daily apple – peel so delicate, mark you, as to be almost transparent, no unnecessary waste.

So when I sit by a winter log-fire with a Cox's Pippin and my grandmother's silver knife, I feel that I am continuing a family tradition. And the ritual has an added attraction because we have been credibly informed that a distant relation of my wife, Cox by name, first grew and named the perfect English fruit.

That same day, visiting a friend in Longtown I saw several lovely roses blooming in her garden untouched by winter's hand. And in her cottage window was a bowl of yellow jasmine – of course spring is coming, nothing can stop it! Man can play the fool with many natural things, but not with the seasons – thank heaven.

So take a walk along the sheltered side of a wood or in a sunny coppice where the hazel catkins are lengthening, ready to give their pollen to the wind. Here in January, and certainly in February, you will find signs to cheer you these watery days. In many a cottage garden too –

> *The spendthrift crocus, bursting through the mould,*
> *Naked and shivering with his cup of gold.*

It is all a bit early, I grant you – but who would put back the flower or tighten the sheath about a leaf bud?

Wise men through the ages have praised country life and labour. 'O, more than happy countryman, if only he knew his good fortune', wrote Virgil; and Cicero, 'There is nothing better than farming, nothing more fruitful or more delightful, and nothing more worthy of a free man'. In Job we read, 'speak to the earth and it shall teach thee'. Wise people today are awake to the danger of destroying our country heritage.

In a radio survey I heard, on recent new discoveries resulting from the twelve-year journey into space, an American scientist said 'There is nothing like *Earth* in all the solar system'. I would add 'There is nothing like *England*' and *would* that we could ring all the church bells in praise of efforts being made to halt the destruction of both.

Listen to W H Hudson, that great naturalist writing in the last century: '...close by, a plough-field of about forty-acres was the camping ground of an army of peewits – quietly resting over the whole area. More abundant were small birds in mixed flocks or hordes – finches, buntings and larks in thousands on thousands, with pipits and pied and grey wagtails. It was a rare pleasure to be in this company, to revel in their astonishing number, to feast my soul on them as it were...and to reflect that they were safe from persecution here in England'.

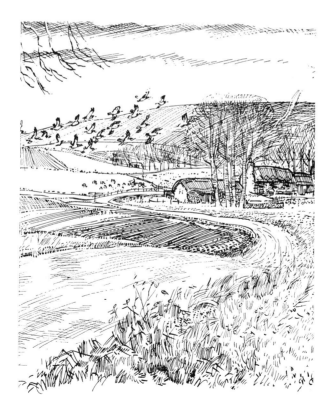

On a winter's morning a blackbird sang of spring from an apple tree in Somerset. Later the west wind carried the sound of cathedral bells from Wells mingled with the joyful voices of several village churches.

Few things move me more than this lovely English sound. If I had to be a castaway on a desert island, with a few records and a gramophone, this would be my choice. The sound of the surf and the sight of swaying palm trees would disappear when I played the record. And I should mount a stile and walk a field path to a village church, where the bells called all good folk to come; stirring the rooks in the tall elms until their cawing mingled with the organ's voice and helped the parson with his prayers. I should choose a seat so that I could glance up through a window and see them swaying against a backcloth of blue sky and fleecy clouds.

My record ended, I should need no television to excite my mind; the screen of memory can range far and wide, undistorted by impact from without.

England still has quiet villages, peaceful homes and pleasing prospects, bearing the stamp of centuries of countrymen and women: builders, farmers, gardeners, the village blacksmith, the rich wool merchant, the parson, the squire and the yeoman.

Like my ancestor Thomas Gamon (yeoman 1524–1588), my furrow is completed. The headland only remains, like the frame round a picture, and the gate is closed on a tidy job.

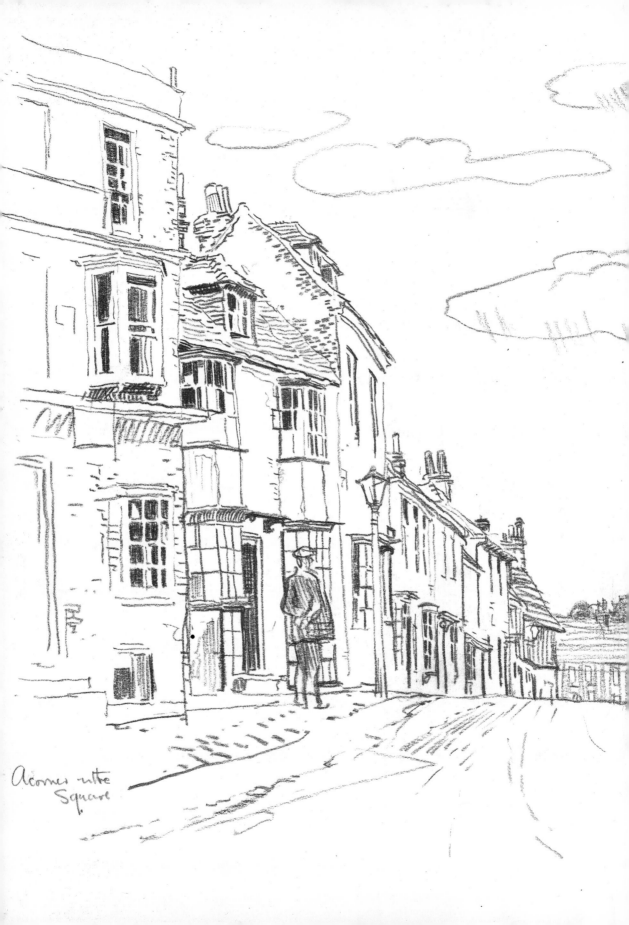

A corner in the
Square